An Introduction to Greek Art

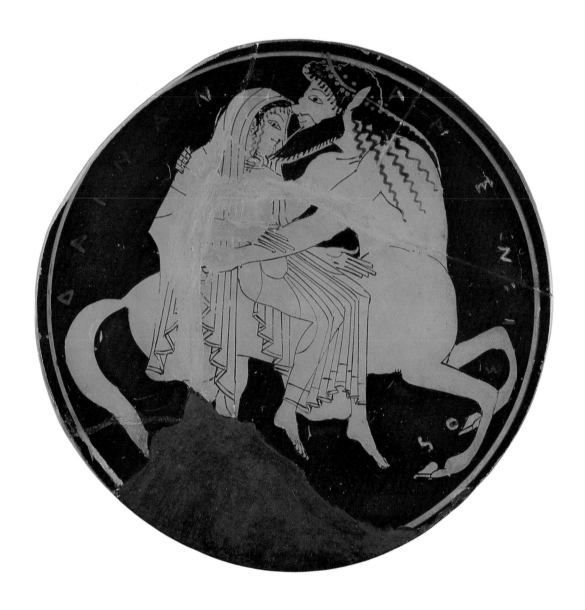

Nessos carrying Herakles' wife Deianeira, Attic
red-figure cup interior, painted by the Ambrosios
Painter, about 520 BC, British Museum, London

An Introduction to Greek Art

Susan Woodford

Cornell University Press

Ithaca, New York

First published 1986 by Cornell University Press.
First printing, Cornell Paperbacks, 1988.
Third printing 1993.

Printed in the United States of America

⊗ The paper in this book meets the minimum requirements of the American National Standard for Information Sciences—Permanence of Paper for Printed Library Materials, ANSI Z39.48-1984.

Library of Congress Cataloging in Publication Data

Woodford, Susan.
 An introduction to Greek art.

 Bibliography:p.
 Includes index.
 1. Sculpture, Greek. 2. Vase-painting, Greek.
I. Title.
NB90.W66 1986 730′.0938 86–9012
ISBN 0-8014-1994-8 (cloth)
ISBN 0-8014-9480-X (paper)

Contents

Note on terminology

Archaic is the term used for the early period of Greek history and art from about the middle of the 7th century BC to the early years of the 5th century BC, the time when the Greeks were eagerly acquiring ideas and techniques from the Near East and Egypt, and gradually making them their own.

Classical refers to the period between the Persian wars (490-479 BC) and the death of Alexander the Great (323 BC). It is divided into three sub-periods: *Early Classical* (from the early years of the 5th century BC to about 450 BC), *High Classical* (from the middle of the 5th century BC to about 425 BC), and *Late Classical* (from the end of the 5th century BC to 323 BC).

Attica is the territory belonging to the Athenians. *Attic* is the adjective pertaining to Athens, the city, its people, products and territory.

The Glossary, pp. 177-80, defines other terms which are less frequently used.

Table of dates BC

Century BC	Beginning	1st quarter	2nd quarter	3rd quarter	4th quarter	End
8th (700s)	799	799-775	775-750	750-725	725-700	700
7th (600s)	699	699-675	675-650	650-625	625-600	600
6th (500s)	599	599-575	575-550	550-525	525-500	500
5th (400s)	499	499-475	475-450	450-425	425-400	400
4th (300s)	399	399-375	375-350	350-325	325-300	300

to
George M.A. Hanfmann

Preface

Greek art is much admired, and rightly so, but it can be baffling on first acquaintance. Obstacles to both appreciation and understanding abound. Most of the statues that were highly esteemed in antiquity have disappeared without a trace; among those that have survived, few are more than battered fragments and almost all lack the original colours that once brightened them. Roman copies of famous lost works can sometimes be identified, but they are seldom anything more than pale reflections of great ideas, inferior in execution and disappointing as works of art. Vases, by contrast, are preserved in abundance, but their quality is not easy to appreciate at first glance. The colours that decorate them are limited in number and subtlety and the subjects they depict are usually unfamiliar and difficult to decipher.

And yet there is no doubt that these broken bits of statuary and painted pieces of pottery are the remains of one of the world's most brilliant periods of artistic development.

The purpose of this book is to make the beauty of Greek art more readily accessible and comprehensible. It was commissioned by the Joint Association of Classical Teachers, who believed that a book which focused on a limited number of works in sculpture and vase painting during a critical period (from the 8th to the 4th centuries BC) could serve such a purpose better than a handbook which covered a wider range of media or a more comprehensive survey. Within this specified, but by no means unduly restrictive, scope I have attempted to provide a systematic approach and an analytic framework that will help the novice – student, traveller, art lover – not only to develop understanding and appreciation, but also, I hope, to discover and enjoy the splendour of Greek art.

I have had the good fortune to have been advised by many kind friends and colleagues who have tried to save me from both errors and obscurity by giving freely of their time and learning and by an editor and a publisher who have been unstinting in their efforts to produce a book worthy of its illustrious subject.

I would therefore like to thank Susan Bird, Deborah Blake, Lucilla Burn, Lesley Fitton, Jenny Gibbon, Catherine Hobey Hamsher, Colin Haycraft, Ian Jenkins, Helen Solomon, Geoffrey Waywell, Dyfri Williams, Richard Woff and Peter Woodford, none of whom should be held in any way responsible for whatever inaccuracies or infelicities of expression remain.

It is a special pleasure to acknowledge the unfailing encouragement and meticulous criticism which, over the years, have been given with characteristic generosity of spirit by the distinguished scholar and inspiring teacher to whom this book is dedicated, George M.A. Hanfmann.

London 1985 S.W.

Acknowledgments

The author and publisher wish to thank all those who have supplied and given permission to reproduce illustrations, the sources of which are as follows:

Alinari: 247

American School of Classical Studies at Athens, Agora Excavations: 208

Archaeological Museum, Corfu: 33

Bibliothèque Nationale, Paris: 22, 176, 181

Susan Bird: 1, 11, 25, 26, 27, 40, 42, 70, 71, 73, 101, 127

British Museum: frontispiece, plates 1 & 2, figs 7, 8, 14, 20, 43, 46, 50, 79, 82, 83, 84, 85, 86, 91, 92, 95, 110, 140, 152, 153, 154, 155, 159, 160, 161, 162, 165, 166, 167, 168, 170, 172, 175, 177, 178, 179, 180, 182, 183, 201, 205, 214, 215, 216, 220, 249

A. Conze, *Die Attischen Grabreliefs* I (W. Spemann 1893): 232

E. Curtius & F. Adler, *Olympia* (A. Ascher & Co. 1897): 134 (drawing by L. Otto & M. Kühnert), 139 (drawing by M. Kühnert)

Delphi Museum, Greece: 120

Eleusis Museum, Greece: 6

Alison Frantz: 28, 29, 30, 31, 35, 52, 53, 54, 58, 63, 68, 69, 72, 88, 103, 109, 119, 129, 130, 131, 133, 135, 136, 137, 141, 142, 143, 144, 145, 146, 147, 148, 169, 171, 209, 210, 211, 218, 222, 225, 236

A. Furtwängler & K. Reichhold, *Griechische Vasenmalerei* (F. Bruckmann 1904-1932): 16, 90

German Archaeological Institute, Athens: 57, 121, 212, 213, 223, 229, 230, 231, 233, 241

German Archaeological Institute, Rome: 99, 100, 111, 112, 114, 189, 204, 219, 221, 245

D.E.L. Haynes, *An Historical Guide to the Sculptures of the Parthenon* (British Museum 1962): 156

Hirmer Fotoarchiv, Munich: 3, 13, 18, 23, 38, 55, 80, 81, 107, 108, 132, 164

Michael Ivy: 193

Katholische Kirchengemeinde, Xanten: 246

R. Lullies, *Griechische Plastik* (Hirmer Verlag 1979): 226

Mansell Collection: 187, 203

Metropolitan Museum of Art, New York. Fletcher Fund, 1932: 44, 45, 47, 49, 51, 196; Joseph Pulitzer Bequest, 1963: 78; Rogers Fund, 1911: 4, 5; Rogers Fund, 1917: 198

Susan Morris: 127, 134

Musée du Louvre: 12, 93, 94, 149, 242

Musei Vaticani: 19, 113, 235

Museo Archeologico Nazionale, Ferrara: 197

Museo Provinciale, Lecce: 151

Museum of Fine Arts, Boston: 74, 75, 199, 200 (drawing by Suzanne Chapman)

National Archaeological Museum, Athens: 9, 10, 64, 65, 102, 184, 185, 194, 195

Ny Carlsberg Glyptothek, Copenhagen: 243

D. Ohly, *The Munich Glyptothek: Greek and Roman Sculpture* (C.H. Beck 1974): 36, 37

Lucy Parker: 128

Liberto Perugi Fotografo, Florence: 115, 116, 117, 118

Phaidon Picture Archive – all from G.M.A. Richter, *Archaic Gravestones of Attica* (Phaidon 1961): 59 (drawing by L.F. Hall), 60, 61, 62, 244

G. Rodenwaldt, *Altdorische Bildwerke in Korfu* (Gebrüder Mann 1938): 32

G. Rodenwaldt, *L'Acropole* (Deutscher Kunstverlag 1930), photos by W. Hege: 106, 158, 207

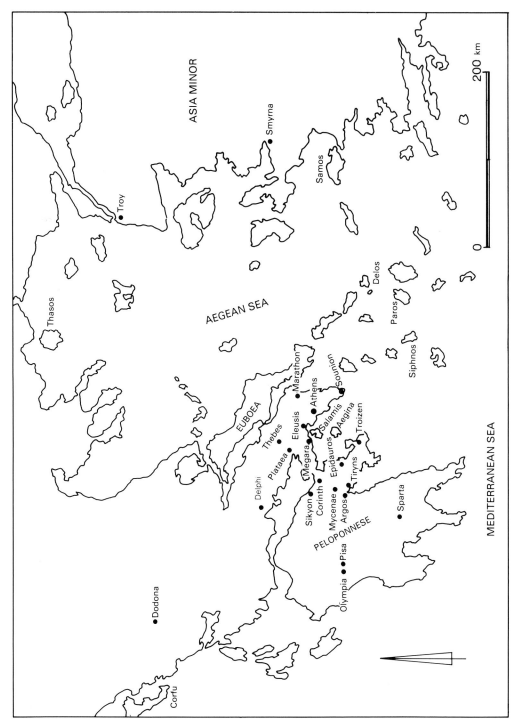

1. Greece and the West Coast of Asia Minor

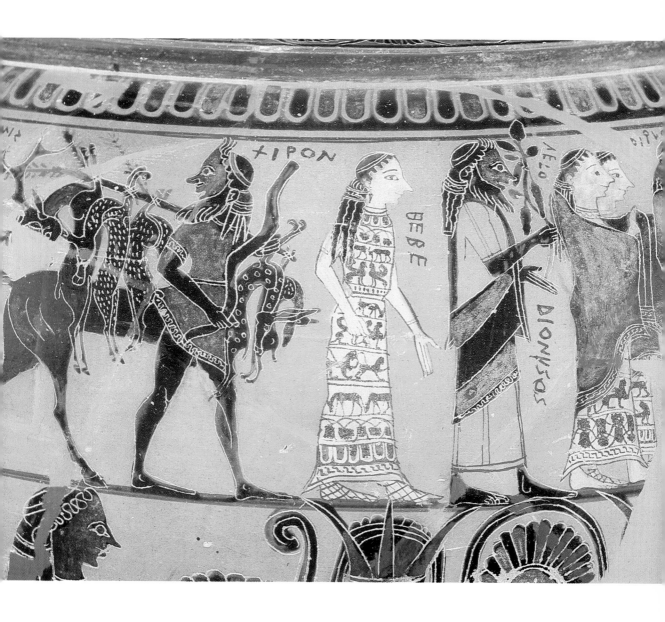

1. Cheiron, Hebe, Dionysus, Leto and others; detail
from the Wedding of Peleus and Thetis, Attic
black-figure dinos, painted by Sophilos, 580-570 BC,
British Museum, London

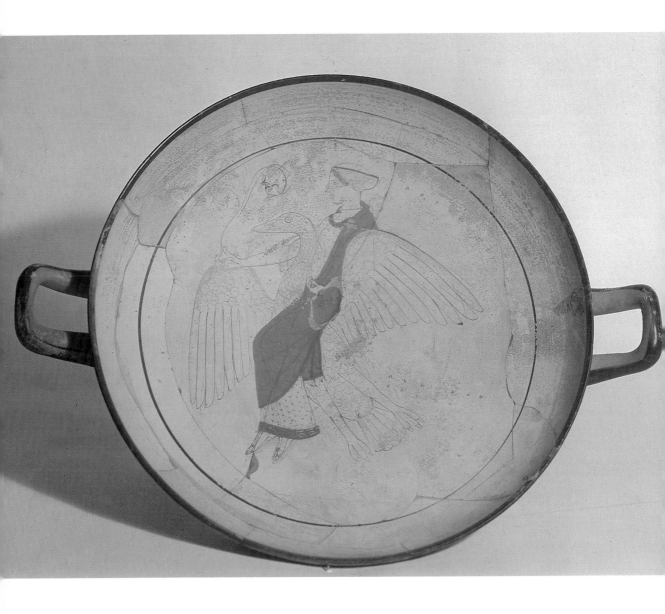

2. Aphrodite riding on a goose, Attic white-ground cup
interior, painted by the Pistoxenos Painter, about 460
BC, British Museum, London

1

Beginnings

The beginning of Greek civilisation

'In the beginning', Hesiod tells us, 'there was chaos.' He is speaking of the origin of the gods, but his words could equally aptly describe the dawn of Greek civilisation: it was born out of the chaos of the Dark Ages which lasted from the 11th to the 9th centuries BC.

At that time, people speaking an early form of Greek had already been living in Greece for hundreds of years. They had even produced a civilisation of considerable brilliance which flourished between the 16th and the 12th centuries BC. We call this civilisation *Mycenaean* to distinguish it from the later *Greek* civilisation, which is the subject of this book. It was named by modern archaeologists after Mycenae, the city whose legendary power was celebrated by Homer and whose magnificent ruins still awe the visitor today (Fig 2).

During the course of the 12th century BC the Mycenaean world disintegrated. Amid widespread destruction, mighty walls began to crumble, great palaces were abandoned, populations dwindled, trade ceased, crafts declined and even the art of writing was forgotten. By the beginning of the 11th century BC, the once impressive civilisation lay in ruins.

A huge number of people must have died; many of the survivors migrated to new homes. Some crossed the Aegean and settled along the west coast of Asia Minor, others occupied the islands along the way.

A period of profound isolation and impoverishment – a dark age – separates the splendour of Mycenaean civilisation at its height from the Greek civilisation that

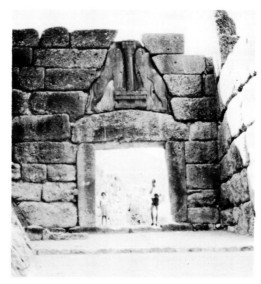

2. The Lion Gate, Mycenae, 13th century BC

was to develop later. Little more than a memory bridges the gap, but this memory was a stirring one, for it inspired songs and stories that recalled the glamour of bygone days and stimulated legends about the past that gradually grew into the tradition of oral poetry which culminated in the two great epics of Homer: the *Iliad* and the *Odyssey*.

The theme of Homer's poems, the Trojan war, belonged to the Mycenaean past, but the epics themselves were part of a new beginning, the beginning of Greek civilisation.

The Homeric epics were created sometime during the course of the 8th century

1

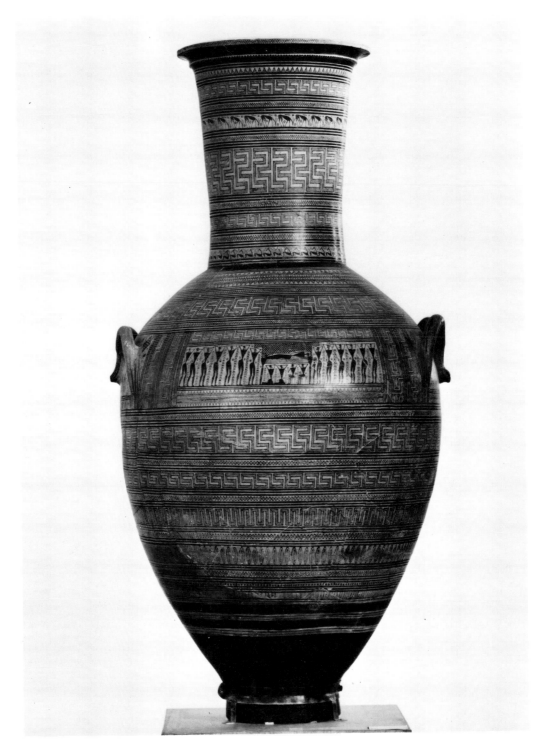

3. Attic amphora used as a grave marker, Geometric
style, mid-8th century BC, National Archaeological
Museum, Athens

2

BC, a crucial period in the evolution of Greek culture. Prosperity was returning, populations were increasing and trade was reviving. People began to travel. Every four years Greeks would come together from far and wide to celebrate the Olympic games (traditionally thought to have been instituted in 776 BC). Exchanges with non-Greeks now also became more frequent and brought inestimable cultural benefits; already by the end of the 8th century BC the Greeks had cleverly adapted the Phoenician alphabet in such a way as to enable them to write their own language again.

Intellectually, culturally and economically during the 8th century BC seeds were sown that were to blossom in the following centuries. The development from this time on was continuous and unbroken.

The beginning of Greek art: the geometric style

Increasing wealth encouraged increasing display. Festivals became more spectacular and recitals of poetry more splendid, but no one seemed able to produce equally impressive visual works of art. Knowledge of how to cut and move large stones or of how to cover great walls with colourful paintings had been lost with the collapse of Mycenaean civilisation. Only utilitarian skills practised on a relatively small scale appear to have survived the debâcle.

Of these, the humble craft of the potter alone seemed capable of being enlarged sufficiently to produce works of the desired grandeur. Potters, therefore, had to provide the monuments for the new age. They rose, magnificently, to the occasion.

Some of the vases potters made about the middle of the 8th century BC were huge. The one illustrated in Fig 3 is over a metre and a half in height and originally stood as a grave marker upon an Athenian tomb, a proud demonstration of wealth and power.

Though the vessel itself is very large, the patterns that decorate it have been kept small so that they cover the surface with a network of light and dark, subtly varied to emphasise the different structural parts of the vase: off-set lip, cylindrical neck, expanding shoulder and wide belly tapering into the vertical foot. Strong black lines, arranged in groups of three, divide the surface into horizontal bands called *friezes*. These are filled with carefully drawn, repeated patterns, some of which are very simple – triangles, diamonds and the like – while others are more complex, the meanders occasionally becoming very elaborate indeed. These abstract patterns are mostly sharp and angular and designed so that they (or their parts) are either vertical or horizontal. In this way the decoration can contribute to the stable and monumental appearance of the vase while, at the same time, contrasting interestingly with its curving contour.

Two friezes on the neck are different from the others: one is made up of grazing deer and the other of reclining goats. Though these are representations of living creatures, there is no hint of life or movement; the animals have been stylised into patterns and disciplined to fit into the decorative scheme.

The most prominent part of the vase, the area between the handles, has received special treatment: interest is focused on a panel limited and framed on all four sides. Within it mourners are shown expressing their grief around a bier. The corpse lies conspicuously in the centre, the checkered shroud raised above it so that the body can be seen. Four mourners sit or kneel in front of the bier; seven figures stand to the left, six more and a child to the right. The general impression is one of balance, but the lack of exact symmetry gives life to the picture.

The figures, who fill their alotted space from top to bottom, are precisely drawn silhouettes. The painter has shown only what is essential: head, neck, torso, hips, legs (flexed at the knees) and arms (bent at the elbows). The form of the body has been subjected to the same logical analysis as

the shape of the vase: each significant structural part is clearly articulated, crisply separated from its neighbour.

The spaces between the figures have been filled with rows of zig-zags. These *filling ornaments* prevent the black silhouettes from standing out too boldly from the rest of the decoration.

This vase is one of the finest examples of the *geometric style*, the style that was flourishing at the time when Homer was composing his epics. Both poet and painter in the mid-8th century BC were able to construct an impressive work of art out of small units meticulously arranged, for Homeric poetry employs formulae – 'swift-footed Achilles', 'wine-dark sea', 'winged words' – to build up lines and thoughts in much the same way that the geometric vase painter uses triangles, meanders and even animal forms to fill his space. But while the painter seems to restrict himself to generalised scenes (other examples show processions of warriors or chariots, battles, ships and shipwrecks), the poet deals with particular heroes and their individual deeds and accomplishments – themes that were soon to engage the attention of artists too.

By the end of the 8th century BC the geometric style was showing signs of exhaustion. Innovative artists began to develop a bolder style that made use of bigger, more active figures, included images of wild animals and monsters, and could illustrate myths.

Foreign trade stimulated vase painters' imaginations and also provided them with interesting ideas. Textiles, ivories and other small objects imported from the Near East were often decorated with pictures of heroes in combat, monsters triumphant or subdued and wild animals either attacking their prey or prowling solemnly in processions. Furthermore, oriental images often relied on large swinging rhythms and were enriched with well-rounded floral motifs which offered formal alternatives to the mincing and angular geometric style.

Not surprisingly, Greek artists re-sponded enthusiastically to oriental inspiration. Though they seldom copied Near Eastern prototypes exactly, the influence of such works was so pervasive that the 7th century BC is known as the *orientalising period*.

Artists in different centres in Greece drew on different aspects of the new repertoire provided by oriental models, each guided by whatever ideas he was interested in exploring at the time.

The beginning of narration on Attic vases

The Athenians, though they never ceased to portray scenes of daily life, were now becoming ever more eager to recount myths in visual form, and this encouraged them to develop a new style. By the middle of the 7th century BC, Attic vase painters had almost entirely rejected the geometric style. They had replaced narrow friezes filled with small angular patterns (Fig 3) by large pictures confined within bands of loose curvilinear decoration (Figs 4 and 5) and instead of just presenting generic scenes, they had begun to illustrate specific myths.

The story represented on this vase (Figs 4 and 5) concerns the hero Herakles and the centaur Nessos. A centaur was a monster that was part horse and part man. This particular centaur, Nessos, worked as a ferryman. In the course of his duties he offered to carry Herakles' wife, Deianeira, across a river, but midway he was overcome by her charms and tried to assault her. Herakles' response was swift and decisive.

The painter has shown the centaur collapsing (Fig 4) as Herakles advances to attack him with his sword (Fig 5, left), while Deianeira, on the other side of the hero, demurely holds the reins of the four-horse chariot at the right of the picture (Fig 5).

In order to make his visual narrative more vivid and intelligible, the artist has ceased to rely solely on the simple

4

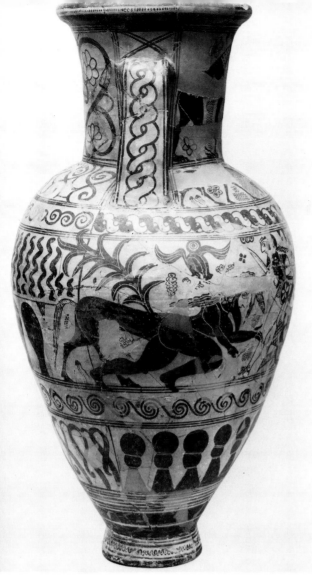
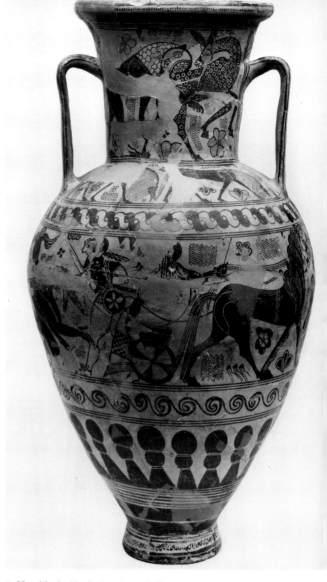

4. Nessos collapsing before Herakles' onslaught (left side of Fig 5), Attic amphora used as a grave marker, about 660 BC, Metropolitan Museum of Art, New York

5. Herakles' wife, Deianeira, minds the chariot while Herakles attacks Nessos (front view of Fig 4)

silhouettes of the geometric style and has, instead, made use of a mixed technique: in some places he has combined outline drawing with pure silhouette and in others he has articulated the silhouette by means of incision. The faces, with their large, expressive eyes, Herakles' arms and legs and Deianeira's skirt are drawn in outline; incision (scraping a line in the black paint with a sharp instrument before the vase is fired) is used to clarify Nessos' complicated anatomy, to separate his human buttocks

from his horse-body and to show his nearer arm and leg, which otherwise would be indistinguishable from his body.

The artist employed this same mixed technique to paint a monstrous carnivore (probably intended to represent a lion) devouring a deer on the neck of the vase (Fig 5). He used filling ornament consisting of both geometric zig-zags and orientalising floral motifs to decorate the background.

This vase, with its large, irregular forms

and sometimes unsteady freehand drawing, lacks the disciplined control that made the geometric vase (Fig 3) a masterpiece; the artist has, however, effectively contrasted the faltering monster with the determined hero, and the lean body of the centaur with the stolid forms of the plodding chariot horses, so that, despite a certain clumsiness, he has succeeded in telling his story with vigour and zest.

Another mid-7th-century BC Attic artist used both the neck and the body of his vase as fields for narration (Fig 6). The figures are again large and squeeze the zones of ornament into limited areas at the top and the bottom of the vessel.

The scene on the body of the vase shows Perseus and the Gorgons. According to the myth, there were three Gorgon sisters, only one of whom, Medusa, was mortal. These monsters had faces so horrible that a mere glimpse of them was enough to turn a person to stone – they were literally petrifying. The hero Perseus was ordered to kill Medusa and carry off her head, a task requiring both ingenuity and courage.

As no picture of a Gorgon was known, the artist was obliged to invent one. He tried hard to create an image worthy of the reputed hideousness of these creatures. He painted big-eyed Gorgons with sparse tombstone teeth and snaky hair – a valiant first attempt at a horrific visage. Pride of place has been given to the two immortal sisters of Medusa. They turn their terrible faces towards us as they pursue Perseus, whose fleeing legs are still preserved at the far right. The slim figure of the goddess Athena stands between Perseus and the Gorgons, covering the hero's flight. The horizontal, decapitated body of Medusa lies at the far left, beyond the range of our illustration.

The story of Odysseus and the cyclops, Polyphemus, is told on the neck of the vase. Odysseus, one of the heroes of the Trojan war, was trapped on his way home in the cave of the gigantic one-eyed cyclops. The cyclops closed the mouth of the cave with an enormous boulder and proceeded to eat up pairs of Odysseus' men at mealtimes. Odysseus, realising that he and his friends could not possibly move the great boulder, had to find a way to get the cyclops to do this himself while the men escaped unseen. The first step in the clever plan Odysseus devised was to make the cyclops drunk; the second was to blind him.

To make the story clear, the painter chose to illustrate the easily recognisable scene of blinding. The cyclops is shown seated at the right, his great size indicated by the fact that, though seated, his head reaches to the top of the available space. To the left, three men are driving a stake into his single eye. Their leader, who leaps forward, is Odysseus. He was originally painted white to distinguish him from the others, but the white paint has flaked off, revealing the artist's vigorous preparatory sketch. The cyclops raises one ineffectual hand to try to push the stake away; with the other he holds a wine cup. The painter did not intend to suggest that Odysseus and his men were so foolhardy as to attack the cyclops while he was still drinking; he has introduced the wine cup in order to make it clear that the cyclops had been made drunk before the rest of the plan was put into effect. He was not interested in representing a single moment accurately, but in evoking the story in its entirety.

On the shoulder, a now-recognisable lion attacks a boar, and in the field, the filling ornament is almost entirely floral.

This painter freely combined outline and silhouette, but used hardly any incision.

These two over-large Attic vases (Figs 4-6) were, like the geometric vase (Fig 3), not meant for everyday use, but stood on graves as tomb monuments. Both are experimental in style and technique, and neither is entirely successful. Though myths are represented in a lively way, the anatomy of the large figures seems rather rubbery and the finer points of just how limbs are meant to be attached are often shamelessly glossed over. The use of outline drawing contributes to the intelli-

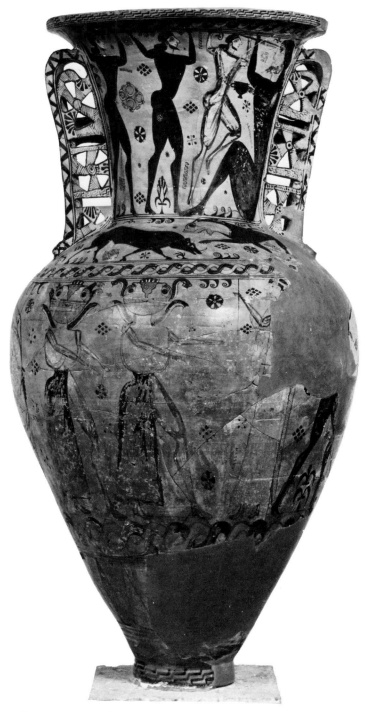

6. Gorgons pursuing Perseus; on the neck, Odysseus
and his men attack the cyclops. Attic amphora used
as a grave marker, mid-7th century BC, Eleusis
Museum, Eleusis

gibility of the stories, but looks rather thin on the brightly coloured, curving surface of a vase.

The beginning of the black-figure technique: vase painting in Corinth

While some Athenian vase painters were interested in adapting Near Eastern models to help them illustrate myths, several vase painters in Corinth were busy developing their own versions of oriental processions of animals, real and imaginary. Images of such fierce creatures may have been felt to derive a certain power from the beasts themselves and seem to have been much prized for their novelty and impact.

In contrast to the Athenians, the Corinthians often worked on a small, sometimes miniature scale; the tiny oil flask illustrated in Fig 7 is only a few

7. Processions of animals, aryballos (Protocorinthian) made in Corinth about 650-640 BC, British Museum, London

centimetres high. In matters of technique, too, the Corinthians differed from the Athenians; they retained full silhouettes for their figures, but enlivened and articulated them consistently with finely controlled incision.

The oil flask shown in Fig 7 was painted in Corinth about the middle of the 7th century BC. It is divided into four zones, the lowest decorated with elongated triangles like rays, the next with running dogs, the largest with a procession of impressive animals (bull, boar, lion), and the shoulder with a similar procession, only smaller. The animals are painted in silhouette while their internal markings are indicated by clear, precise incision. The figures stand out strongly against the surface of the vase, dot-rosettes tempering the bleakness of the background; at the same time details like the shoulder of the boar, his sharp tusk and his bristly back are convincingly conveyed.

A deep cup also made in Corinth, but somewhat later (Fig 8) strikingly demonstrates how much livelier images can become when incision is used. Once again a procession of orientalising animals (some mythical like the griffin-headed winged lion) occupies the principal frieze, and rays are painted in the lowest zone. An old-fashioned row of identical birds in unrelieved silhouette decorates the top. How dull they look, lacking the incision that enlivens the beasts below! On this vase the artist has added touches of dark purplish-red. Sometimes a little white is used as well.

Figures drawn in black silhouette and systematically articulated by incisions that clarify their internal structure are painted in what is called the *black-figure technique*. In its fully developed form this initially austere technique is enriched by the addition of purplish-red and white. The three painted colours contrasting with the red-orange ground can often produce a surprisingly cheerful effect (see Plate 1, opposite p. xiv).

The Corinthian invention of the black-

8

8. Processions of animals, skyphos (late Corinthian), made in Corinth, 600-575 BC, British Museum, London

figure technique proved immensely valuable for vase painters. It allowed figures to be as decoratively effective as any that were painted in pure silhouette. At the same time, the crisp incision that marked internal structure and defined individual figures permitted them to be enlarged without losing definition and to overlap without confusion.

The beginning of Attic black-figure vase painting

By the end of the 7th century BC, Attic vase painters had come to appreciate the merits of the black-figure technique. A magnificent vase, probably the last of the Attic

pottery tomb monuments, illustrates this (Fig 9). Like Fig 6, it has a story painted both on the body and on the neck.

The story on the body is that of Perseus and the Gorgons, though on this vase the hero himself is not represented, having presumably already made good his escape. All we see are the two pursuing Gorgons with their decapitated sister collapsing at the left. These two winged Gorgons have the mask-like faces derived from oriental prototypes that were to become the accepted convention for the representation of Gorgons: bearded, with grinning mouths, lolling tongues, terrifying tusks and staring eyes. They seem to be racing along, an effect produced by two devices: first, the way they raise their knees high in front and kick up their heels behind, and second, the counter-movement suggested by the dolphins beneath them, who leap in the opposite direction.

9

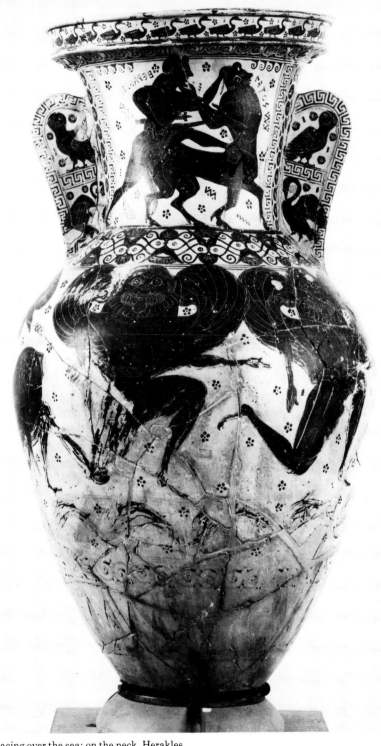

9. Gorgons racing over the sea; on the neck, Herakles
killing Nessos. Attic amphora used as a grave marker
(black-figure technique), late 7th century BC,
National Archaeological Museum, Athens

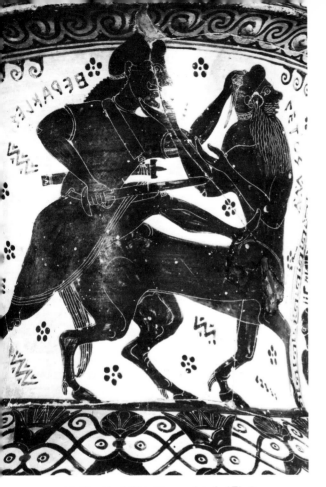

10. Herakles killing Nessos, detail of Fig 9

On the neck (Fig 10), Herakles is shown about to kill Nessos, a concise and compact rendering of the myth (compare Figs 4 and 5). Nessos, represented here as a man only down to the waist, is beginning to buckle at the knees. He touches Herakles' chin with one hand in a gesture of supplication, while the angry hero, sword drawn, clearly intends to show no mercy. The position of Nessos' left arm echoes that of his right; such repetition makes for good decoration, but here it also intensifies the emotional appeal of the subject. The names of the figures are written beside them, an indication that literacy is now becoming widespread, while the rest of the field is largely sown with dot-rosettes (compare Fig 7).

Herakles and Nessos have been carefully differentiated: Herakles is neat and ener-getic, his beard trimmed and his hair tidy; Nessos is unkempt and despairing, hair and beard in disarray. Notice how effectively the artist has used incision to depict the muscles of Herakles' legs and the fingers gripping the sword; he has realised its value both in deepening characterisations and in clarifying details.

Attic artists had, up to this point, excelled in two different, apparently ir-reconcilable, kinds of vase painting: during the geometric period they had been distinguished for the precision of their drawing and their meticulous control of detail, while during the orientalising period they had been notable for their bold – though somewhat messy – designs and lively narratives. For a long time it must have seemed as if exploration along one line of development precluded any along the other, and that if artists wished to create powerful mythological illustrations by means of large figures, they would have to abandon their concern with impeccable detail.

Happily, the adoption of the black-figure technique at the end of the 7th century BC resolved the dilemma, for it enabled Attic artists at last to combine elegant execution with vivid narration on a monumental scale (Figs 9 and 10). And it made possible the remarkable flowering of Attic vase painting that took place during the archaic period which followed.

11

2

Attic Black-Figure Vase Painting

How Greek vases were used

The huge Attic vases of the 8th and 7th centuries BC (Figs 3, 4-6 and 9) that were placed on tombs as monuments were unusual both in size and in function. Pottery was normally made for everyday use. Most utilitarian pottery was either entirely covered with black paint or simply left undecorated; a small proportion was painted. Such painted pottery – a modest luxury – was generally used in one of four ways (Fig 11):

1. *as containers and storage jars of ample, but not enormous capacity*: a two-handled *amphora* or *pelike* usually held olive oil or wine, while a *hydria* with three handles (a horizontal pair at the sides for lifting and a vertical one at the back for pouring) was used for water.

2. *as equipment for drinking parties (symposia)*: since the Greeks drank their wine diluted with water, they needed a wide-mouthed mixing bowl (a *krater* or a *dinos*) into which they could pour the two liquids. A wine jug (*oinochoe*) with a handle at the back was used to dip out and serve the wine. Drinking cups came in a variety of shapes ranging from the simple, unpretentious *skyphos* to the graceful, stemmed *kylix* and the elaborate, high-handled *kantharos*.

3. *as vessels used in connection with personal hygiene and adornment*: olive oil was used not only for cooking and lighting, but also for cleansing the body and as a base for perfumes. A *lekythos* could hold a substantial quantity of oil; it had a single handle at the back and a constricted neck that prevented the valuable oil from flowing too freely. Athletes carried the oil they needed for their rub-down before exercise in a small flask called an *aryballos*. A thong slipped through the handle made it easy to carry. Women had their perfume decanted into an elegant *alabastron*, the shape of which was probably inspired by expensive prototypes in alabaster. They kept trinkets and cosmetics in a cylindrical box called a *pyxis*.

4. *as vessels for use in certain rituals*: for instance, a saucer-like *phiale* was used to pour libations to the gods and a slender *loutrophoros* was used to carry the water for a bride's ritual bath before her wedding. A *lekythos* of normal shape but covered with a white slip and decorated with colours that could not be fired on (the usual, more durable black, white and purplish-red were applied before vases went into the kiln) was often used as a container for oil presented as a gift to the dead. Such *white-ground lekythoi* were too delicate for everyday use, but very suitable as grave-offerings. Sometimes they were made with false necks so that only a small part at the top had to be filled in order to give the impression that the whole vessel was full, a clever economy, for oil was expensive. Very fine vases of almost any shape were occasionally made especially for dedication in sanctuaries, and miniatures could either be offered to a god or given to the dead.

Vases with a handle at the back (hydriai, lekythoi and oinochoai) were usually decorated with only one picture on the front; those with handles at each side (amphorae, pelikai, kylikes, skyphoi,

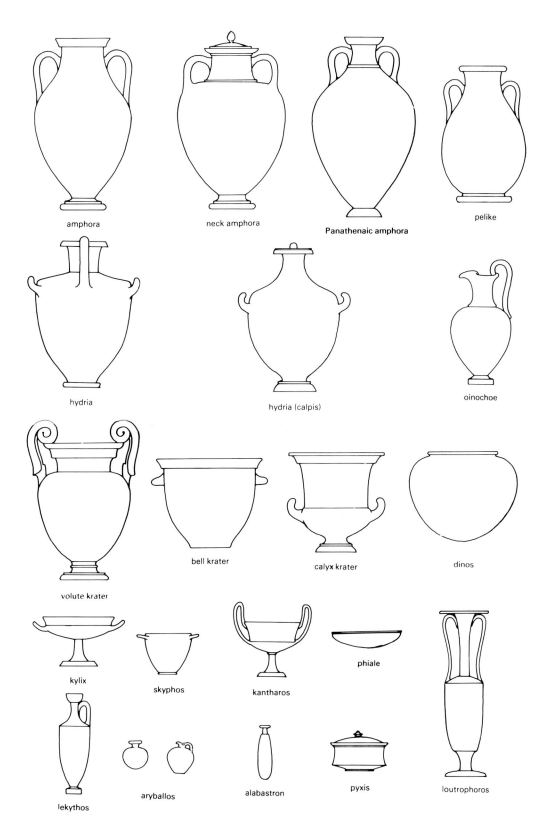

amphora

neck amphora

Panathenaic amphora

pelike

hydria

hydria (calpis)

oinochoe

volute krater

bell krater

calyx krater

dinos

kylix

skyphos

kantharos

phiale

lekythos

aryballos

alabastron

pyxis

loutrophoros

11. Shapes of vases

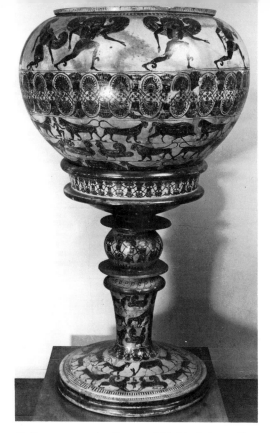

12. Gorgons pursuing Perseus, Attic black-figure dinos and stand, painted by the Gorgon Painter, 600-590 BC, Louvre, Paris

the surface has been divided up into narrow friezes, each filled with rows of smaller decorative units. Grandeur has been replaced by neatness. The bold contrasts between large and small and light and dark have been muted, and an impression of more even, overall decoration has been obtained. The effect approaches that of the geometric vase (Fig 3), but the interest in figures, animals and floral motifs makes it more complex and, perhaps, less harmonious. The tension between the need for aesthetically pleasing form and the interest in naturalistic content that dominates all later Greek art is already present here.

The dinos (Fig 12) is divided into five zones. The bottom three friezes, like the stand on which the dinos' rests, are filled mostly with animals in the Corinthian manner (see Fig 8). Next there is an ornate floral band, and at the top, crowning the whole, a familiar myth (Fig 13). Two winged Gorgons, with the now-standard type of horrible faces, pursue Perseus, who flees to the right. Their headless mortal sister Medusa falls, while at the far left Athena and Hermes (barely visible in this illustration) survey the scene.

Though some of the earlier exuberance has had to be sacrificed, the new discipline has brought its own rewards. The drawing is tidy; figures remain flat, but increasingly capable of convincing action and expression. Anatomy is regularised; legs are habitually drawn in profile, chests either in profile or full front, heads normally in profile, but full front in exceptional cases, the most noteworthy being Gorgons. The attachment of limbs is clarified – even monsters no longer have legs that spring directly from their waists or awkward, insect-like arms (as in Fig 6).

Between 580 and 570 BC, a decade or so after the Gorgon Painter decorated his dinos, Sophilos painted a dinos now in London (Fig 14). We know his name because he signed his vase; he liked the written word and made abundant use of it, labelling the figures he drew and some-

kantharoi and kraters) generally had two pictures. Vessels without handles (dinoi, pyxides) could carry decoration that ran all round them.

Attic black-figure vase painting at the beginning of the 6th century BC

By the end of the 7th century BC, Attic artists had adopted the Corinthian technique of black-figure vase painting. A dinos on a stand (Fig 12) by the so-called Gorgon Painter (see p. 170) made in the early years of the 6th century BC shows how diligently Attic vase painters were studying Corinthian models (see Figs 7 and 8).

Comparing it with the late-7th-century BC Attic amphora (Fig 9), we can see the new stylistic features that were now emerging. The decoration is no longer dominated by a few large figures; instead,

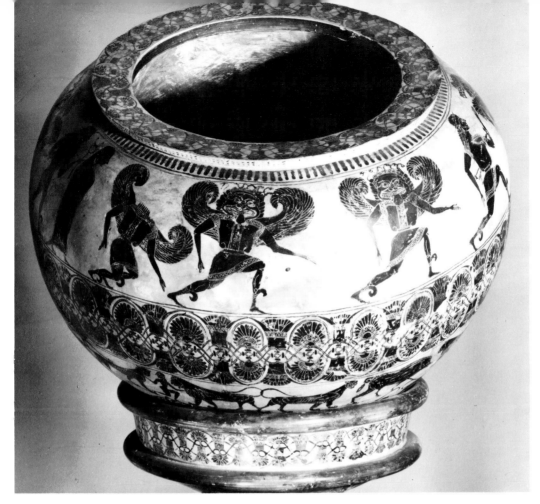

13. Perseus and the Gorgons, detail of Fig 12

14. The Wedding of Peleus and Thetis, Attic black-figure dinos, painted by Sophilos, 580-70 BC, British Museum, London

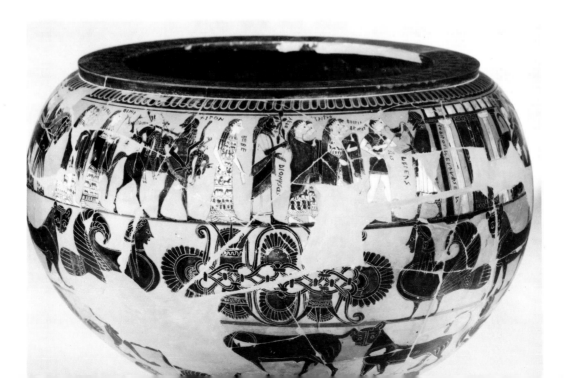

times titling whole scenes. Following the fashion of the time, he divided the surface of his dinos into several zones and filled the lower friezes mostly with animals and monsters. He drew these conventionally and rather carelessly, for they no longer held the interest of innovative painters; his heart was in the mythological scene he portrayed at the top. This showed the wedding of Peleus and Thetis, the parents of Achilles, a great event attended by virtually all the major gods and many of the minor ones as well. The procession of wedding guests goes all the way round the bowl; each participant is identified by name, the letters in the field serving rather like filling ornaments. (These had been swept away in the earlier dinos (Fig 13).)

The portion shown in Fig 14 reveals Peleus standing in front of his house, hospitably offering a kantharos of wine to the approaching deities. Iris, messenger of the gods, leads, followed by several other goddesses. The spacing between the figures is interestingly varied – some overlap, some are shown in isolation. Dionysus, the god of wine and always a welcome guest, follows the group of ladies; Hebe, goddess of youth, wearing a magnificently woven dress, comes after him. The good centaur Cheiron (who later became Achilles' tutor) is next, and others follow behind. Ample use is made of the four colours available to a black-figure painter (Plate 1, opposite p. xiv). Touches of purplish-red have been freely added and the women's flesh is painted white, something that from now on becomes usual in black-figure vase painting. In most cases (though not here) the white paint is laid on top of black; often it has flaked off, leaving behind a rather dull patch of black which indicates where it had been.

The climax of early Attic black-figure narration: Kleitias

The illustration of myths soon came to absorb the greater part of the more ambitious painters' interest. This was certainly true of Kleitias, who was working in Athens a little later than Sophilos. His masterpiece is an elaborate volute krater painted around 570 BC (Fig 15) and called the 'François vase' in honour of the man who patiently pieced it together from innumerable widely scattered fragments. Kleitias, like his predecessors, divided the large surface of his krater into a number of narrow friezes. There are seven of these; no fewer than five are devoted to myths. The lip shows a group of heroes hunting the gigantic Calydonian boar, and the neck the chariot races that were part of the funeral games in honour of Patroklos. Most impressive is the wide band on the shoulder, the theme of which, despite the interruption of the handles, encircles the entire vase. The subject is again the wedding of Peleus and Thetis. Peleus is shown at the right, in front of his house; Thetis can just be glimpsed within. A splendid procession of divinities, some on foot, some riding in chariots, approaches. Below, the story of Troilos is told, and beneath this frieze the animals and monsters, once so important, make their sole appearance. On the foot there is a representation of pygmies fighting cranes. Three more myths complete the decoration on the other side. Inscriptions abound, identifying not only people but even inanimate objects. The small figures, some 200 of them, no more than a few centimetres high, are drawn with delicacy and precision. They are very different from Sophilos' figures, for Sophilos was easily satisfied with a generally cheerful effect and was not so meticulous about details.

Kleitias was a master story-teller. The drawing in Fig 16 shows the Troilos frieze in its entirety and gives a good idea of his quality as a narrator. According to the legend, Troy could not be taken if the young prince Troilos reached the age of twenty. To prevent this happening, the Greek hero Achilles resolved to kill the boy. When Troilos left the protecting walls of the city to water his horses, Achilles was waiting for him, hidden behind the

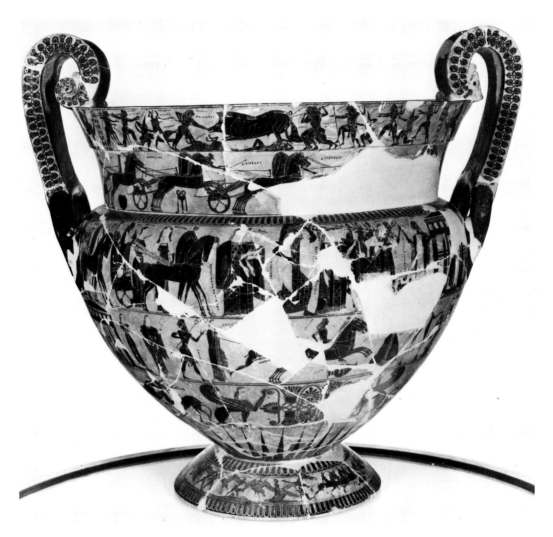

15. The François vase, Attic black-figure volute krater, painted by Kleitias and made by Ergotimos, about 570 BC, Museo Archeologico, Florence (from top to bottom: hunt of the Calydonian boar; funeral games in honour of Patroklos, wedding of Peleus and Thetis; Achilles pursuing Troilos; animals, battle of pygmies and cranes)

16. Achilles pursuing Troilos (drawing), detail of Fig 15

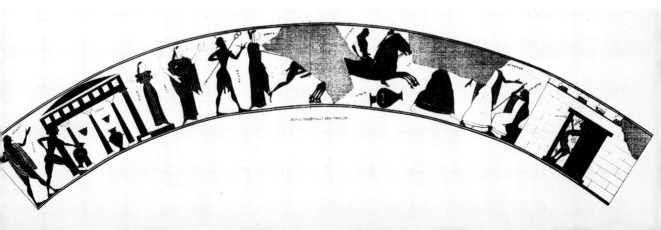

fountain-house. Suddenly Achilles leapt out; Troilos sprang on to one of the horses (he was tending a pair) and rode for his life. But Achilles, 'swift-footed Achilles', as Homer calls him, sped after the fleeing youth, overtook the galloping horses and slew Troilos.

The frieze extended half way round the krater; another myth was illustrated on the other side. At the far left we see the god Apollo and then the fountain-house. A young man is just placing his hydria beneath one spout; a girl stands on the other side waiting for her hydria to fill. Three gods come next (Thetis, who is Achilles' mother, Hermes and Athena), exerting an influence on the action, though presumably unseen by the mortals. In the centre Troilos is shown urging his horses forward with all his might. The figure of Achilles is mostly lost, but even the single leg that has been preserved is telling. The foot has left the ground as the hero leaps forward to overtake the desperate boy. Polyxena, Troilos' sister, who accompanied him, runs in front of her brother. The hydria that she dropped in her fright lies overturned beneath the horses. Further to the right, the old king of Troy, Priam, sits bent under the weight of his sorrows, while his friend Antenor brings him this latest piece of bad news. At the extreme right we see two of Troilos' brothers emerging from the city gates, eager to avenge his murder.

There is a Homeric flavour in Kleitias' rendering of the story, for it recalls the

17. Achilles pursuing Troilos, detail of Fig 15

death of Hector as told in Book 22 of the *Iliad*. Homer tells in detail there how Achilles pursued Hector around the walls of Troy. It is a chilling account: 'And the pace was furious,' the poet explains, for 'this was no ordinary race, with sacrificial beast or leather shield as prize. They were competing for the life of horse-taming Hector.' He then describes the landmarks that the two heroes pass, the look-out, the fig tree, even 'the troughs of stone where the wives and lovely daughters of the Trojans used to wash their glossy clothes in the peaceful days before the Achaeans came'.

The life-and-death pursuit – part of the present war – is here poignantly contrasted with the peaceful past, when women could still conduct their normal activities outside the walls without fear. Kleitias, by juxtaposing the tranquil scene at the fountain-house to the left with the terrifying chase in the centre, translates epic poetry into a visual image, and imparts to the death of Troilos something of the depth and pathos that Homer gives to his account of the death of Hector.

The quality of Kleitias' work can be appreciated in a close-up view of Troilos (Fig 17). The boy's hair blows back, suggesting the speed of his fruitless flight. Notice the intent look on his face, his tensely arched back and the desperate gesture of his arm as he whips his steed on. Notice, too, the economy and effectiveness of the incision used to show the anatomy of the nervous, high-bred horse.

Narrow friezes like this require many figures to fill them up. They encourage artists to choose subjects like processions, races, hunts, battles or revels that can be indefinitely expanded. When a specific myth is illustrated painters have to think it out in an extended form. Kleitias' excellence is revealed in the way he was able to give meaning to every element in his frieze; lesser artists add spectators or 'extras' quite lacking in significance to fill out the space as necessary.

When more confined, Kleitias worked

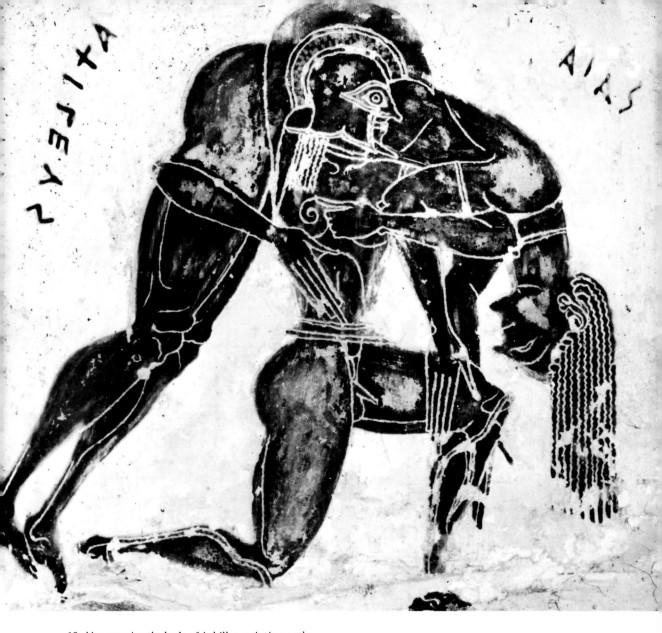

18. Ajax carrying the body of Achilles, painting on the handle of the François vase, Fig 15 (much enlarged)

just as well, but rather differently. This can be seen in part of the decoration he painted on the outside of the handles of the vase. The space available was limited: a rectangular panel that demanded a compact, succinct image. Kleitias chose to represent Ajax carrying the dead body of Achilles (Fig 18). Achilles, like his victims, had met a violent end. According to most versions of the legend, the mighty Ajax carried his body out of battle. Ajax is drawn in the bent-knee pose that conventionally indicates running; here it might be interpreted as showing the hero rising slowly under his heavy burden.

Ajax looks grave and dignified. His head and torso are upright, his limbs extended or bent at right angles. The placement of virtually all the parts of his body along either verticals or horizontals provides the compositional stability that gives his figure

19

19. Ajax carrying the body of Achilles, Attic
black-figure cup interior, painted by the Phrynos
Painter, mid-6th century BC, Musei Vaticani, Rome

such an air of solemnity.

The huge body of Achilles, draped across his shoulders, nearly touches the ground on either side of him. The diagonal of Achilles' well-muscled legs, their swiftness stilled forever, dominates the left side of the picture; the drooping lifeless hair, paralleled by the dangling fingers of the once 'man-slaying hands', closes the right side. Sensitive incision contrasts the serious wide eye of Ajax with the closed, unseeing eye of Achilles. The heroes' names are written beside them, discreetly adding interest to the otherwise blank corners.

The power of Kleitias' image can be measured if it is compared with the Phrynos Painter's slightly later rendering of the same theme (Fig 19). This artist has painted the group in the centre of the interior of a cup and has arranged the figures so that they, together with the inscriptions of their names, provide a suitable decoration for the circular shape. Here Ajax is unambiguously running. Notice how similar the position of his legs is to that of the Gorgons in Fig 9. This is a lively image, well designed for the space it occupies, but lacking Kleitias' refinement of touch (contrast the way the hair, the hands and the eyes are delineated) and the tragic dignity that Kleitias could convey even on so small a scale.

Little master cups of the mid-6th century BC

Though the François vase is a large vessel, Kleitias has covered it with decoration in a miniaturist's style. The artists who carried the miniaturist tradition on into the middle of the 6th century BC were the

so-called 'little master' painters who decorated smaller vessels, especially cups (kylikes).

Around the middle of the 6th century BC two kinds of cup were popular; lip cups (Fig 20) and band cups (Fig 21), each named after the area of its principal decoration.

On a lip cup the sparse, figured decoration is concentrated in the centre of the lip. Fig 20 shows three figures: the goddess Athena in the middle is presenting her protégé, the hero Herakles (identified by his characteristic lion-skin, club and bow) to the seated god Zeus. The figures are small, but they look vigorous and have been drawn with care. A strong black line beneath them marks the lip of the cup; the bowl below is enlivened by an inscription. Though this was the standard formula for a lip cup, the elements within it could be freely varied. The three figures could be replaced by a racing chariot, a handful of roosters or a single animal. The inscription could spell out a greeting addressed to the drinker or it might be the proud signature of the potter and/or the painter. It could even be composed of a random selection of letters, meaningless but decorative. In any case the general impression produced was always that of a light-coloured vessel graced with a few, carefully placed dark accents.

The band cup, by contrast, makes a dark impression (Fig 21). With the exception of the band running between the handles, it is almost entirely painted black. The long, narrow band requires the same sort of decoration as any other frieze. This artist has painted Dionysus and his bride Ariadne in the centre and flanked them with alternating satyrs (wild creatures with horses' ears and tails, associated with Dionysus, the god of wine) and maenads (women who were devoted to Dionysus). The satyrs and maenads dance enthusiastically, their freely extended limbs creating interesting patterns against the background. Their poses, which at first sight look very similar, are skilfully varied so

20. Athena introduces Herakles to Zeus, Attic black-figure lip cup, painted by the Phrynos Painter, mid-6th century BC, British Museum, London

21. Dionysus and Ariadne with dancing satyrs and maenads, Attic black-figure band cup, mid-6th century BC, Metropolitan Museum of Art, New York

that although one gains a general impression of balance, there is no exact symmetry.

The theme was well chosen, not only because it was appropriate for a drinking cup, but also because it was easy to adapt to the awkward shape: satyrs and maenads could be added – almost mechanically – at either side until there were enough to fill up the frieze. It is, in fact, the very multiplication of these lively, repetitive figures that gives such charm to the design as a whole.

21

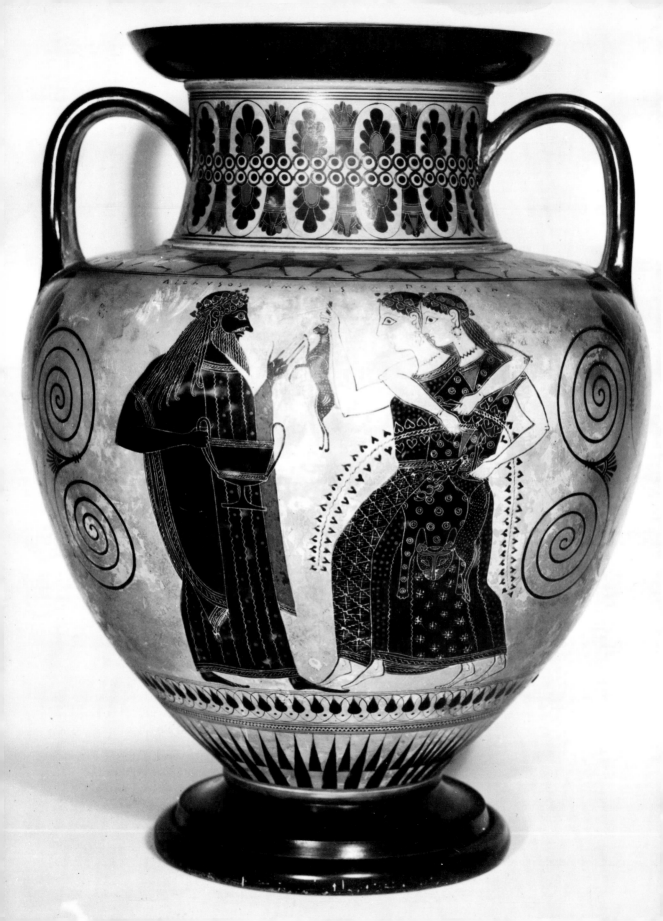

Vase decoration with figures on a large scale

The Athenian talent for drawing on a large scale did not disappear after the end of the 7th century BC. A fine example was painted by the Amasis Painter in the third quarter of the 6th century BC (Fig 22). Since the artist has used virtually the whole body of the amphora instead of dividing it into many narrow strips, he needs only three bold figures to fill his large, rectangular field. Like the painter of the band cup (Fig 21), he has chosen a Dionysiac subject. Dionysus himself, to the left, holds a kantharos and raises one hand to greet two maenads who come tripping towards him. They have their arms around one another and hold wild animals in one hand and ivy branches in the other. Unusually, the flesh of the maenads is not painted white but simply outlined and left the natural colour of the clay.

The painting is a decorative delight. Much of its success is due to the artist's clever use of repeated patterns: the rays at the bottom, the lotus-bud chains above them and the floral frieze on the neck. Repetition is also used, though more subtly, in the figures themselves. The profile of one of the maenads is repeated in that of her companion; the two step forward in unison so that the front feet of both are raised together and the back feet rest on the toes parallel to one another; even the shape and position of the nearer maenad's left arm is repeated in the arm of her companion, encircling her shoulder. Lines are carefully incised to make repeated patterns – the folds of Dionysus' garment, the locks of his hair, the decoration of the maenads' dresses, the spots on the panther-skin worn by one of them. The total effect is bright and cheerful.

A much more sombre impression is produced by an approximately contem-porary amphora made and painted by Exekias, the finest of all black-figure artists (Fig 23). Both the shape and the scheme of decoration are different. The amphora decorated by the Amasis painter (Fig 22) has a sharply off-set neck and nearly horizontal shoulder; it is called a *neck amphora*. The friezes ornamenting the body and neck and the three figures are the only dark touches on the light surface of the vase. In Exekias' amphora (Fig 23), by contrast, neck and body are combined in a single sweeping curve; this is a *one-piece amphora*. Except for the panel on the body, it is painted almost entirely black – a predominantly dark vase, like a band cup.

The eye-catching, clearly defined panel needs a compact, self-contained image. Spot-lighted within it are two warriors. Though fully armed and ready for battle, they are seated quietly, absorbed in the game they are playing. Each one touches a gaming piece; both lean forward, studying the board intently. The hunched shoulders and gently inclined bodies of the figures not only contribute to the mood of the scene, but also play an important part in the design of the vase painting. Notice the way the outline of the backs of the figures echoes the curve of the vase. In other ways, too, Exekias took care to adjust the elements of his drawing to the shape of the vessel he was decorating. The shields of the warriors, placed behind them, continue the descending line of the handles, while the spears they seem to hold so casually point up to where the handles join the neck.

These warriors are no anonymous heroes, for their names are written beside them: Achilles on the left, Ajax to the right. Achilles, the mightier of the two, wears his helmet – it gives him the appearance of greater stature. He also has the better throw, for the word 'four' is issuing from his mouth. Ajax, by contrast, calls out only a three. Other artists had shown the friends united at a less happy moment, when Ajax carries the dead Achilles out of battle (Figs 18 and 19).

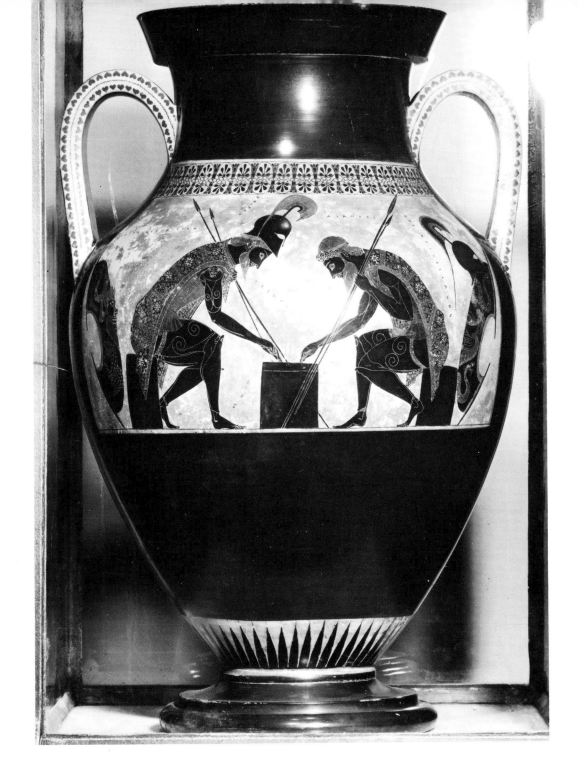

23. Ajax and Achilles playing a game, Attic
black-figure amphora, painted and made by Exekias,
540-30 BC, Musei Vaticani, Rome

While they both lived, the two heroes were in many ways equal and opposite. They alone, so Homer tells us, were confident enough in their own strength to station their ships at the extreme ends of the Greek line. The poet thus describes them symmetrically facing each other across the Greek camp just as the painter shows them facing each other across the gaming board.

The incident that Exekias portrays here is nowhere mentioned in surviving Greek literature. Perhaps it was the painter's own invention, the product of his reflection on the characters of the two heroes and his speculation on how they might have spent their time while they were 'off duty'.

The figures and their accoutrements are conceived on a large scale, carefully related to the surface that they decorate, but at the same time delineated with the most exquisite detail. Their elaborately woven cloaks and the strands of their hair are executed with incision of extraordinary delicacy.

Design and the decoration of a tondo

Long thin friezes and nearly rectangular panels demand different kinds of design. The circular field within the interior of a cup, known as a *tondo*, presents still other problems. Various solutions were devised (see Figs 19, 79, 82, 83 and 153). One of the most imaginative and haunting was again created by Exekias (Fig 24). According to a Homeric Hymn, some bold pirates tried to abduct Dionysus, mistaking him for a king's son and hoping for a royal ransom. But when they tried to tie him up, they

24. Dionysus sailing, Attic black-figure cup interior, painted by Exekias, 540-530 BC, Staatliche Antiken-sammlungen und Glyptothek, Munich

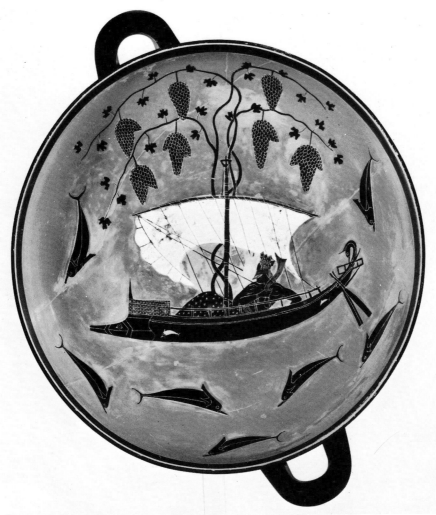

found that no bonds could hold him, and soon he caused miracles to happen – a vine spread along the top of the sail and ivy climbed the mast. Dionysus then turned himself into a lion and pursued the guilty pirates until they jumped overboard and were transformed into dolphins.

Exekias' cup is no literal illustration of the Homeric Hymn, but a poetic evocation of it. The god lies at ease in his ship holding a drinking horn. A wonderful vine overtops the billowing sail and seven rich clusters of grapes dangle from it; seven slim dolphins play around the elegant craft. No formal line marks the boundary between sea and sky; one element flows into the other unhampered in this magical vision.

The ship is set at an angle to the handles of the cup it decorates. As the drinker drained his cup, he would notice the painting and, turning the vessel in his hand to see it more clearly, would make the wine swirl around so that the image would seem to be emerging from beneath the wine-dark sea itself. The subtly calculated balance of forms and the lyrical mood of this cup interior are unmatched in the whole of Greek art.

3

Archaic Architectural Sculpture

The place of architectural sculpture

By the end of the 7th century BC, some Greeks had started to construct their temples and other important buildings out of stone, having by then acquired the skills necessary for this kind of monumental architecture. In time, with the spread of prosperity, more followed suit. Structurally these buildings were very simple: upright columns and walls supported horizontal beams and a gabled roof. When unadorned, they looked rather austere and forbidding, but they could be pleasantly enlivened by the addition of architectural sculpture in certain places. *Metopes*, *friezes* and *pediments* in particular admitted such embellishment (Figs 25-27).

By the beginning of the 6th century BC, the Doric order (see p. 174) had been developed into a coherent system that regulated the design and proportions of the columns and the superstructure that they held up. The superstructure included a band of alternating triglyphs and *metopes* (Fig 25). The triglyphs were carved with vertical stripes (see Figs 138 and 250); the nearly square metopes could be painted, sculpted in relief or just left plain.

The Ionic order (see p. 174) was both a slenderer and a more graceful alternative to the Doric order. The elements that went into its making were never so rigidly fixed as those of the Doric order. A long narrow *frieze* sculpted in relief often decorated Ionic buildings – sometimes at ground level along the bottom of a wall, sometimes along the gutter of the roof, but eventually most frequently as part of the superstructure (Fig 26), in a position corresponding to

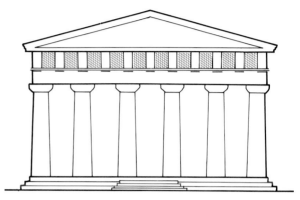

25. The shaded area shows the location of the metopes on a Greek building

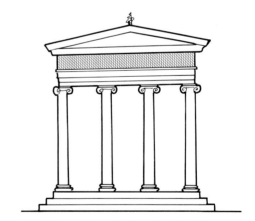

26. The shaded area shows the location of the frieze on a Greek building

the triglyphs and metopes of the Doric order.

Finally, the gabled roof of a Greek building left a triangular space at each end. This could be decorated with sculpture either in relief or carved free and set

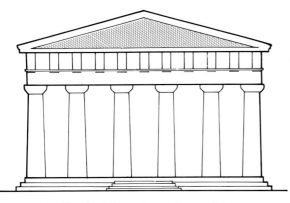

27. The shaded area shows where sculptures were placed within the pediment of a Greek building

against the background. The area so decorated is called the *pediment* (Fig 27).

The first and most important require-ment of architectural sculpture was that it should provide handsome decoration. Abstract patterns and floral motifs could be made to do this rather simply and were much used in subordinate positions, but in prominent places the Greeks preferred to represent fierce animals or terrifying monsters (which would protect a temple against evil spirits) or to illustrate myths (which would give pleasure to the gods) or both. Such preferences made the design of architectural sculpture no easy task.

Metopes

Metopes, being rectangular or sometimes square, presented problems to sculptors similar to those faced by vase painters decorating panels. If they wished to use the space effectively for story-telling, they had to select a significant and recognisable moment for representation. Sculptors decorating a building also had to make sure that the images they created were intelli-gible at a distance. They therefore made their principal figures as large as possible, thereby restricting their number to no more than three (or, very rarely, four).

Fig 28 shows a metope carved about the middle of the 6th century BC for a temple

in Sicily. It represents one of the minor events in the story of the hero Herakles. Once when Herakles was asleep, the two imp-like Kerkopes stole his weapons. When the hero awoke and caught them, he tied them upside down to a pole and carried them over his shoulders. From this peculiar vantage point the Kerkopes had an excellent view of Herakles' hairy bottom. They so amused him by the jokes they made on this subject that eventually he let them go.

The metope shows the two mischievous creatures hanging one on each side of the hero. All three look to the front, but Herakles walks firmly to the right. His striding legs provide enlivening diagonal

28. Herakles and the Kerkopes, metope from temple C at Selinus (limestone), 575-550 BC, Museo Nazionale, Palermo

accents in a composition that is otherwise dominated by emphatic verticals and horizontals.

The whole well-constructed design is based on the play of symmetrical forms, both large and small. Not only do the two Kerkopes hang in such a way as to appear mirror-images of each other, but also most of the elements of which they are composed – arms, hair, faces – are carefully arranged to yield symmetrical patterns.

The metope is carved in *relief*, that is, drawings were made on the surface of the stone and the area around the figures was cut away. The figures protrude from the background as a result. The carving is not very deep and the figures are only slightly rounded. The sculptor has not thought about the design in three dimensions, but rather has conceived of it as a flat pattern, not very different from a black-figure vase painting, except that incisions have been replaced by carved lines and some planes have been cut back in order to clarify the representations. In later reliefs the modelling of the figures becomes more rounded and the transitions subtler.

The image was originally sharpened further by the addition of paint (see p. 173), for the details of the figures, their hair, eyes and clothing and the background were all coloured. Sculptures in stone were always finished in this way, and they must have looked much livelier when the paint, now only rarely preserved, was intact.

Another mid-6th-century BC metope, this one from Delphi (Fig 29) uses repetition rather than symmetry as a device to give the composition decorative coherence. The story illustrated concerns a cattle raid conducted by two pairs of heroic brothers – the fourth raider (now lost) was shown at the far left. The three surviving heroes occupy the full height of the metope, a triad of parallel vertical figures. In their left hands they all hold their sloping spears at the same angle and walk in step with the cattle, whose legs, meticulously aligned, recede into the background. A fine, tightly-knit pattern is built upon repeated

29. Heroic cattle-raid, the Dioskouroi and the sons of Aphareus, metope from the Sikyonian Treasury (limestone), 575-550 BC, Delphi Museum, Delphi

forms – notice how the frontal head of the nearest animal in each group and the horizontal spears held in the right hands of the heroes help to bind the design together.

Friezes

Architectural friezes, like friezes on vases, were long, narrow bands which could be suitably filled with only certain kinds of subjects. As we saw when looking at vases, battles, assemblies, processions, races and revels lend themselves best to the kind of indefinite prolongation that is required.

In some early friezes identical figures were simply repeated to produce a pattern. Races and processions could easily be treated in this decorative but non-narrative way. But soon the pervasive enthusiasm for narration began to captivate archaic designers of friezes. This can be seen from the Siphnian Treasury, carved shortly before 525 BC. The treasury

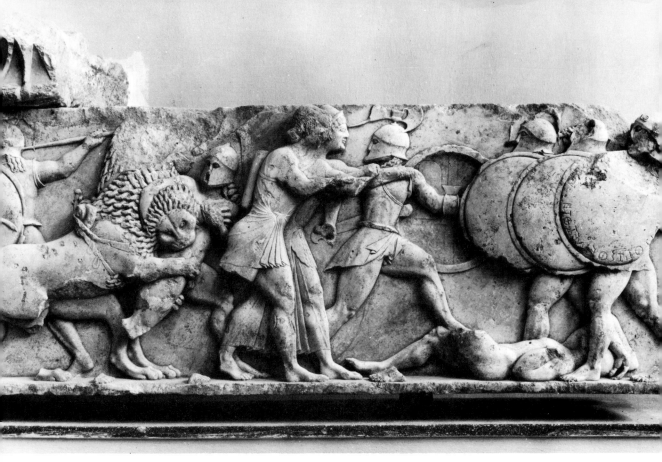

30. Battle of gods and giants (Gigantomachy), part of the frieze on the Siphnian Treasury, shortly before 525 BC, Delphi Museum, Delphi. This frieze is made of marble. Marble, on which details can be more sharply carved than limestone, was the stone preferred by Greek sculptors. It was used whenever sufficient funds were available. All the sculpture in this book, unless otherwise specified, is made of marble.

31. *Below and opposite*: Seated gods and goddesses conferring, part of the frieze of the Siphnian Treasury, shortly before 525 BC, Delphi Museum, Delphi

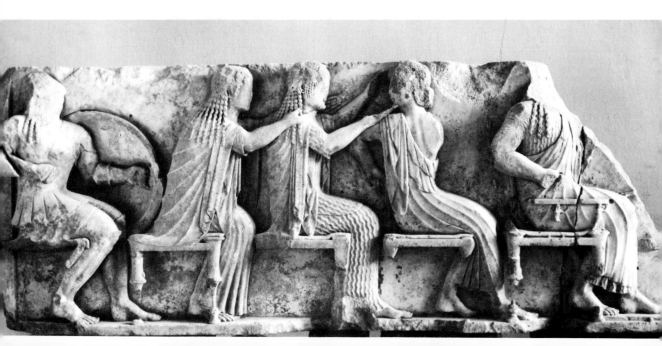

was only a small building erected by the Siphnians to house the dedications they made to the god Apollo at Delphi, but it was nevertheless very richly adorned with friezes that ran along all four sides of the building and illustrated at least three different myths.

One of the finest shows the battle of the gods and the giants (Fig 30). A great number of gods and goddesses participate, each carefully characterised. Our section shows the lions who draw the goddess Cybele's chariot helping the divine cause by taking a large bite out of a terrified giant. To the right of the lions, Apollo and his sister Artemis march side by side shooting their arrows at a group of three giants who confront them with shields overlapping in neat hoplite order. Between the two groups of combatants, a frightened giant tries to beat a hasty retreat. His legs rush forward to the right, but he looks back anxiously to the left. His body swivels improbably at the waist; the sculptor could not devise an anatomically plausible way to indicate the 180° change in direction between his legs and his head. This awkward transition was to engage the interest of artists for a long time.

Even in this small excerpt from an extensive frieze one can see how cleverly the artist has found ways to punctuate the long strip of carving with striking patterns (for instance those provided by the repeated forms of Apollo and Artemis and the three giants opposing them), while still maintaining the sense of continuity that joins one episode to the next.

Another part of the frieze shows seated gods conferring about the progress of the Trojan War (Fig 31). Five sit to the left of a break, three to the right. Although the gods are identifiable as individuals and differ slightly in the way they sit and the positions of their arms and legs, the overall effect of the upright seated figures on their virtually identical, clearly carved stools is one of handsome ornamental pattern. Within each figure certain motifs – strands of hair or folds of drapery – are repeated for decorative effect, and the scene as a whole is composed of rhythmically repeated verticals and horizontals.

Pediments

The low triangle formed by a pediment is a particularly awkward shape to fill, but as early as the first quarter of the 6th century BC, impressive sculptures were carved in relief to decorate a large pediment on the temple of Artemis on the island of Corfu (Figs 32 and 33).

The centre of the pediment was occupied by the huge figure of a running Gorgon. This was a doubly effective image, not only powerful in protecting the temple from evil spirits, but also capable of suggesting a

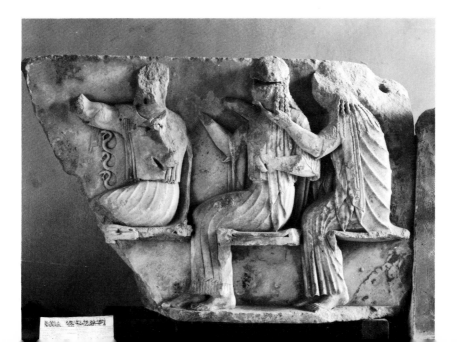

32. Medusa with her children between panthers; to the left, the death of Priam and the fall of Troy; to the right, Zeus killing a giant. Reconstruction of the west front of the temple of Artemis at Corfu, 590-580 BC

33. Medusa with her children between panthers; to the left: Priam about to be slain on the altar; to the right: Zeus killing a giant. Relief sculptures decorating the west pediment of the temple of Artemis at Corfu (limestone), 590-580 BC, Corfu Museum, Corfu

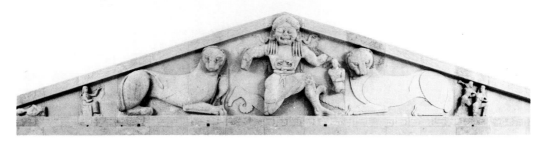

story. For this was no ordinary Gorgon, but Medusa herself, fleeing, presumably from Perseus. She is identified by her two children who are shown flanking her, Pegasus, the winged horse (whose hind parts alone are preserved) to the left and Chrysaor, the man with the golden sword, to the right. These children were born, monster-fashion, from Medusa's neck when Perseus severed her head from it. Their presence here evokes that final episode in the story. Greek artists who wished to illustrate the myth were un-

troubled by the fact that Medusa could not possibly be accompanied by her offspring while she was still in possession of her head. Such niceties of logical (or chronological) consistency did not occur either to artists or to spectators until considerably later times (compare the similarly suggestive, but illogical, treatment of the cyclops story, Fig 6).

Reclining panthers lie on each side of the central group. They are probably intended primarily to serve as guardians of the temple; their crouching position fits them

32

34. Herakles attempting to steal the tripod of Apollo, flanked by unrelated unidentified stories, east pediment of the Siphnian Treasury, shortly before 525 BC, Delphi Museum, Delphi. The lower parts of the figures are carved in relief, but the upper parts have been carved free of the background. The pediment is very small (0.74 metres high at the centre) and its size may have encouraged this strange combination of techniques. By this time other pediments were normally filled with figures carved fully in the round.

neatly under the slope of the pediment.

Small active figures are carved in the corners and dead bodies fill the extreme angles. On the left a man is shown seated, threatened by a spear. He is most probably Priam, king of Troy, about to be slain on the altar by the son of Achilles. If so, the body behind him is that of a dead Trojan and the vignette as a whole an illustration of the fall of Troy.

On the right a male figure brandishes a thunderbolt menacingly against a fleeing figure. The thunder-wielder must be the god Zeus (who alone uses this weapon) and his enemy, a giant. Another giant lay dead in the corner. The scene is an excerpt from the battle of the gods and giants, an expanded portrayal of which was carved later for one of the friezes of the Siphnian Treasury (Fig 30).

No fewer than three stories, therefore, have been evoked and two grim beasts portrayed in this ambitious early work. It must have been greatly admired for its size (the central Medusa is almost three metres tall), decorative effectiveness and narrative richness. A good deal of its success can be attributed to the fact that the artist has not tried to do too much. He made no effort to represent any of the three stories at all naturalistically or to relate the different elements in the pediment to one another in terms of a single unified scale.

As time passed, representations of fierce animals lost their fascination. We have

seen how they virtually disappeared from Attic vase painting after the middle of the 6th century BC, though they had been very popular before (cf. Figs 7, 8, 12 and 14). The same thing happened in pedimental sculpture. By the last third of the 6th century BC mythological scenes had come to dominate the principal fields of pediments, and wild animals were forced into subordinate positions or eliminated entirely.

Now, too, artists wished to create more vivid and convincing illustrations of myths. Perhaps they were eager to rival the poets who were so adept at bringing the stories they told to life. But moulding a flow of words into a vivid tale is much easier than fitting a group of figures into the awkwardly shaped confines of a pediment. For one thing, if an image were to seem plausible, all the figures would have to be rendered on the same scale, a difficult requirement to satisfy.

An ingenious attempt to do so was made around 525 BC for a pediment for the Siphnian Treasury (Figs 34 and 35), whose friezes (Figs 30 and 31) we have already looked at. The story illustrated was the struggle between Herakles and Apollo for the tripod. Herakles came to Apollo's sanctuary at Delphi seeking purification, but when this was denied him, he seized Apollo's sacred tripod in anger and tried to carry it off. Apollo, understandably, resisted, and in the end Zeus, father of both contenders, had to intervene.

The artist cleverly put Zeus, chief of the gods, in the middle, where he towers over his sons and conveniently fills the apex of the pediment. The males on either side of him – Herakles striding away with the tripod to the right, and Apollo, holding on, at the left – are consequently shorter, and the female figures flanking them shorter still, so that the five central figures, all

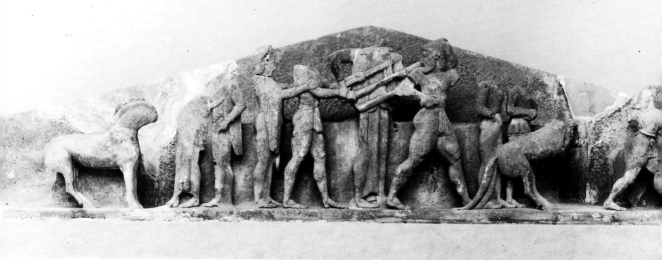

35. Herakles attempting to steal the tripod of Apollo, detail of Fig 34

conceived of on a unified scale, are easily and naturally accommodated to the slope of the pediment (Fig 35).

A formal solution was relatively simple to find for the centre of the pediment, but it was more difficult to discover one for the sides (Fig 34). Flanking the central group are figures who face the corners. These are just depicted as shorter as the pediment gets lower with the result that the man at the far right looks positively stunted in comparison with the more central Herakles.

The narrative, too, works better in the centre than at the sides. Artemis stands to the left of her brother Apollo and belongs to the story, but the other figures who face the corners and the horses accompanying them are not involved with the struggle for the tripod – even the woman to the right of Herakles, compositionally part of the central group of five, seems to be related to whatever myth (or myths) might have been told at the sides. In fact, the further one moves from the centre, the less satisfactory the design of the pediment becomes. The sudden break in the story is disturbing and the mechanical, illogical diminution of the figures as they approach the corners is disappointing. The same defects can be found in the Corfu pediment (Figs 32 and 33) where three myths are told, all quite unrelated in scale and meaning, but there, because the style and arrangement are so obviously formal and artificial, the effect is not so jarring.

It is relatively easy to balance forms and even suggest stories by means of shorthand hints if there is little concern for realism. Trouble begins with the introduction of greater naturalism. The rational, natural arrangement of the figures at the centre of the pediment of the Siphnian Treasury (Fig 35) aroused expectations that could be satisfied only by ever more thoroughgoing naturalism.

Once it had been stimulated, the demand for naturalistic representations increased with time. Before the end of the 6th century BC sculptors had found a way to treat the pediment shelf as if it were a real space, populated with credible figures, conceived of in terms of a unified scale and involved in a single story.

The key to the solution they devised lay in the choice of subject: a theme of violence presided over by a god. The deity in the centre satisfactorily filled the apex, while figures in combat – standing, striding, kneeling, falling or even expiring in the corners – could assume postures consistent with the narrative that would lower their heads as required without affecting the scale of their bodies.

This solution is splendidly realised in two pediments carved for the temple of

34

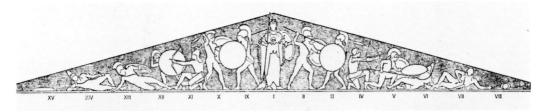

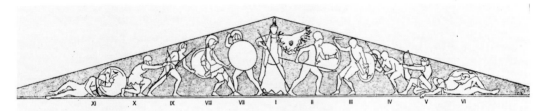

36. *Above:* Greeks (from the expedition led by Agamemnon and sung of by Homer) fighting Trojans in the presence of Athena, reconstruction of the west pediment of the temple of Aphaia on Aegina, shortly before the end of the 6th century BC

37. *Below*: Greeks (from the expedition led by Herakles, a generation before that led by Agamemnon) fighting Trojans in the presence of Athena, reconstruction of the east pediment of the Temple of Aphaia on Aegina, beginning of the 5th century BC

Aphaia at Aegina at the end of the 6th century BC and during the early years of the 5th century. They illustrate the two Greek campaigns against Troy, the first led by Herakles, the second led by Agamemnon and celebrated by Homer.

In the earlier pediment, on the west (Fig 36), the goddess Athena stands solemnly in the middle while combatants fight on each side of her. These pairs of duellists are flanked by archers, who initiate a movement out to the sides that is concluded by the dying figures lying in the corners. In the later pediment, on the east (Fig 37), Athena has sprung into action and the movement out from the centre is balanced by a counter-movement inward from the corners to produce a more unified design.

Although only a few years separate them, there is a distinct change in tone between the two pediments. The earlier one shows the culmination of the archaic style, which had been developing throughout the 6th century BC, while the later pediment foreshadows the early classical style, which flowered during and just after the Persian wars (490-479 BC). A closer look at two of the corner figures illustrates this difference (Figs 38 and 39).

The dying warrior (Fig 38) from the right-hand corner of the earlier pediment (Fig 36) was probably carved in the last decade of the 6th century BC. The fatally wounded man lifts his upper arm up and forward and reaches his lower arm down to extract an arrow (or a spear), which was originally added in bronze. His right leg is folded over his left in such a way that its position seems to echo that of the right arm. Thus despite his painful predicament, the figure is arranged so as to present a complex and beautiful design. Repetition as a decorative principle appears not only in the arrangement of the limbs, but also in the carefully carved locks of hair that frame the face and even in the triangular gaps between arm and body, leg and body and body and ground.

The dying warrior (Fig 39) from the left-hand corner of the later pediment (Fig 37), carved in the early years of the 5th century BC, is organised very differently. While the earlier warrior boldly confronts the viewer – head, shoulders, hips all face front – the later warrior turns away as his strength fails. His left hand has lost its grip on the shield and droops with pathetic

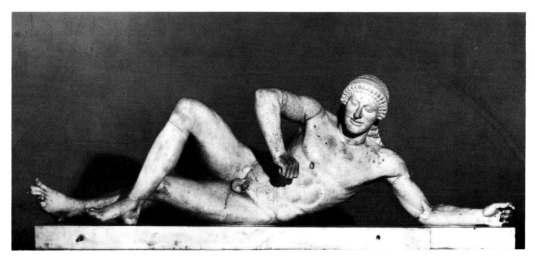

38. *Above*: Dying warrior from the west pediment of
the temple of Aphaia on Aegina (see Fig 36, far right)
Staatliche Antikensammlungen und Glyptothek,
Munich

39. *Below*: Dying warrior from the east pediment of
the temple of Aphaia on Aegina (see Fig 37, far left)
Staatliche Antikensammlungen und Glyptothek,
Munich

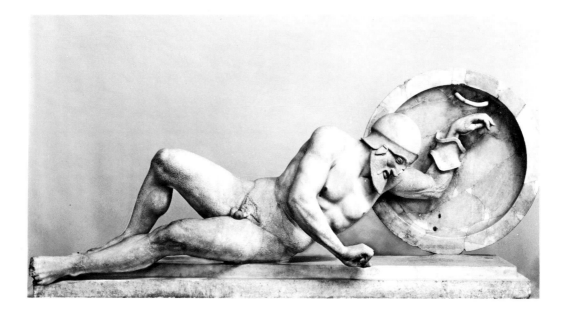

lifelessness. He tries to raise his sword with
his right hand, but nevertheless begins to
keel forward onto his chest. Ebbing life,
slipping away is powerfully suggested –
with no less art than was used in
composing the earlier figure, though differ-
ent principles are at work here. While

parallelism and repetition dominate the
design of the earlier warrior (Fig 38), an
apparently orderly succession of move-
ments and forms controls the later one
(Fig 39). The figure is neither simply
frontal nor simply in profile, but gradually
unwinds from one point of view into the

next. The further (right) leg is seen from the left, the hips are almost frontal, the chest rotated towards the right and the head turned fully to the right. Both arms are bent at right angles, but they are not parallel to each other; on the contrary, the pattern they produce suggests a controlled sequence of movements.

Such pedimental figures were intended to be seen from only one point of view. They were nevertheless carved fully in the round and developed in depth. Thus in Fig 38 the further arm and leg are brought forward in space as well as down and in Fig 39 the position of the body is rotated continuously through a series of gradually changing planes.

Using architectural sculpture to tell stories presented the Greeks with many problems. Metopes demanded designs reduced to a very few figures; friezes had to be filled with subjects which permitted indefinite extension in either direction, and pediments required an arrangement of many figures fitted into a long, low triangle. Trying to adjust figures to fill such awkward shapes, while ensuring that beautiful patterns were produced and at the same time making the figures themselves and the scenes they enacted convincingly naturalistic was a great challenge. It was on just such challenges that Greek art thrived.

4

Archaic Free-Standing Statues and Grave Stelai

How marble statues were made

Free-standing statues were far more difficult to produce than architectural sculpture. To begin with, architectural sculptures were comparatively easy to support: figures carved in relief simply remained attached to the background, while figures in the round could be braced by unseen props. Architectural sculptures were also comparatively easy to design: they had to look good from only one point of view, since the angle from which they could be seen was always severely restricted even when the sculptures themselves were carved fully in the round, as at Aegina (cf. Figs 38 and 39). By contrast, free-standing statues had to be constructed so that they were self-supporting and so designed that they would present an acceptable appearance from many different points of view.

Much careful planning had to go into the creation of free-standing statues, for the material itself was costly and the expenditure of labour was considerable (a man would need between six months and a year to carve a life-size figure). No one could afford to make mistakes; some reliable system had to be devised.

The method used by early Greek sculptors of free-standing figures in marble appears to have been the following. First, a grid of lines was marked on the rectangular block of stone from which the figure was to be carved (Fig 40a). Then the artist drew the front view of the proposed statue on the front of the block, the profile view on the side, and so on (Fig 40b). The grid helped the artist make his drawing conform to a set of proportions (e.g. one unit up to the ankle, six to the knee, eighteen to the shoulder, etc.) so that he could be sure that the four sides of his statue would be co-ordinated with one another. Room was left beneath the feet for a plinth which would assure stability. Ultimately the plinth would be inserted into a base on which an explanatory inscription could be carved (as on Fig 58).

Once the drawings had been completed, the artist began to chip away the surplus stone (Fig 40c). He worked not only from the front, but constantly from all four sides so that he was continuously aware of the three-dimensional form emerging from the block. An unfinished statue (Fig 41) shows how a sculptor went about disengaging a figure from the stone. He used the same rough tool (a punch) on all four sides – no one of which is any more finished than another. The point at which he changed from working from the drawing at the front to working from the drawing at the side is evident from the abrupt transition from front to side views, which still come together sharply at right angles. This is particularly noticeable on the arms, thighs and cheek. Had the work not been abandoned at this early stage, the sculptor would have continued defining the figure with the aid of increasingly finer tools (Fig 42) and abrasive powders until all the features had been smoothly finished (Figs 40d and 44), though in early statues the sharp corners revealing the shift from one view to the next were never entirely obliterated (see Fig 56).

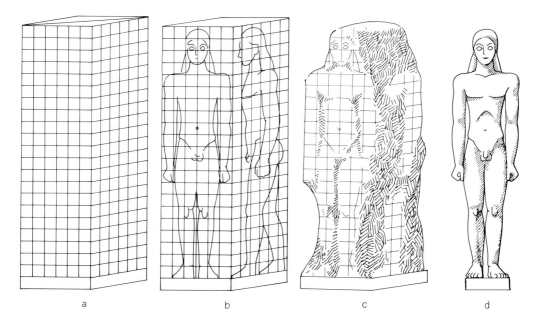

a b c d

40. Diagram showing the early Greek method of carving free-standing statues: (a) grid marked on the block of stone to help with planning the proportions of the figure; (b) different views of the proposed figure drawn on the appropriate sides of the block; (c) excess stone chipped away; (d) finished figure

41. Unfinished statue of a kouros, about the middle of the 6th century BC, National Archaeological Museum, Athens. The sculptor has blocked out the figure with the help of a punch. The work was abandoned before he started to use any finer tools (chisels), see Fig 42.

Greeks and Egyptians

The Greeks began to carve large-scale, free-standing statues out of hard stones around the middle of the 7th century BC. The inspiration for such ostentatious works probably came from Egypt. Egyptian hostility to foreigners was relaxed around 660 BC, and from that time on Greeks could visit Egypt and see for themselves the splendours of that ancient civilisation. The Greeks were accustomed to rather humble surroundings, and the novelty and grandeur of what they found in Egypt must have impressed them deeply. They must have been dazzled as they beheld row upon row of statues the size of men and some stone figures as big as giants. It was a revelation to them of hitherto undreamt-of possibilities. They, too, now wanted to make stone statues of men.

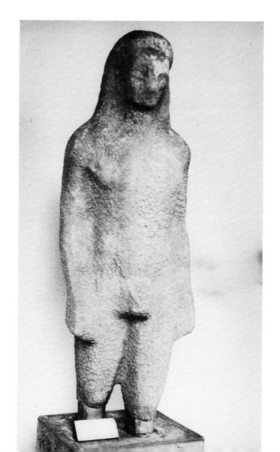

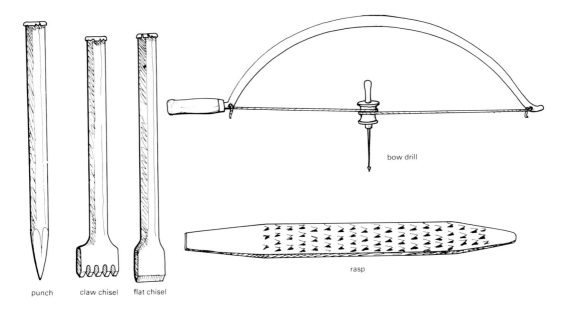

punch claw chisel flat chisel

bow drill

rasp

42. The tools used by Greek sculptors carving stone. The sculptor would begin by blocking out the figure with the help of a heavy tool like a punch; he would then define the forms with finer chisels; finally he would remove the tool marks with the aid of a rasp and finish the statue by smoothing it with abrasive powders. Drills were used to make single holes (e.g. nostrils) and to perforate large blocks of stone that had to be removed (e.g. between the legs).

They quickly learned the technique of stone carving from the Egyptians, for the method they used (just described) was derived from Egyptian practice. Their system of proportions was also borrowed, at first, from the Egyptians (Fig 43).

It is hardly surprising, therefore, that the earliest Greek statues of youths, carved toward the end of the 7th century BC (Fig 44), greatly resemble contemporary Egyptian works (Fig 43). The straightforward frontal pose with arms hanging parallel to the sides and left leg advanced is nearly identical. In both, head and body are upright; eyes, mouth, shoulders, hips, knees and ankles are all level (see Fig 196). The drawings on the grid encouraged this sort of organisation based on simple verticals and horizontals and discouraged

any experiments that might involve bends, turns or twists, for such complicated poses would require awkward foreshortenings that would be difficult to visualise and draw.

Though the similarities between early Greek statues like the one now in New York (Fig 44) and the sort of Egyptian figures that inspired them are profound, the differences between them are equally important. While the Egyptian statue wears a kilt, the Greek figure is nude. While the Egyptian statue has forms that are broadly naturalistic, the forms of the Greek figure are schematised into decorative patterns. Finally, while much of the original block is retained in the finished Egyptian statue, the Greek figure is cut entirely free.

The nudity of the Greek figure, which was acceptable for representations of males in Greece, permitted the sculptor to devote himself to the portrayal of living forms undisturbed by the intrusion of any inanimate drapery. It also allowed him more freedom to organise the parts of the body into an aesthetically pleasing composition.

40

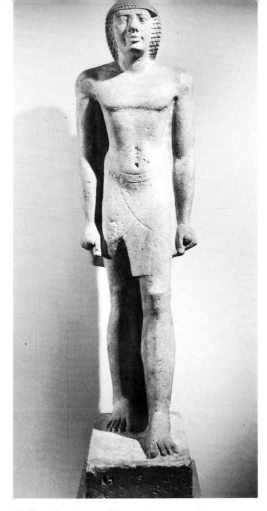

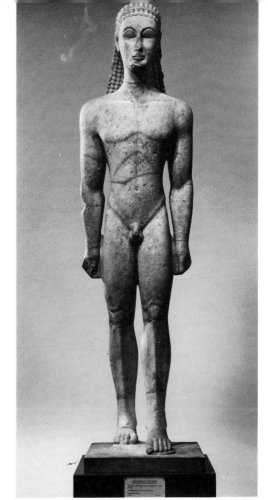

43. Egyptian statue, Tjayasetimu, XXVI dynasty, about 630 BC, British Museum, London

44. Kouros from Attica in New York, late 7th century BC, Metropolitan Museum of Art, New York

The Greek sculptor who valued symmetry highly as an element in design must have been glad of a pose that so happily accentuated the natural symmetry of the human body with its balanced pairs of eyes, ears, arms and legs and made the right side virtually a mirror-image of the left.

While symmetry around a vertical axis was thus easily achieved, any sort of symmetry around horizontal axes must, at first glance, have seemed impossible to impose. Nevertheless, the sculptor, with his strong desire for order, was able to arrange the forms of the human torso into a satisfying formal pattern. He imagined a horizontal axis running across the body at the level of the navel and then produced a symmetrical design on either side of it by making the upright 'V' of the groin into the mirror-image of the inverted 'V' of the lower boundary of the thorax (Fig 45, dotted lines). He imagined another horizontal axis mid-way between the collar bones and the pectoral muscles. He then balanced the shallow 'W' of the pectorals below it by the inverted shallow 'W' of the collar bones above (Fig 45, dashed lines). These symmetries can be best appreciated if the picture is turned sideways.

The sculptor has used not only symmetry but also repetition as a device to impose decorative coherence on the living body. He repeated some forms exactly (as in the

41

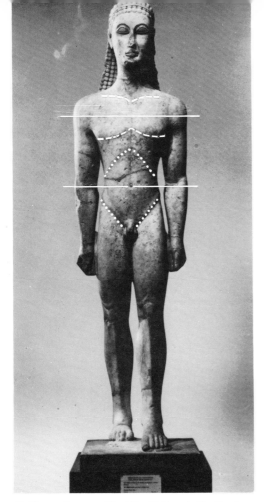

45. Kouros (same as Fig 44) with lines indicating how the anatomy was decoratively organised around horizontal axes.

The Greeks' interest in representing living forms only also led Greek sculptors to a more daring approach to the material. Egyptian sculptors had prudently left the stone between the legs of the statue and between the arms of the body untouched. These bits of dead stone the Greek sculptors boldly cut away.

The aesthetic advantages of the Greek approach are instantly apparent. The interplay of mass and void makes the statue much more interesting visually. From the right side (Figs 46 and 47) the space between the legs adds animation to the image; from the left side (Figs 48 and 49) the cutting free of the block is crucial, for in the Egyptian statue the further leg has disappeared entirely, obscured by the uncarved stone. At the back the Egyptian sculptor has used the surface of the block for an inscription and has made no effort to maintain the organic quality of his representation (Fig 50). The back view of the Greek figure (Fig 51), by contrast, though rendered largely in terms of pattern, nevertheless remains the representation of a man from head to heel.

The Greek sculptor has produced the illusion of a figure standing on his own two feet. He has done this by means of carefully shaping and piercing a piece of stone. Physically, statue and plinth form a single continuum of stone through which three holes have been carved – one between the legs, from the feet to the groin, and the other two between the arms and the body. These holes weaken the fabric of the stone, and it is not surprising that such statues often break at the ankles or the knees (Fig 41) and that the arms are very vulnerable (Fig 53). Changing time-tested procedures is always risky and often produces unexpected problems. This was a fact that the bold and innovative Greeks had to face over and over again.

arch of the eyebrow, which carefully follows the arch of the upper lid, or in the identical beads that indicate the hair); others he echoed on a smaller scale (thus the shallow 'W' of the pectorals is reflected in the shallow 'W's above the knees, and the protruding 'V' of the groin is transformed into the recessed 'V's in the elbows). He thereby ensured that the whole statue was knit together in a network of calculated interlocking patterns which have no parallel in the Egyptian figure. This was the result of the Greeks' ability to combine representation with abstract design and their desire that a statue should be not only the image of a human being, but also a thing of beauty.

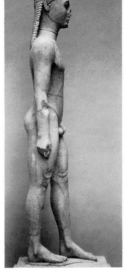

46. Egyptian statue

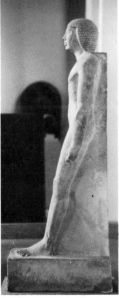

48. Egyptian statue
50. Egyptian statue

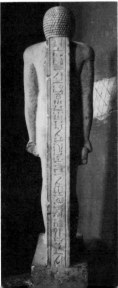

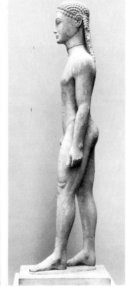

47. Kouros in New York

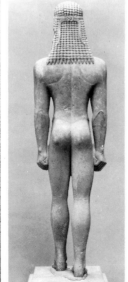

49. Kouros in New York
51. Kouros in New York

How Greek statues were used

Greek statues of nude male figures standing in this frontal, symmetrical pose and carved during the archaic period (late 7th century BC to the early 5th century BC) are called *kouroi* (singular: *kouros*). The word simply means 'young man' but it has come to be used as a technical term to describe this kind of statue.

There were three main functions a kouros could serve: it could be used as a dedication to a god (Fig 52), or as a memorial to a man (Figs 53, 54 and 58) or, with slight modifications, as a representation of a god (Fig 102). *Korai* (singular: *kore*), the draped female counterparts of kouroi, served analogous functions.

The purpose for which the kouros now in New York (Fig 44) was originally intended is not known, but a huge kouros carved around the same time and found at Sounion (Fig 52) was one of a group of colossal youths made as dedications to the god Poseidon.

Both the New York kouros and the Sounion kouros (see p. 170) are Attic, and despite the great difference in scale – the New York kouros is about life-size, while the Sounion kouros is over three metres tall – they show many of the same qualities of abstract design.

A pair of statues found at Delphi (Fig 53) illustrates one of the ways kouroi could be used as memorials of men. The Greek historian Herodotus (1.31ff.) tells how the people of Argos had statues erected at Delphi to commemorate two brothers, Kleobis and Biton, who had distinguished themselves by a pious act before their death. Inscriptions carved, unusually, on the plinths (the base has never been found) seem to identify these figures as the very ones mentioned by Herodotus.

Though Kleobis and Biton were made only a few decades after the New York and Sounion kouroi (Figs 44 and 52) and were probably carved within the first two decades of the 6th century BC, they were created in a different spirit. The sculptor

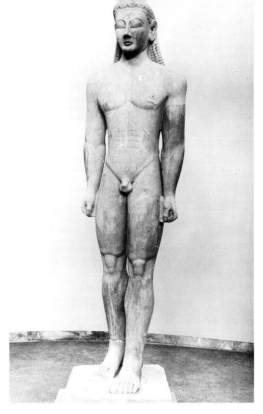

52. Colossal kouros found at Sounion in Attica, late 7th century BC, National Archaeological Museum, Athens

53. Kleobis and Biton, about 580 BC, Delphi Museum, Delphi

from Argos was apparently more interested in giving an impression of robustness through vigorously curved forms and less interested in patterning the surface than were the Athenians. There is the beginning of a smile on the faces of the two brothers, probably not because the sculptor wanted to indicate that they were happy, but because he found that this expression made their faces look more alive. From this time on the 'archaic smile' became a standard feature of kouroi. It was also used for architectural sculptures (cf. Fig 38).

A kouros could also be used to commemorate a man by being set up as a monument over his grave. The inscription on the base explains that this is how the kouros found at Anavyssos in Attica was used (Fig 54).

Though the Anavyssos kouros was made around 530 BC, a half-century after Kleobis and Biton, he stands in the same pose as they. This is hardly surprising since the method of carving, which dictated the

54. Kouros found at Anavyssos, set up as a memorial to Kroisos, about 530 BC, National Archaeological Museum, Athens

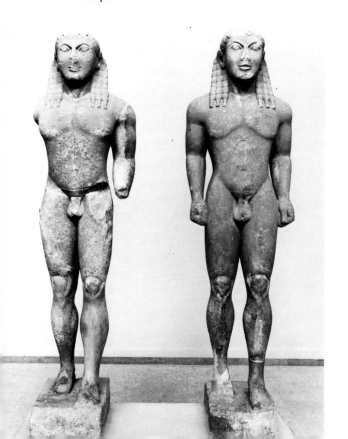

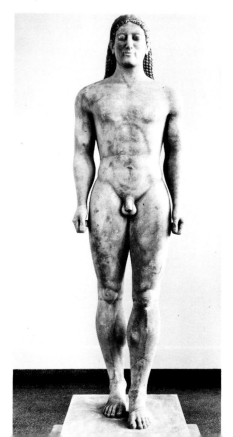

pose, remained unchanged throughout the archaic period. Nevertheless, important naturalistic innovations had been introduced.

The growth of naturalism

As time passed, sculptors tried to make their statues ever more plausible and convincing. They wanted to make their statues of men look like real men, just as they wanted to make the scenes illustrated in architectural sculpture look like real scenes. They cautiously retained the conventional pose imposed by the technique, but within this stable framework they systematically modified proportions, rounded forms and corrected details in order to approach ever closer to a naturalistic ideal.

The means they used and the degree of their success can be appreciated if one compares the head of the Anavyssos kouros

(Fig 55) with the head of the New York kouros (Fig 56), carved less than a century before. Instead of being sharply incised, forms are gently rounded; flat planes meeting sharply at angles have been transformed into curved masses suggestive of soft flesh rather than hard stone. The sensitive swelling of the cheeks, the subtle modelling around the eyes and mouth give the face a radiant expression. Some of the original paint has survived on the hair and the eyeballs, and this contributes to the effect. Other statues, from which the paint has been rubbed off, have lost much of the immediacy that this figure retains.

But advances could not be sustained on all fronts at the same time. Thus although the later artist has succeeded in making the ear appear much more realistic, he has not been able to improve very noticeably on the formula that was used for hair. The decorative, bead-like rendering of the hair, which was in harmony with the rest of the

55. Head of the kouros found at Anavyssos, detail of Fig 54

56. Head of the kouros in New York, detail of Fig 44

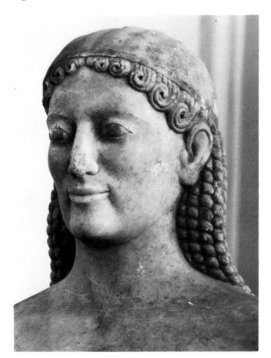

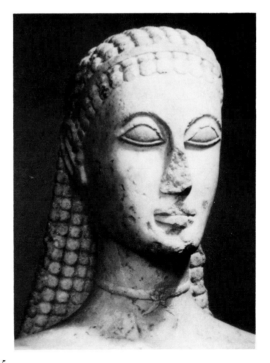

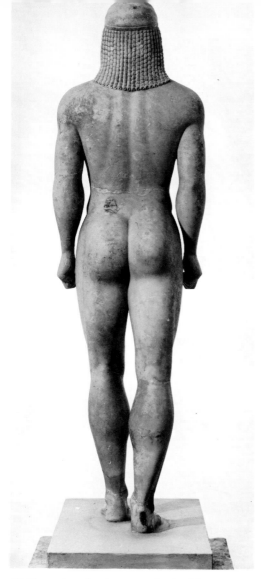

57. Kouros found at Anavyssos, back of Fig 54

achievements, for success along one line of development frequently revealed failure along another. Thus, rationalising the scale of the figures in the centre of the Siphnian Treasury pediment (Fig 34) brought out the awkwardness of the treatment of the corners (see p. 34) and improving the rendering of the anatomy of the Anavyssos kouros (Fig 54) showed how artificial the representation of the hair remained.

The creation of a more naturalistic art was a constant complex challenge to Greek artists, who expended time, patience and imagination upon it. The very difficulty of the undertaking (which looks simple only in retrospect) contributes significantly to the vitality of early Greek art.

By the end of the 6th century BC, helped by a change in fashion, the Attic artist who carved a statue to stand as a grave monument for a certain Aristodikos (Figs 58 and 64) had solved the problem of the discordant hair: he cut it short. At the same time he continued to work on developing increasingly naturalistic formulae for the representation of the human body. So successful was he that the realism of the figure he created makes even the masterpiece of a generation before (Fig 54) look, by contrast, almost like an inflated balloon.

But his triumph was marred by the emergence of a new and even more awkwardly intractable problem: the Aristodikos (Figs 58 and 64) is so convincingly realistic, looks so much like a living man, that the way he stands now appears unnaturally stiff. For the first time in over a hundred years, the pose itself is called into question. The dilemma must have seemed insoluble as artists came to realise that each new, improved naturalistic detail only served to reinforce the apparently unnatural rigidity of the pose.

Nothing less than a drastic and revolutionary change could solve this problem. What it was and how it was arrived at will be discussed in Chapter 6.

decorative, formal treatment of the earlier kouros (Fig 56), now jars in the context of the otherwise more naturalistic forms of the later kouros (Fig 55). The back view makes this discord particularly disturbing (Fig 57). By contrast, the back view of the New York kouros (Fig 51) is stylistically perfectly harmonious.

Naturalism could not be attained all at once, and innovations were difficult to reconcile with established conventions. Sometimes unanticipated problems arose as a by-product of new and positive

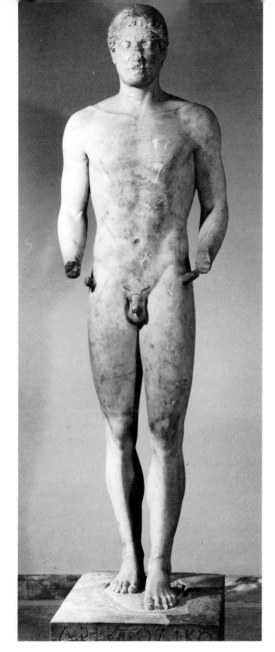

58. Kouros set up as a memorial to Aristodikos, end of the 6th century BC, National Archaeological Museum, Athens

Attic grave stelai

The last two kouroi (Figs 54 and 58) served as grave monuments, splendid examples of conspicuous display. This need could also be satisfied by the erection of a *stele* (plural: *stelai*). Vases were not used as

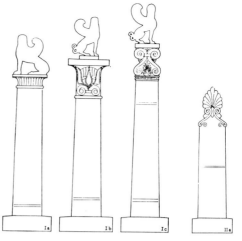

59. Archaic Attic grave stelai
Types I a, b and c – about 610-525 BC
Types II a and b – about 530-500 BC

tomb monuments after the end of the 7th century BC.

A stele was a thin slab of stone (Figs 59-63). On it a sculptor would usually draw something very similar to the side view of a kouros (cf. Figs 47 and 64). He could then carve the figure he had drawn in shallow relief. The image would have been completed by the addition of paint – a dark background to set off the figure and details of hair, eyes and costume accentuated by colour.

Most stelai were at first large and elaborate, crowned with a sphinx carved fully in the round (Figs 59 and 61). Stelai made from about the beginning of the last quarter of the 6th century BC were more modest, topped by simple palmettes (Fig 59).

The figures portrayed on stelai were given more individual characteristics and attributes than were the kouroi. The fragment of one stele from about the middle of the 6th century BC (Fig 60) shows a bearded man with a broken nose and swollen ear who is identified as a boxer by the thongs of his boxing gloves tied around his wrist. The low relief carving is fine and delicate; the surface of the hair was left rough in order for it to hold the paint better. Though the head is in profile, the eye is drawn as if it were seen full face. It was difficult for artists to learn how to

60. Boxer, fragment of a grave stele, mid 6th century
BC, Kerameikos Museum, Athens

61. Youth and small girl, grave stele complete with
base, shaft and finial including sphinx seated at the
top, third quarter of the 6th century BC, Metropolitan
Museum of Art, New York (head, shoulder and left
hand of the girl are a plaster copy from the original in
Berlin)

represent eyes in profile, and they did not
do so consistently until well into the 5th
century BC (see p. 106).

Occasionally more than one figure would
be shown; a youth is accompanied by a
small girl on a stele from the third quarter
of the 6th century BC (Fig 61). The entire
stele including the sphinx stood well over
four metres high, an impressive monument
indeed. The youth holds a pomegranate in
his left hand, while the aryballos that
characterises him as an athlete hangs from
his wrist. Otherwise his appearance is not
very different from the side view of the
kouros from Anavyssos, with which the
stele is approximately contemporary.

An unusually wide format must have
been used for a stele which probably
showed a seated mother with her child,
only fragments of which are preserved
(Fig 62). Despite its simplicity and the lack
of any sentimentality in the represent-
ation, the image manages to convey a
touching tenderness.

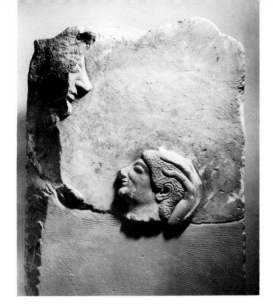

62. Mother and child (?), fragment of a stele, third quarter of the 6th century BC, National Archaeological Museum, Athens

Throughout the 6th century BC, the grave stelai kept pace stylistically with the kouroi, gradually becoming more naturalistic. One of the latest (Fig 63), which is close in date to the Aristodikos (Fig 64), was erected for a certain Aristion, who is shown as a warrior wearing leg-guards, breast-plate and helmet and holding a spear. As is usual in surviving archaic grave stelai, the carving is fine and sensitive: the curls of the hair and the strands of the beard (the tip of which was attached separately) are delicately cut. The massiveness of the figure is cleverly suggested by means of overlapping forms, despite the fact that the further limbs – the hand holding the spear and the advanced

63. Grave stele set up as a memorial to Aristion, about 510 BC, National Archaeological Museum, Athens

64. Kouros set up as a memorial to Aristodikos, right side of Fig 58

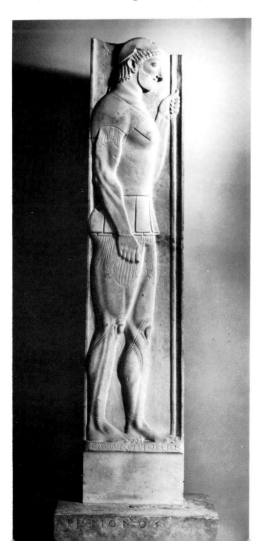

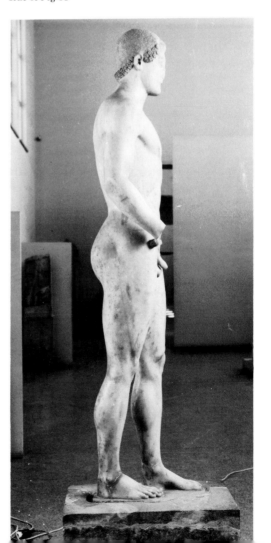

leg – protrude to the same level as the nearer ones.

An over-life-size figure on a stele like this (Fig 63) made a handsome monument, but once the elaborate sphinxes were abandoned, such stelai became far less demanding of time and material and consequently cheaper than figures carved in the round, like kouroi.

Draped female figures

While Greek convention permitted men to be portrayed nude, the same did not apply, for centuries, to women. During the archaic period, therefore, statues of female figures were invariably draped.

The earliest large-scale female figure preserved is a dedication to the goddess Artemis on Delos offered by a woman called Nikandre (Fig 65). It was carved about the middle of the 7th century BC and so is earlier than any of the kouroi we have looked at. Living forms appear only at the extremities: arms hanging passively at the sides, feet peeping out beneath the skirt, head (now much weathered) framed by abundant hair. The main bulk of the statue is devoted to the heavy drapery that covers the body so completely that there is hardly a hint of a human form concealed beneath its severe surface.

The image of a woman or a goddess, carved in Athens in the second quarter of the 6th century BC (Fig 66), though still dominated by heavy drapery that obscures rather than reveals the body it covers, shows the beginnings of a livelier approach. The face is bright and alert and the arms, instead of hanging limply by the sides, are brought in front of the figure at different heights in order to add interest to the otherwise wholly symmetrical composition.

It is from the back, however, that we can best see the innovations and achievements of the artist (Fig 67). Here he demonstrates his discovery that although female figures offered little scope for the portrayal of anatomy that made male figures so fascinating, their drapery and hair pro-

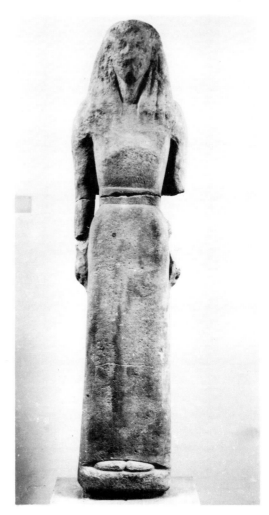

65. Draped female figure dedicated by Nikandre on Delos, third quarter of the 7th century BC, National Archaeological Museum, Athens

vided an excellent field on which a gifted sculptor could develop his talent for decorative organisation.

The hair is formally stylised into a number of patterns composed of relatively small elements. The cloak falls in larger, concentric curves; the skirt, with its regular straight folds, swells slightly over the buttocks. The balance of simple but sensitively varied forms combined with a suggestion of the living body beneath the

50

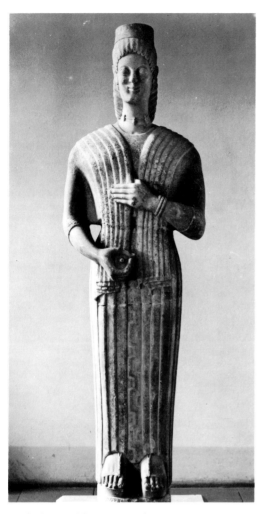

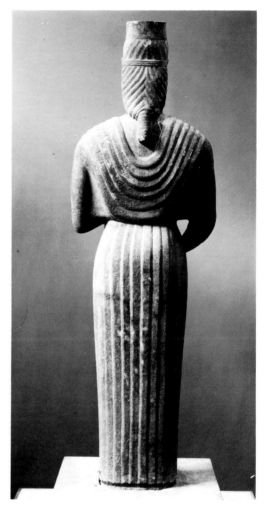

66. Goddess holding a pomegranate, found in Attica, 570-60 BC, Antikensammlung, Staatliche Museen zu Berlin, East Berlin

67. Goddess in Berlin, back of Fig 66

drapery shows the mettle of the Attic artist who carved this image.

From now on, artists began to respond ever more ingeniously to the double challenge offered by the draped female figure; first, finding a way to suggest that a body exists beneath the drapery, and second, arranging hair and drapery into decorative patterns.

An eastern Greek artist treated the drapery of a figure dedicated to Hera at Samos (Fig 68) rather differently than but no less effectively than his Attic contemporary. The graceful, columnar figure wears a thin linen undergarment that falls into many tiny folds, indicated by numerous small, parallel incisions, and fans out at the bottom. A fine, smooth veil covers part of the skirt to the right, while a heavy woollen cloak, characterised by deep, wide folds, is draped diagonally over the upper part of the body. In contrast to the simple

51

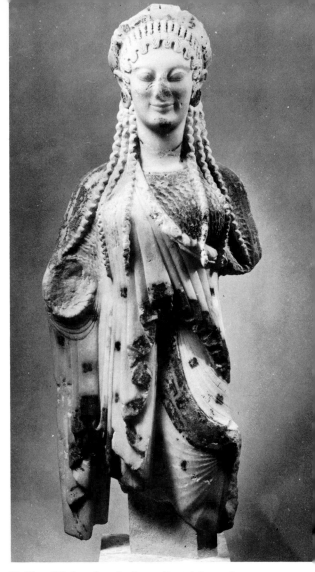

68. Draped female figure dedicated to Hera on Samos, about 560 BC, Louvre, Paris

69. Kore 675, found on the Acropolis at Athens, about 530-520 BC, Acropolis Museum, Athens

symmetry of the Attic goddess now in Berlin (Figs 66 and 67), the artist here relies on variety in the play of patterns, which must have been reinforced by the original colours. The form of the body beneath the drapery is subtly hinted at, giving the warmth of human content to this elegant study in design.

By the third quarter of the 6th century BC, a richly decorative formula for drapery and figure had virtually become standardised at Athens (Fig 69). Girls wearing a thin garment called a *chiton* (Fig 70) and a diagonally draped heavy woollen cloak (Fig 71), pull their skirts to one side with the left hand and hold out an offering in the right (which, having been made of a separate piece of stone and inserted in a socket, has often come adrift, as here). The breasts are now clearly indicated beneath the drapery and as the skirt is pulled to one side, the outline of the legs also becomes visible. The drapery itself falls into a number of lively folds of various kinds and

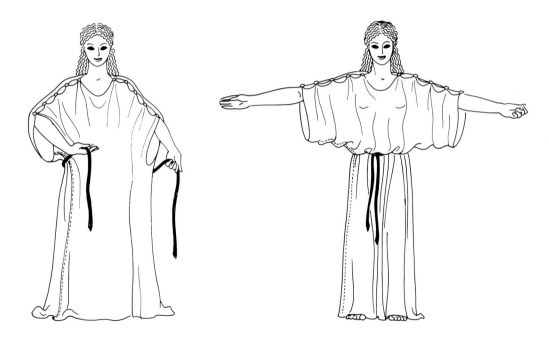

70. Diagram showing how a chiton is worn. A wide
rectangle of fine linen is folded along one vertical edge
and sewn along the other. It is buttoned at the top to
make sleeves. It is usually belted. If it proves too long
for the wearer, some of the excess can be pulled up
over the belt.

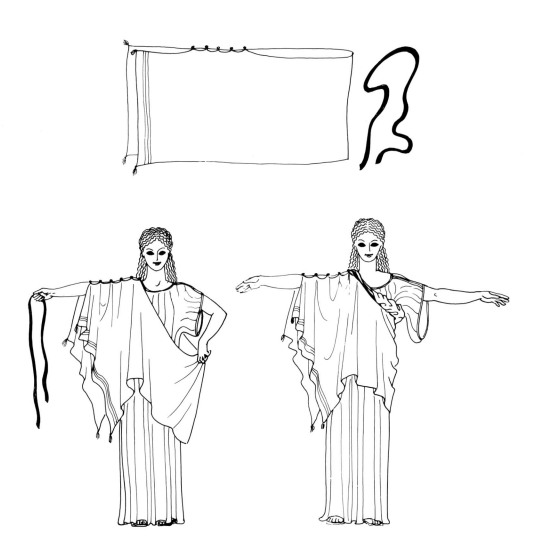

71. Diagram showing how a short diagonal cloak is worn. The long, narrow rectangle of cloth is worn under one arm and buttoned along the other shoulder.

the paint (in this case well preserved) adds to the charm of the figure. The hair is stylised into three different patterns: ringlets over the shoulders, an undulating fringe and, above it, tight curls. Body and drapery have both come alive, and the decorative potential of the draped female figure seems to have been perfectly realised. This type of statue was carved both on a small scale (as in this example) and on a very large scale. Such *korai*,

72. 'Peplos kore', found on the Acropolis at Athens, about 540-30 BC, Acropolis Museum, Athens

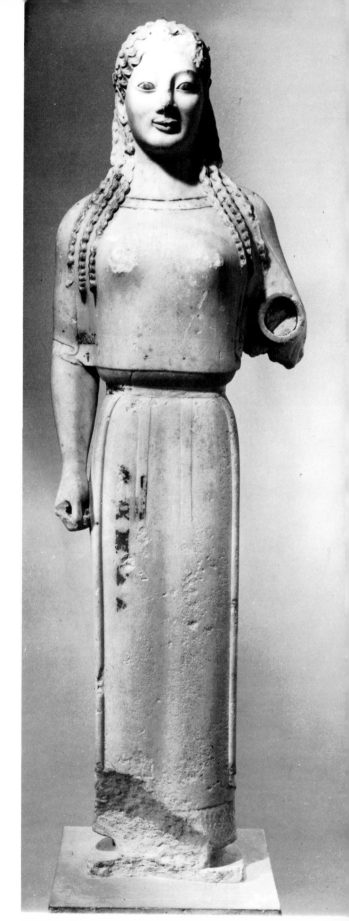

dedicated to the goddess Athena, have been found in great numbers on the Athenian Acropolis. Clearly this format had become conventional during the last third of the 6th century BC.

Occasionally, there were exceptions. One of the most delightful, also found on the Athenian Acropolis (Fig 72), wears over her chiton a simple woollen *peplos* (Fig 73). The peplos was the usual garment worn by women in mainland Greece until the mid-6th century BC brought in the fashion for the Ionian chiton and diagonal cloak. The drapery is treated in terms of broad, simple masses (Fig 72). It is enlivened by slight irregularities (for instance, just above the waist) to convey a sense of the young and supple body it conceals. It provides a cleverly understated base for the radiant, sensitively carved head.

Archaic free-standing statues are almost entirely of standing nude male figures (*kouroi*) and standing draped female figures (*korai*). Examples of seated (Fig 180) and reclining figures and of animals (dogs, lions and horses) also exist, but they are comparatively rare.

Within a small range of themes artists refined the images they produced. Always eager to create works of formal beauty or decorative charm, from before the middle of the 6th century BC, they also began systematically to make their statues conform ever more closely to a more natural ideal. While this effort was to a large extent successful, particularly in matters of detail, increasing naturalism produced new and unexpected problems, some of which archaic artists were simply unable to resolve. These artists possessed great technical skill and created works with exquisitely refined surfaces; yet despite their mastery of naturalistic detail, they were not able to make their statues come alive. The next generation picked up the challenge where they left off.

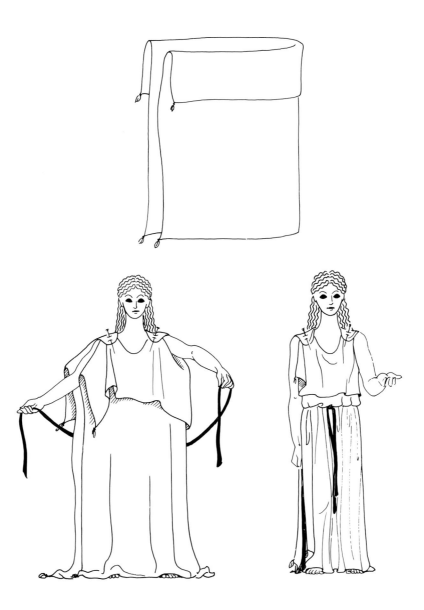

73. Diagram showing how a peplos is worn. The simple
rectangle of woollen cloth was folded around the
wearer and pinned at the shoulders. Usually, part of
the cloth was folded over at the top (the overfold) in
order to shorten the garment (rather than taking up a
hem at the bottom). A belt was usually worn. If the
garment was very long, in addition to the overfold,
part of the length could be pulled up over the belt to
form a pouch (see Figs 203, 204 and 205), or the
overfold could be made so long that the belt came on
top of it (see Figs 184, 185 and 188).

5

Early Red-Figure Vase Painting

The invention of red-figure

Exekias had created masterpieces in the black-figure technique (Figs 23 and 24). The extraordinary quality of his work must have set a daunting precedent for his more ambitious followers. Many of the more gifted were reluctant simply to carry on in the shadow of the master and eager to try something different. Some painters who worked with the potter Andokides began to explore the possibilities of a new technique; the man we call 'the Andokides Painter' has a good claim to have been the first.

His innovation can be appreciated if we compare the decoration on two sides of a one-piece amphora now in Boston (Figs 74 and 75). On one side (Fig 74), the Andokides Painter (or his colleague the Lysippides Painter – opinions differ as to the authorship of this panel) drew a normal black-figure picture showing Herakles driving a bull to sacrifice. On the other side of the vase (Fig 75) the Andokides Painter drew much the same picture, but instead of painting the figures black, he left them in the natural colour of the clay and painted the background black instead.

74. Herakles drives a bull to sacrifice, Attic black-figure on a bilingual amphora, probably painted by the Lysippides Painter, 530-515 BC, Museum of Fine Arts, Boston

75. Herakles drives a bull to sacrifice, Attic red-figure on a bilingual amphora, painted by the Andokides Painter, 530-515 BC, the other side of Fig 74

The reversal of the traditional colour-scheme was revolutionary; nevertheless, from the very first, it was remarkably successful. Though the figures were now red on a black ground (see Frontispiece), the principle of strong contrast that was so important for the effectiveness of paintings on vases had been preserved. The new look in vase painting even had something comfortingly familiar about it, for the backgrounds of contemporary relief sculptures which were used either to decorate architecture or to commemorate the dead were also regularly painted a dark colour to contrast with the paler figures that protruded from them (see pp. 47 and 173).

The Andokides Painter made other experiments as well, but this, his invention of the red-figure technique around 530 BC, was the one that held most promise. It was soon developed and exploited by a number of gifted painters.

At first glance the red-figure technique may seem little more than a simple reversal of black-figure, but in fact there are some fundamental differences, the wider implications of which became apparent in time.

Black figures are articulated by incision, whereas the internal marking of the red figures could be painted with a brush. However sensitive incision may be, it can never attain the fluency of a brush. The use of a more flexible instrument invited artists to evolve a more flowing style.

Black figures look like flat shadows, whereas red figures give an impression of greater roundness, which encouraged artists to develop suggestions of mass and three-dimensionality.

Black-figure can be used to produce complex decorative patterns; red-figure can be just as effective, but with fewer elements, for the shiny black background itself can replace many of the filling ornaments which often seem necessary to balance the design of black-figure.

The different qualities inherent in black-figure and red-figure are perceptively developed on another 'bilingual' vase, that is, one decorated in black-figure on one side (Fig 76) and red-figure on the other (Fig 77). Both scenes show Herakles feasting, attended by Athena. In the black-figure version two more figures are added: Hermes to the left and a servant boy to the right beside a dinos on a stand.

The black figures, the vine laden with large bunches of grapes, the little table laid with loaves of bread, long hanging slices of meat and a spare cup are spread over the field so that the whole panel is covered with interesting dark accents and there are few blank spaces (Fig 76). The play of pattern evenly covers the whole panel, the bold figures being finely balanced by the delicate filling ornament provided by the vine with its leaves and fruit and the table which so neatly decorates the space beneath the couch. Great stripes of purplish-red enliven the drapery of the three clothed figures and white paint was originally used to colour Athena's flesh and pick out some parts of the furniture, though most of it has now flaked off.

The red-figure scene has fewer, larger figures, more sense of physical mass and less of decorative patterning (Fig 77). The use of colour is more restrained. Purplish-red is used only for the hanging slices of meat and the leaves on the vine; white has been eliminated entirely. There seems to be a conscious effort to suggest depth, or at least layers of space. The little table is now shown clearly in front of the couch; one of Herakles' legs is unmistakably behind the other; the hand that grasps his knee is further back still. There is also an attempt to portray the hero's torso in a three-quarter view – notice the asymmetry of the collarbones. The figure is so large that his head overlaps the border; the artist has tried to make him correspondingly massive. The softness of cloth is suggested by the fluent painting of the folds, particularly those that fall from Herakles' arm and those at the bottom of Athena's skirt.

In the black-figure version, the vine with its grape clusters provides some welcome decoration. In the red-figure version the

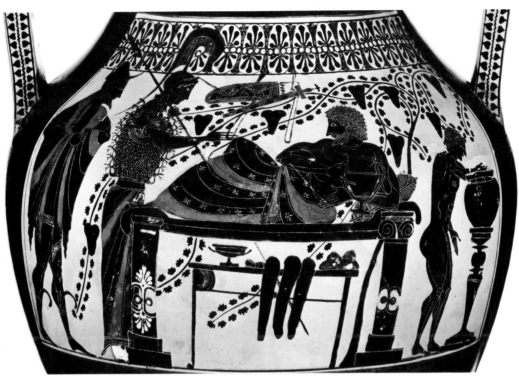

76. Herakles feasting in the presence of Athena, Hermes and a servant, Attic black-figure on a bilingual amphora, probably painted by the Lysippides Painter, 530-515 BC, Staatliche Antiken-sammlungen und Glyptothek, Munich

77. Herakles feasting in the presence of Athena, Attic red-figure on a bilingual amphora, painted by the Andokides painter, the other side of Fig 76

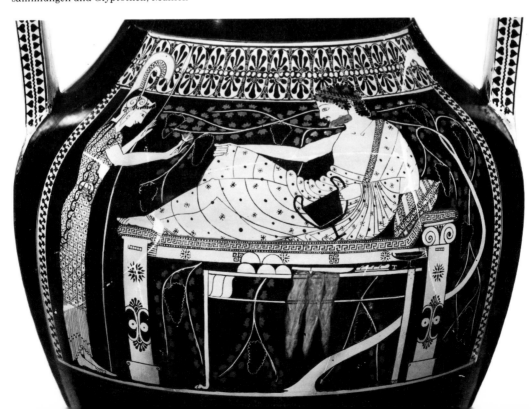

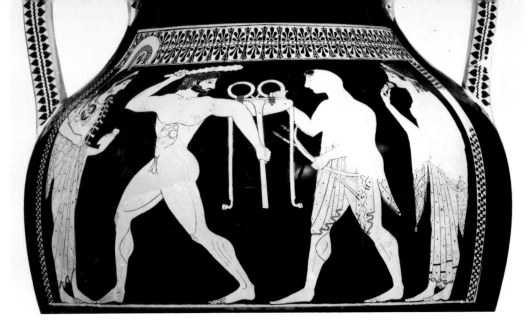

78. Herakles attempting to steal Apollo's tripod in the presence of Athena and Artemis, Attic red-figure amphora, painted by the Andokides Painter, 530-515 BC, Metropolitan Museum of Art, New York

slender vine with its purplish-red leaves and barely perceptible black bunches of grapes seems crowded; the shiny black background was sufficient in itself to set off the figures pleasingly. Soon this sort of filling ornament was abandoned altogether in red-figure vase painting.

An amphora painted by the Andokides Painter somewhat earlier than the examples we have been looking at so far shows Herakles and Apollo struggling for the tripod (Fig 78), a myth that was illustrated in the pediment of the Siphnian Treasury at about the same time (Fig 35).

The central figures are flanked by concerned goddesses, Athena to the left holding an owl, Artemis with her bow to the right, smelling a flower. The drapery of both goddesses falls in numerous soft folds and displays delicate patterns. The vase is contemporary with the most elaborately dressed korai on the Acropolis (cf. Fig 69). Herakles brandishes his club in one hand and grasps the tripod in the other. He strides to the left but looks back. In pose he is rather like the fleeing giant in the Gigantomachy frieze on the Siphnian Treasury (Fig 30), but here the painter has

made a valiant effort to suggest the twist of the torso in a more plausible manner. Apollo, to the right, only partially preserved, appears to have been a more conventional figure. The future of red-figure lay with the development of the representation of convincingly soft drapery and plausibly foreshortened anatomy. Here the first steps have already been taken.

79. Nessos carrying Herakles' wife Deianeira, Attic red-figure cup interior, painted by the Ambrosios Painter, about 520 BC, British Museum, London

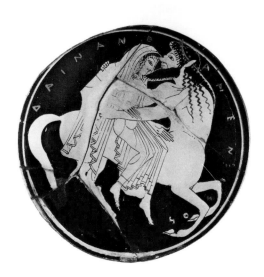

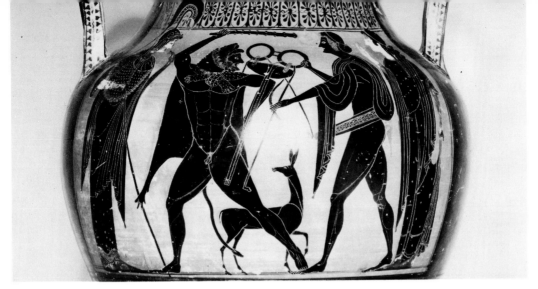

Further developments in red-figure and black-figure

Within a decade of its invention, many artists were exploring the effects that could be obtained with the red-figure technique. For instance, the Ambrosios Painter rethought the story of Herakles and Nessos (cf. Figs 4-5 and 10). He shifted the emphasis away from the death of the centaur to the cause of his doom. In the centre of a cup (Fig 79 and Frontispiece), he illustrated a critical moment in the story. Herakles' wife Deianeira is demurely seated on the centaur's back, modestly veiled, but wearing seductively thin clothing. Nessos gallops to the right, but turns round and reaches out to steady his passenger. The conscientious gesture slides easily into a lascivious embrace as a smile steals over the face of the crude monster and he prepares, ever so gently, to kiss the girl. Subtle emotions were difficult to describe in black-figure; red-figure artists delighted in developing devices to convey them.

In the meantime, artists using the black-figure technique began to notice and admire work by early red-figure painters. The Painter of Tarquinia RC 6847 (Fig 80) tried his hand at the same story that the Andokides Painter had illustrated (Fig 78). He added a small deer behind Herakles to fill the space which might otherwise seem bleakly empty. He endeavoured to make

80. Herakles attempting to steal Apollo's tripod in the presence of Athena and Artemis, Attic black-figure amphora, painted by the Painter of Tarquinia RC 6847, about 520 BC, Museo Nazionale, Tarquinia

the drapery look soft and fall in many folds, but his incision has a harsh effect and Apollo's cloak looks more like pleated aluminium foil than finely woven wool. Although Herakles' head is turned to the right while he strides to the left, his trunk is presented frontally, with lines suggesting anatomy scratched somewhat implausibly on it. By contrast, the foreshortened front view of his left leg, perhaps inspired by red-figure work, is very well executed.

An amphora painted by Phintias (Fig 81) shows how much more easily the most advanced ideas could be developed in red-figure. The two protagonists alone fill the scene. The pose of Herakles is much like that of the black-figure Herakles. The figure of Apollo is more ambitious. The position of his legs, one in profile, one front view, resembles Herakles', but the torso, instead of being presented frontally, is shown to be in three-quarter view by means of the asymmetric delineation of the groin. His short cloak responds to the movement of his body and hangs in folds that look natural.

While some effects are easier to obtain in red-figure, others are more difficult. Ornament is one of the latter. On Phintias' amphora (Fig 81), three sides of the frame of the panel are decorated with black-

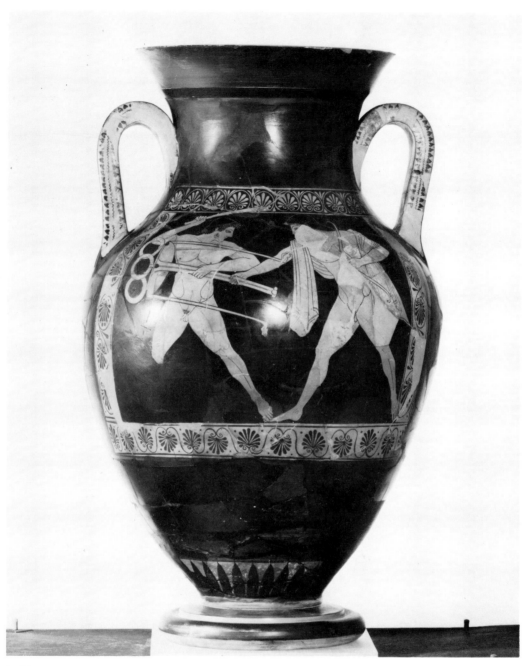

81. Herakles attempting to steal Apollo's tripod, Attic
red-figure amphora, painted by Phintias, about 510
BC, Museo Nationale, Tarquinia

figure palmettes linked by tendrils, while the top alone has red-figure palmettes enclosed by arched tendrils. The artist's restraint is readily comprehensible, for the red-figure decoration is enormously more demanding than the black-figure. In the black-figure strips, the painter simply drew the leaves of the palmettes and then, with steady hand, the slender tendrils connecting them. In the red-figure strip he had to *draw around* each leaf and paint in the background. The thin red arched tendrils are not drawn at all, but left in the natural colour of the clay. The artist had to paint the lower boundary of the arching tendril and then, very carefully, the upper border. He had to make sure that the distance between the two borders was exactly the same throughout so that the red line left unpainted should appear smooth and continuous.

Red-figure and black-figure seemed destined to develop in different directions and most artists, after a little while, generally chose to specialise in one or the other.

Epiktetos was unusual in that he seems to have been as accomplished in black-figure (Fig 82) as he was in red-figure (Fig 83). A master of exquisite, precise drawing, he had a wonderful sense of how to fill a circle. The black-figure rider on his spirited horse is balanced by the inscription within the tondo of a cup (Fig 82) to produce a thoroughly satisfactory design, while the red-figure running archer, limbs spread out to break up the space (Fig 83), fills the centre of a plate to perfection.

Panathenaic amphorae

Although the most forward-looking artists soon turned to red-figure, black-figure continued to be produced in abundance for decades and for one kind of vase painting actually outlasted the painting of any red-figure. This was in the decoration of Panathenaic amphorae (see Figs 84-86). The Panathenaic Festival was celebrated in Athens in honour of Athena with special

82. Horseman carrying spears, Attic black-figure cup interior, painted by Epiktetos, 520-510 BC, British Museum, London

83. Scythian archer, Attic red-figure plate, painted by Epiktetos, about 510 BC, British Museum, London

63

pomp and ceremony that included athletic competitions every four years. The Panathenaic amphorae were the vessels used to hold the oil that was given to the victors in these games.

One of the earliest preserved examples dates from about 560 BC (Fig 84). Athena, armed with helmet, shield and spear, was represented in a threatening posture on one side of the amphora, while the competition in which the victorious athlete had triumphed was shown on the other side. In later versions (for instance, Fig 85) the

84. Athena, Attic black-figure Panathenaic amphora, about 560 BC, British Museum, London

distinctive shape of the amphora with its unusually narrow neck and small foot was accentuated (contrast Figs 23, 74, 81 and 87), and Athena was flanked by columns topped by cocks, symbols of competitive zeal. The inscription running along the side continued to read, as before: '[one] of the prizes from Athens.'

When the first Panathenaic amphorae were produced in the second quarter of the 6th century BC, the black-figure technique was the only one available; thereafter religious conservatism required that the traditional style be retained. Since the quantity of oil awarded was considerable, many vases had to be made to contain it. The quadrennial state commission for several hundred amphorae was consequently so valuable that during the 5th and 4th centuries BC artists who normally worked in red-figure were willing to employ the more old-fashioned technique in order to win it.

On the Panathenaic amphora painted by the Euphiletos Painter around 520 BC (Fig 85), one can see how the artist has responded to the contemporary interest in depicting garments that fall in many and complex folds.

On the back (Fig 86), there is a lively representation of athletes preparing to jump, hurl the javelin and cast the discus. The positions assumed by the athletes are complicated, but the artist has not tried seriously to explore the effects they have on their anatomy.

Innovations in the rendering of anatomy and foreshortening

Red-figure vase painters of the last decade of the 6th century BC felt very differently about such matters. Euthymides was one of the leading painters of this period. He decorated a panel on an amphora (Fig 87) with an unedifying scene from daily life: three slightly tipsy men, carousing. The central figure is brilliantly drawn from the back. His feet point in one direction, his head is turned in the other; the transition

64

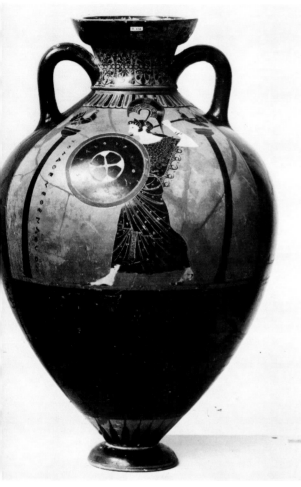

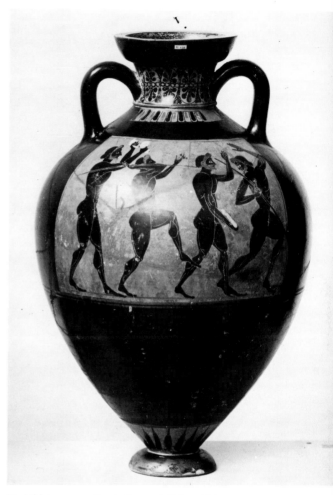

85. Athena, Attic black-figure Panathenaic amphora, painted by the Euphiletos Painter, about 520 BC, British Museum, London

86. Athletes competing in the pentathlon, Attic black-figure Panathenaic amphora, the other side of Fig 85

between the two extremes is rendered with consummate skill. We have come a long way in a short time from the awkwardly portrayed giant on the frieze of the Siphnian Treasury (Fig 30).

The depiction of foreshortened forms and of human anatomy fascinated Euthymides. He expended great care on the two side figures as well. He used a strong, clear, very black line that stood up slightly in relief to indicate major forms and thinned paint that fired in the kiln to a light brown for the minor ones (for instance, in the area

between chest and waist on the figure to the right). This distinction in the thickness of paint used for different parts of an image was also made by other painters and continued in use for a long time.

The portrayal of figures in action combined with a careful study of anatomy apparently occupied the most advanced artists in many fields towards the end of the 6th century BC. The Roman writer Pliny (see p. 169) says of a certain Kimon of Kleonai that he 'invented *katagrapha*, that is to say three-quarter views; he also

65

87. Three men carousing, Attic red-figure amphora,
painted by Euthymides, about 510-500 BC, Staatliche
Antikensammlungen und Glyptothek, Munich

disposed the countenances of his figures in various ways, showing them looking backward, upward, and downward: he made the distinction between the parts of the body more clear by articulating the joints; he emphasised the veins; and beyond that, he depicted the creases and folds in drapery.' (Pliny, *Natural History* 35.55-6). Kimon was a painter – but not a vase painter. He decorated walls and panels. His concerns, nevertheless, seem to have been the same as those that occupied the vase painter Euthymides.

Sculptors, too, eagerly joined in the search for better formulae to render the anatomy of figures in action or at rest. A relief carved on a base which once supported a statue (Fig 88) shows six athletes in a variety of poses that might well have impressed Kimon. The relief is like a manifesto for the new interests that were captivating artists. It contrasts markedly with the carefree decorative approach of only a few years before (cf. Fig 86). Comparison of similar figures in the relief (the second one from the left) and the Panathenaic amphora (the one on the far right) reveals the gulf that separates the two artists.

Euthymides was justifiably proud of his splendid amphora (Fig 87) and on it wrote a challenge to his rival, the vase painter Euphronios. Euphronios was also a powerful artist, as can be seen from the volute krater (Fig 89) that he decorated with a battle of Greeks and Amazons (legendary

88. Athletes, relief on a statue base, late 6th century BC, National Archaeological Museum, Athens

89. Herakles fighting Amazons; on the neck, revellers. Attic red-figure volute krater, painted by Euphronios, about 510-500 BC, Museo Civico, Arezzo

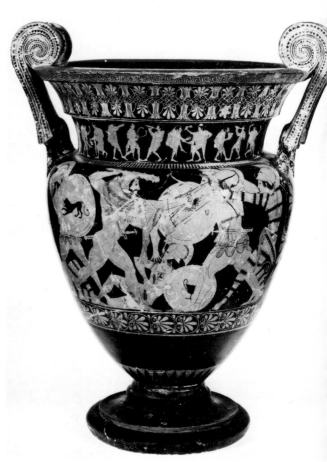

67

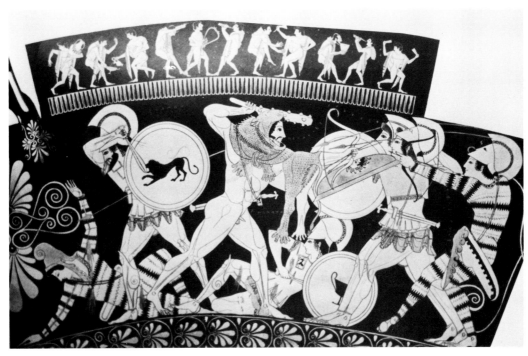

90. Herakles fighting Amazons, drawing of Fig 89

female warriors who lived in Asia Minor) on the body, and a group of men cheerfully drinking, dancing and making music on the neck.

The composition on the body is rich and complicated (Fig 90). Herakles, on the Greek side, attacks vigorously from the left. His opponents are three Amazons. Two of them march in step, a handsome decorative formation, the third in striped, tight-fitting oriental clothing advances more stealthily, her forward foot impressively foreshortened. Between Herakles and the attacking Amazons lies a fallen Amazon. The upper part of her left leg lies along the ground, the lower part is concealed behind her thigh – a bold idea. Consider how differently the further leg of the dying warrior in the west pediment at Aegina is treated (Fig 38). To the left, another downed Amazon lies on the ground. Her body and legs are a mirror image of the central fallen Amazon, but her costume is the same as that of the Amazon

at the far right. Back to back with Herakles, his friend Telamon prepares, with sword upraised, to deliver a death blow to the fallen Amazon on the left. The scene is filled with action, large vigorous figures, dramatic foreshortenings, and complex patterns echoed, mirrored or reflected. In terms of drawing and composition, it is masterly, but as decoration on the surface of a vase it is perhaps less satisfying than the primitive figures and simple patterns that were so sensitively arranged by the geometric vase painter more than two hundred years before (Fig 3). Increasing skill in draughtsmanship was not an unmixed blessing for vase painters.

Red-figure vase painting in the early 5th century BC

The last decade of the 6th century BC, the period of Euphronios and Euthymides, was a time of bold exploration and lively experimentation. The following generation

68

By the beginning of the 5th century BC, the anatomy of figures in action had been mastered and its rendering was no longer such a challenge. New realms of feeling and design could now be investigated. The change in tone is well illustrated by comparison of Euphronios' volute krater (Fig 89) with a volute krater painted by the Berlin Painter about 490 BC (Fig 91). The shape is virtually identical, but the decoration is very different. The Berlin Painter has covered the body of the vase with black paint. He has used the lip as a field for a virtuoso display of red-figure ornament (Fig 92), while on the neck below he has portrayed an intense drama. Wide spaces separate the four figures, all of whom are labelled. The two warriors are Achilles and Hector, Achilles charging confidently from the left; Hector faltering,

91. Achilles fighting Hector in the presence of Athena and Apollo, Attic red-figure volute krater, painted by the Berlin Painter, about 490-480 BC, British Museum, London

92. Achilles fighting Hector in the presence of Athena and Apollo, detail of Fig 91

about to collapse. Athena stands to the left of Achilles, hand lifted in a gesture of support. According to Homer, she had been instrumental in inducing Hector to face the terrible Achilles. Apollo, at the far right, loved Hector and stood by him as long as he could: now he reluctantly abandons the doomed hero, looking back and threatening the victorious Achilles with an arrow which he holds, significantly, parallel to Hector's spear. Homer's verses recounting the death of Hector are among the most poignant and moving in the *Iliad*; the Berlin Painter has evoked them without literally illustrating them. He conveys something infinitely sad in the way Hector's arms stretch out helplessly on either side of him, one ineffectually grasping his spear, the other dragged down by the shield, protection no longer. The once brave body is already wounded; it is open to Achilles' fierce attack, exposed and vulnerable.

Quite another mood is embodied in the single figure that elegantly decorates a bell

93. Ganymede, Attic red-figure bell krater, painted by the Berlin Painter, about 500-490 BC, Louvre, Paris

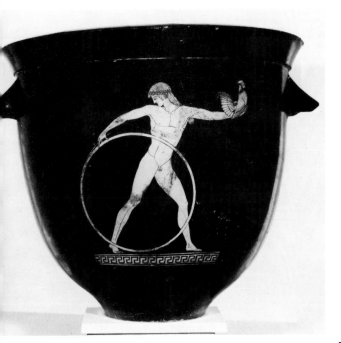

krater also painted by the Berlin Painter (Fig 93). The boy is Ganymede, beloved of Zeus. In one hand he carries a cock, a lover's gift, while with the other he rolls a hoop. (On the opposite side of the vase Zeus is shown in pursuit of the elusive lad.) Ganymede moves to the right, but looks left. The transition from feet pointing one way to head turned the other no longer presents any difficulty for the artist. The twist of the torso is rendered masterfully – and with grace. Epiktetos (Fig 83) ignored such problems, Euthymides (Fig 87) grappled with them; the Berlin Painter takes their solution for granted. He can work with confidence and need only concern himself with producing a beautiful design. In this he has succeeded splendidly. The outstretched arms and legs make an interesting pattern against the plain black ground. The whole surface of the vase is used for the picture – there is no frame, only a strip of ornament beneath the feet. The balance of light and dark, the eloquent contour, the charming contrast between the pure geometry of the hoop and the living beauty of the youthful figure are all perfectly judged.

This youth is Ganymede, but he could be any pretty boy. Red-figure artists who became entranced with problems of representation and design did not always feel the need to tell stories as so many early black-figure artists had. Scenes from daily life (e.g. Fig 87) were just as good for their purposes.

The Brygos Painter was superb at rendering everyday scenes. On a skyphos (Fig 94) he has painted two men with two courtesans apparently at the end of a drinking party – a boy with a cup is preceding them. The men walk none too steadily and grip the girls a little roughly. The girl at the left makes an expressive gesture of indignation with her left hand. Heads, hands, legs are all drawn with brilliant certainty. The drapery combines a sense for the real texture of cloth with a sure feeling for decorative pattern. It is alive with movement in response to the

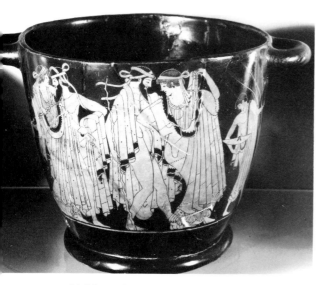

94. Men and courtesans, Attic red-figure skyphos, painted by the Brygos Painter, first quarter of the 5th century BC, Louvre, Paris

95. Satyrs prowling, Attic red-figure kylix, painted by the Brygos Painter, first quarter of the 5th century BC, British Museum, London

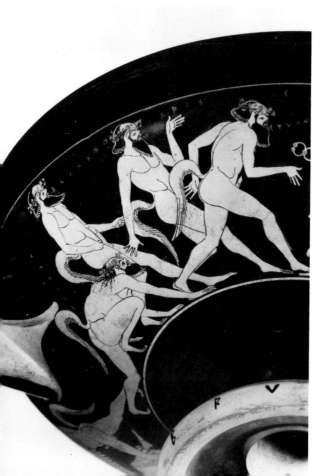

actions of the figures. The women wear thin chitons covered with woollen cloaks. Notice how the heavy cloak responds to the movement of the woman at the right who lifts one corner of it, while the light chiton swirls back at her ankles to indicate that she has not stopped but is still walking on.

The Brygos Painter was just as adept in his rendering of nudes, as his lithe, athletic satyrs show (Fig 95). Brimming with energy, with a hint of menace in their massed formation, they are crisply drawn with economy and verve.

Although examples of this quality of draughtsmanship are remarkably numerous during the first quarter of the 5th century BC, not all vase painters during this period were great masters. Some of them were little more than hacks. Fig 96 shows a group of satyrs drawn by a more ordinary artist. Such undistinguished work is competent enough, but it seems almost crude when compared with the elegance and assurance of the Brygos Painter.

The depiction of human figures in action or at rest and of the drapery that sometimes clothed them was the principal interest of Greek vase painters. Animals, flowers, fruits and vegetables, architecture, landscape, the world of nature and the works of men – all these were very definitely subordinate.

96. Satyrs playing at being athletes, Attic red-figure volute krater (neck), painted by the Nikoxenos Painter, first quarter of the 5th century BC, Staatliche Antikensammlungen und Glyptothek, Munich

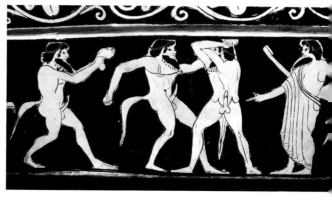

97. Maenad, from an Attic red-figure pointed amphora, painted by the Kleophrades Painter, first quarter of the 5th century BC, Staatliche Antikensammlungen und Glyptothek, Munich.

98. Maenad, from the same vase as Fig 97

The use of old themes to embody new ideas

Dionysus and his retinue were always popular subjects among vase painters. Some black-figure vase painters used this theme as a vehicle for the portrayal of cheerful action (Fig 21), others as an excuse for delightful patterns (Fig 22), but the Kleophrades Painter, working in red-figure, strove to reveal what lay beneath the external activity of his maenads (Figs 97 and 98) and to explore the way different personalities responded to the divine influence. The dark, curly-haired maenad (Fig 97) abandons herself to the emotion and lifts her head to emit a cry of frenzy, while her straight-haired companion (Fig 98) is more quietly but no less deeply moved. The poise of the head, the parting of the lips, the placement of the eye and the pupil within it are all cleverly used to convey a state of mind. Black-figure did not lend itself easily to this sort of introspection, though in the hands of an extraordinary painter like Exekias it could be coaxed into producing similar results. Red-figure, by contrast, allowed even men of lesser talent to essay the portrayal of comparatively subtle psychological states. The better artists, like the Kleophrades

Painter, were able to obtain powerful and moving effects.

Mythological illustrations served as good vehicles to convey new ideas and new depths of feeling, for even quite small changes in conventional scenes can catch the eye and engage the mind. The Kleophrades Painter understood this well when he painted the Sack of Troy on the shoulder of a hydria during the early years of the 5th century BC (Figs 99 and 100).

In the centre the old king, Priam, sits on the altar that should have assured him divine protection (Fig 100). This is how he was shown in the left-hand corner of the Corfu pediment (Figs 32 and 33), but there his image was little more than a symbol of the doomed city. On the vase, Priam holds his hands to his head in a touching gesture of despair. His head has been cut and is bleeding; the battered and gashed body of his grandson lies sprawled in his lap. A young warrior puts his hand on the old king's shoulder, not to comfort him, but to steady him before brutally delivering the fatal blow. To the left (Fig 99) Cassandra, daughter of Priam, nude except for a cloak knotted at her throat, clings to a statue of Athena, to no avail. She extends her right hand in supplication, but a bearded warrior, unheeding, grasps her callously by the hair and threatens her with his sword. Dead Trojans litter the ground, pathetic

72

99. The Fall of Troy, Attic red-figure hydria
(shoulder), painted by the Kleophrades Painter, first
quarter of the 5th century BC, Museo Nazionale,
Naples

100. The Fall of Troy, from the same vase as Fig 99

women crouch in the sanctuary beating their heads and an unarmed woman attacks a Greek soldier with a household implement. Only at the far left (Fig 99) is there a ray of hope as Aeneas, carrying his aged father on his back and guiding his little son, escapes from the fallen city. Otherwise there is nothing but brutal, pointless destruction, the suffering of non-combatant old men, women and children, and the wasted youth of gallant warriors killed while defending their homes. It is a heartfelt indictment of war.

The Kleophrades Painter had ample opportunity to consider the message of his picture, for the first Persian attack on Athens took place in 490 BC. It was beaten back at Marathon. Ten years later the Persians came again. Massively equipped this time, they proved irresistible. The city was sacked. Most of the Athenians had been evacuated, women and children and very old men had been sent to safety in the Peloponnese; fighting men had mustered off the coast on the island of Salamis. They played an important role in the naval battle in the bay and helped to rout the Persians from the sea. But part of the Persian army still remained on land, and before they were finally defeated at Plataea, the Persians ravaged Athens once again in 479 BC.

In later times the Persian wars came to be remembered as a glorious Greek triumph, but while the war was in progress, the Greeks knew all its horrors. Vase painters had recently acquired the skills that allowed them to portray a world of feeling that had never before been accessible to the visual arts. They could now transform their experiences into images and present a new, deeper, richer and more moving vision of humanity.

6

Early Classical Sculpture

The kouros at the end of the archaic period

The kouros that was placed on the grave of Aristodikos (Figs 58 and 64) was both a triumph and a failure. Its anatomy was so perfect that it could hardly be distinguished from that of a real man, but its pose was so stiff that it could not possibly be mistaken for a living person.

When the kouros type was first invented in the late 7th century BC, it was a magnificent creation. The legs, parted as though in mid-stride, suggested the potential of movement – something between walking and standing, while the evenly distributed weight preserved the decorative symmetry of the figure. The archaic smile, introduced early in the 6th century BC, brightened the face and enhanced the impression of vitality.

In the course of the 6th century BC, sculptors gradually modified the proportions and refined the surface details so that kouroi became increasingly naturalistic in appearance. But as the statues began to look more like real men, artists were forced to notice that what had originally been the advantages of the kouros scheme were rapidly turning into disadvantages: the stance, representing neither clear action nor unambiguous stillness, made the figure look awkward, the calculated symmetry made it appear unnatural and the smile, lacking in motivation, made it seem mindless.

To overcome these problems sculptors would have to alter the pose, negate the symmetry and eradicate the smile. Such changes presented difficulties – some of them grave – for sculptors of marble. For bronze-casters it was different.

Bronze casting

A marble sculptor created his statue by the process of chipping away at the stone, guided by the drawings on the four sides of the block (Fig 40). These had to be carefully planned and co-ordinated, and though systematic modifications were possible, radical changes were not. The artist was further inhibited by the fact that marble has very little tensile strength and easily cracks if not adequately supported from below. Marble sculptors therefore had to be cautious about the poses they used and careful not to cut limbs entirely free from the body or extend them very far into space for fear that they would break under their own weight. Thus neither the method nor the material encouraged experimentation.

A sculptor creating a bronze statue, by contrast, began by building up a model in clay (Fig 101a). Walking round his model, removing a little clay here, adding a little there, he could quickly and inexpensively try out new effects in a way that would have been impossible for an artist working in marble. He could also explore a far freer arrangement of arms and legs within a much wider range of poses, for the great tensile strength of bronze meant that the whole figure could rest securely on very slight supports, and the limbs could safely be shown well separated from the body.

When the bronze sculptor had completed

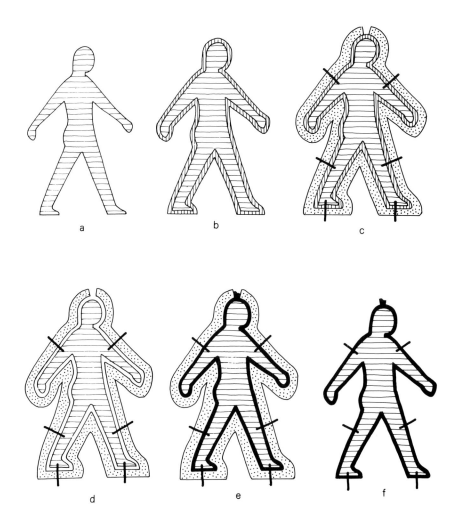

101. Diagram showing the process used for casting bronze statues by means of the 'lost wax' method: (a) model made in clay; (b) clay model evenly coated with wax; (c) wax-covered model encased in a mould; (d) wax melted out leaving a gap between the clay model and the mould; (e) molten bronze poured into the gap between the clay model and the mould; (f) mould removed to reveal the bronze statue

the clay model to his satisfaction, he covered it with a thin, even coating of wax (Fig 101b). The outer surface of the wax showed what the finished bronze would look like. Next the artist encased the wax-covered model in a mould (Fig 101c). The mould, which was made chiefly of clay, had to be flexible enough to follow the contours of the wax exactly and also thick and strong enough to withstand the heat and pressure of molten metal. The mould was held securely in place by metal rods that ran through to the clay core of the statue. Then the wax was melted out, leaving a gap between the clay model and the outer mould (Fig 101d), and molten bronze (an alloy of copper and tin) was poured in to fill the space originally occupied by the wax (Fig 101e). When the bronze had cooled and solidified, the mould was removed and the completed statue (Fig 101f) inspected. Faults were

76

then corrected, holes plugged, details sharpened with the help of a chisel, and the whole figure was smoothed and finished.

This method, known as the 'lost wax' process, enabled sculptors to make hollow-cast statues on a large scale. Because both the material and the process of casting were very expensive – far more so than making statues in marble – figures were not usually cast in a single piece, but in several. Thus if the casting of one part were to go wrong, all would not be lost. At the end the separate pieces would be assembled and put together so carefully that the joins would become virtually invisible. This procedure required additional steps, but was well worth the trouble.

By the third quarter of the 6th century BC, the Greeks had become so accomplished in the use of this technique that they could successfully cast monumental statues like the over-life-size Apollo that was found in the Piraeus in 1959 (Fig 102). Though in general the figure looks much like any normal kouros of about 530-520 BC, it is clear that the artist has begun to exploit the new freedom that the material allowed him: the arms are separated from the body and extended unsupported in a position that would not have been possible in marble. (The left hand originally held a bow and the right, another attribute to identify the god.) The feet were simply attached to the base by fastenings through their soles; there was no need for a plinth.

By the beginning of the 5th century BC the time was ripe for the creation of a revolutionary new type of statue. It seems probable that some bold bronze-caster now produced a figure of a youth that did not stand rigidly to attention like a traditional kouros, but instead stood comfortably at ease, head turned to one side. Bronze in colour, like the sun-tanned young men of Greece, such a statue might actually have looked to a casual observer of the time more like a visitor to the sculptor's studio than a product of it.

Marble sculptors must have flocked to

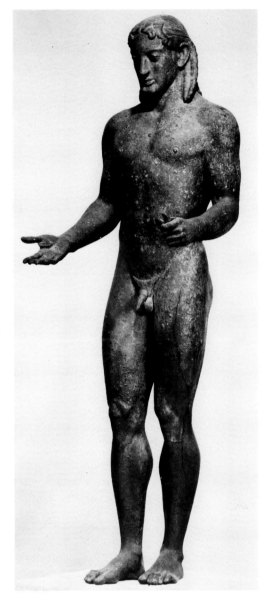

102. Apollo, bronze statue found in the Piraeus, second half of the 6th century BC, National Archaeological Museum, Athens

marvel at such an extraordinary image. Dissatisfied with their kouroi that became ever more unnaturally stiff with each additional naturalistic refinement, inspired (we must suppose) by the illusion of life captured in the new relaxed pose of the

77

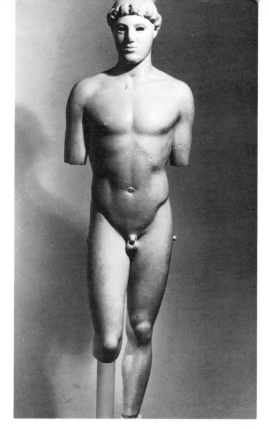

103. Kritios Boy, first quarter of the 5th century BC, Acropolis Museum, Athens

104. Kritios Boy, left side of Fig 103

bronze statue, some of them decided to try to produce the same effect.

Marble statues come to life

The so-called 'Kritios Boy' (Fig 103) reveals what such a marble statue looked like. The details of the anatomy show little advance over the Aristodikos (Fig 58) and the changes in the pose are small – the weight shifted decisively onto the back leg and the head turned slightly in the opposite direction – but the difference in effect is dramatic. Gone are the mechanical smile, the rigid stance and the formal symmetry: the statue has come to life.

The technical daring is impressive. For over a century the drawings that marble sculptors made on their blocks had consistently been modified in the direction of greater naturalism, but had remained fundamentally unchanged (see Figs 44, 52-54, and 58 for front views, 47 and 64 for side views, and 51 and 57 for back views). For the Kritios Boy, four entirely new and

105. Kritios Boy, right side of Fig 103

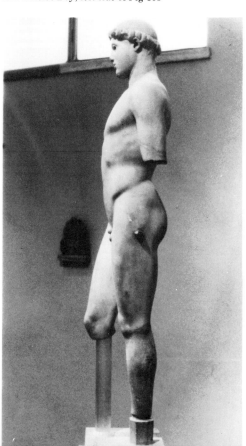

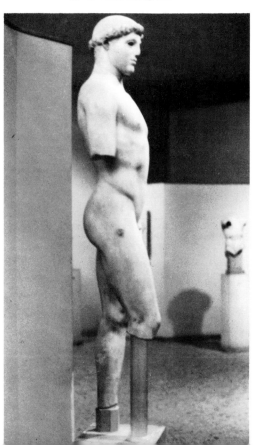

rather awkwardly foreshortened drawings had to be made to correspond to the four views (Figs 103-106). A bronze statue could, of course, have been used to provide guidance, and that would have been a help. The treatment of the Kritios Boy's hair and eyes (Fig 107) strongly suggests that the sculptor had been looking hard at a work in bronze. The hair is mostly indicated by sharp but shallowly incised lines – notice especially the wisps on the neck. This is the way hair was represented on bronze statues (cf. Fig 120), since even a scratch shows up clearly on a shiny, otherwise smooth surface. Marble does not reflect light like bronze, but absorbs it; hair on marble statues therefore is usually carved more deeply so that it will throw a shadow (Figs 55 and 56). The eyes of the Kritios Boy were made separately and inserted into the sockets. This again was a procedure normally used for bronze statues (see Figs 115 and 120); the coloured parts of the eyes of marble statues were usually just painted on the stone (Fig 55).

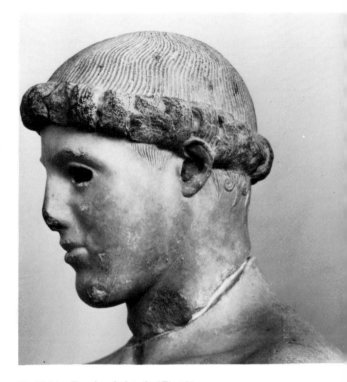

107. Kritios Boy, head, detail of Fig 103

106. Kritios Boy, back of Fig 103

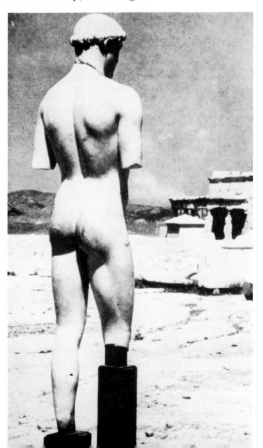

The body of the Kritios Boy is carved with great delicacy and the tenderness of youth is well conveyed by the sensitive modelling of the forms. It is an unusual and extremely fine work, but it was not unique at the time. Other enterprising marble sculptors also tried their hands at figures standing in the new relaxed, asymmetrical pose. The so-called Blond Head (Figs 108 and 109), which was evidently set at an angle on its neck, must have belonged to a similar statue, a fact that is confirmed by a fragment of its pelvis which shows that one hip was higher than the other. The grave and beautiful features of the reflective face demonstrate how accomplished sculptors had become in their ability to convey a sense of intelligent life without resorting to such obvious devices as the archaic smile.

Even though the sculptors were bold and inventive, new poses could be explored in marble only with difficulty. In bronze, however, they could be developed freely.

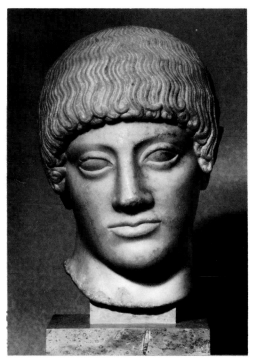

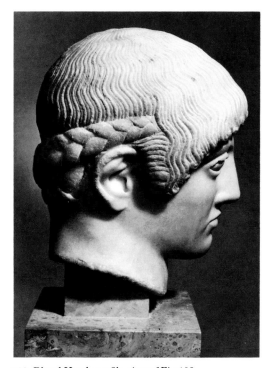

108. Blond Head, first quarter of the 5th century BC, Acropolis Museum, Athens

109. Blond Head, profile view of Fig 108

Bronze, therefore, became the preferred material of the most gifted and creative sculptors, just as the red-figure technique with its greater flexibility and expressive possibilities had come to be favoured by the finest vase painters.

The Persian sack of Athens and its aftermath

When they sacked Athens in 480 BC and again in the following year, the Persians burned, smashed or carried off whatever they could. The broken remains of the Blond Head and the Kritios Boy were found amid Persian debris, and where bronze statues had been removed only the bases were left behind. One base in the Agora, the market-place of Athens, showed by the way the feet had been attached that the statue it had supported had stood in the new, relaxed pose. It, or one like it, had probably provided the inspiration for the

stance of the Kritios Boy (Figs 103-106).

After the final defeat of the Persians at Plataea in 479 BC, the Athenians returned triumphant to their devastated city. It must have been a depressing sight, for the Persian destruction had been thorough-going. The Athenians could have started their work of reconstruction almost anywhere, but practically the first thing they did was to commission replacements for the vanished statues of the Tyrannicides, a surprising priority deserving closer examination.

The Tyrannicides, Harmodios and Aristogeiton, in the year 514 BC, had conspired to kill the tyrant of Athens, Hippias. The scheme had misfired; only the tyrant's brother was slain and another four years had to pass before Hippias was finally expelled. Nevertheless the Athenians felt that the two men who had died while trying to destroy the tyranny had struck the first blow for the democracy that

the Athenians now so highly prized. A pair of statues had been erected to honour Harmodios and Aristogeiton in the Agora some time before the Persian sack of the city and this memorial had been carried off by the Persians.

By 477/6 BC the replacement statues had been completed. A picture of them was used to decorate the shield of Athena on a later Panathenaic vase (Fig 110) and from the open, freely extended poses one can see that the statues were made of bronze.

Bronze is, unfortunately, easily destroyed in accidental fires or sometimes intentionally melted down so that the valuable material can be reused. Consequently very few bronze statues have survived from antiquity to our time. The Tyrannicides are no exception: the original bronze statues of 477/6 have long since perished.

We would have little idea of what these and many other famous statues looked like were it not for the fact that the Romans were great admirers of Greek art and made

110. The Tyrannicides, bronze group made by Kritios and Nesiotes in 477/6 BC, here represented on the shield of Athena painted on a 4th century BC Attic black-figure Panathenaic amphora, British Museum, London

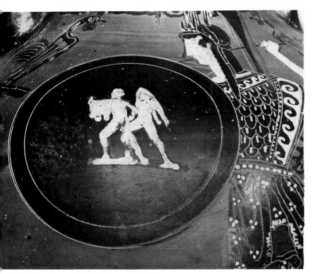

copies of celebrated works. Roman copies were usually made of marble which was far less expensive than bronze, but lacked its tensile strength. The change in material required copyists to introduce additional supports to help hold up the top-heavy mass of stone and prevent it from breaking at the ankles. They tried to keep these structural props unobtrusive; they placed them in inconspicuous positions and tried to give them some sort of naturalistic justification. Thus they would often disguise the unsightly support that was used to strengthen the back of a leg as a tree trunk which, when painted the appropriate colour, would not be confused with the living forms of the body. While the paint was still intact such tree trunks could easily be visually discounted. The struts and supports that now seem so disturbing to us must have been much less distracting when the copies were new.

The copies made by the Romans vary in their quality; some are very good, but most convey little sense of any fine finish that the originals might have possessed. Nevertheless they are invaluable because they can give us clues to the form and composition of works which otherwise might be no more than names to us.

Combining the information we have from the Panathenaic vase (Fig 110) with what we can learn from Roman copies (Figs 111-113), we can gain some idea of what the statues of the Tyrannicides were like. The two bronze-casters, Kritios and Nesiotes, who had been commissioned to make the new group of the Tyrannicides had no idea how the real men, who had died nearly forty years before, had looked, but they knew something about them. They knew that Harmodios had been little more than a youth and had been killed in the course of the attack, while Aristogeiton was already a mature man and had been captured alive. On these meagre facts they built their characterisations of the two men.

Harmodios (to the right), young and impetuous, is shown striding vigorously

Aristogeiton is older and more wary. He drapes his cloak over his arm and holds it before him for protection (it would have been effective in entangling any weapons directed at him). He moves forward with resolution, but holds his sword low, watching for his opportunity.

The differences in personality, temperament and fate were all captured and conveyed in the very conception of the two figures.

The distinctions between them were further refined in the details. Harmodios, beardless and eager, was portrayed with boyish forms (imagine the statue executed with the sensitivity and delicacy that we see in the Kritios Boy (Figs 103-106). The bearded Aristogeiton, clearly an older man, has a firm muscular body. Compare too the faces: the youthful impetuosity of Harmodios (Fig 112) as opposed to the mature caution of Aristogeiton (Fig 113).

Most Roman copies were made by sculptors using plaster casts made from

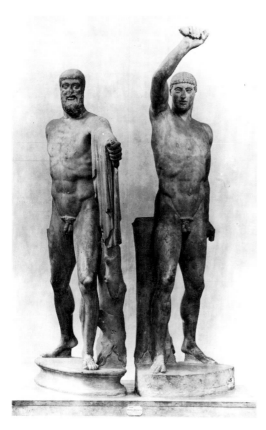

111. The Tyrannicides, Roman copy in marble (see Fig 110), Museo Nazionale, Naples

forward, his sword upraised in preparation for an irresistible chopping blow. The lower part of his right arm is wrongly restored on the Roman copy (Fig 111); it should be bent back over his head, as can be seen in the drawing on the vase (Fig 110). This sort of blow is appropriately used as a *coup de grâce* to finish off a disabled enemy – it is used that way by Herakles' left-hand companion in Fig 90. To attack a still active opponent in this manner is rash, since the whole body of the assailant is left undefended. What brilliant inspiration to characterise the man so unmistakably by his choice of action! Harmodios is all boldness and daring, his whole being focused on the object of his attack with never a thought for his own safety.

112. Roman copy of the head of Harmodios, detail of Fig 111

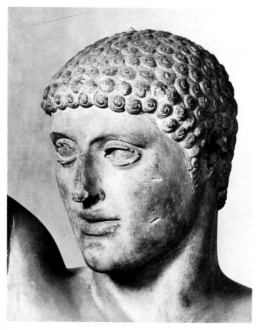

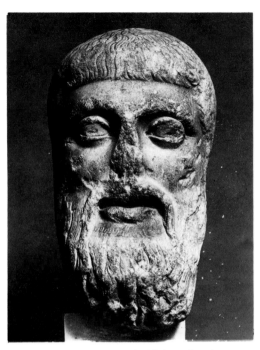

113. Roman copy of the head of Aristogeiton (see Figs 110 and 111), Musei Vaticani, Rome

114. Plaster cast of the head of Aristogeiton, probably made from the original bronze by Kritios and Nesiotes (see Fig 110), from a Roman copyist's workshop in Baiae, Baiae Museum, Baiae

moulds taken from the original bronze statues. Fragments of such casts have been found at Baiae, and among them part of a cast of the head of Aristogeiton (Fig 114). Though the plaster has been damaged and broken, it nevertheless brings us a step closer to the original than the Roman copies on which we have to base most of our ideas. From the Baiae cast we can see how the subtle curve of the cheek contrasts with the crisp, sharp lines defining the eyes, lips and nostril and appreciate the fine rendering of the soft fold of flesh above the wrinkle at the corner of the eye. It enables us to gauge better how much we have lost with the disappearance of the original.

In the group of the Tyrannicides the technical achievements of preceding generations are employed to convey inner life and character in a way never before seen in sculpture. There was a certain sameness about all the kouroi; all were fresh, vigorous and outgoing. The Tyrannicides, by contrast, are carefully differentiated. They are representations of specific ages and personalities. During the archaic period artists had concentrated on the portrayal of the form of the body. In the 5th century BC they began to set themselves new problems; they now sought to reveal the mind within the body, the intention that determines the action.

The development of new poses

The pose of a kouros could be interpreted as something between standing and walking, a suggestion of potential movement within a stable configuration. As representations became more naturalistic, such ambiguities – once so evocative – began to be disturbing. Thus the sculptor of the Kritios Boy (Figs 103-106) made a definite commitment to repose, while Kritios and Nesiotes in their portrayal of the Tyrannicides (Figs 110 and 111) made a definite commitment to action. Depiction of the polarities of movement and rest now became intensely interesting for sculptors.

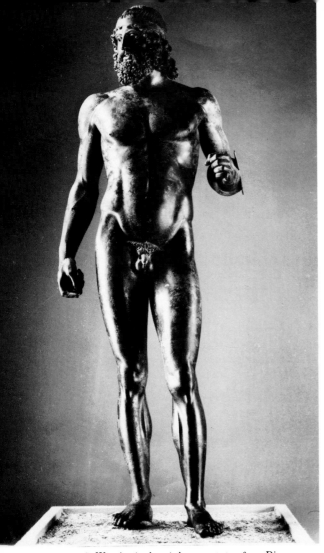

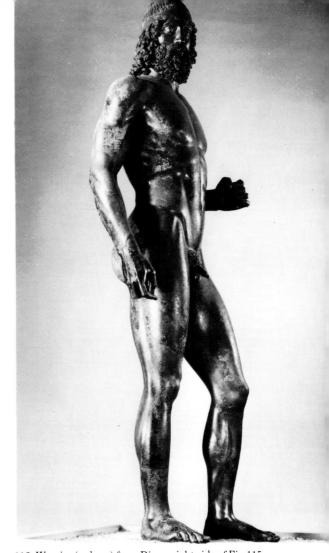

115. Warrior (or hero), bronze statue from Riace, second quarter of the 5th century BC, Reggio Museum, Reggio

116. Warrior (or hero) from Riace, right side of Fig 115

Figures at rest

A kouros, however perfect in detail, always retained something of the mechanical quality of an automaton, whereas the newly invented figures in repose (Figs 103-106) convey the impression of self-possessed human beings. This remarkable effect was achieved by means of two small but essential modifications of the pose – the turn of the head and the shift of the weight onto the back leg, with the consequent raising of the hip on that side

(Fig 103). By such simple measures, the symmetry and frontality of the kouros were destroyed, and the illusion of freedom was introduced.

During the second quarter of the 5th century BC, the new formula was further developed and refined. Thus the warrior in Fig 115, one of two bronze originals of this period found in the sea off the coast of Riace in Southern Italy, stands with his weight on his right leg; his left, slightly bent, is placed a little in front of him. He grasped a shield (now lost) on his left arm; his right arm is held by his side. Although his hips respond to the displacement of the

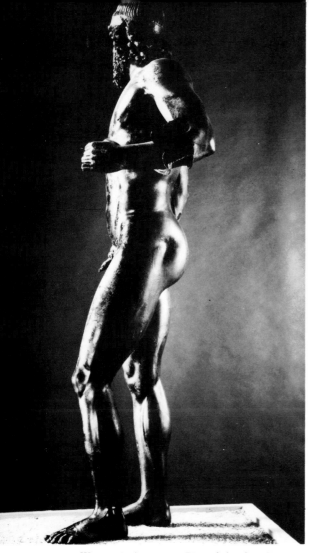

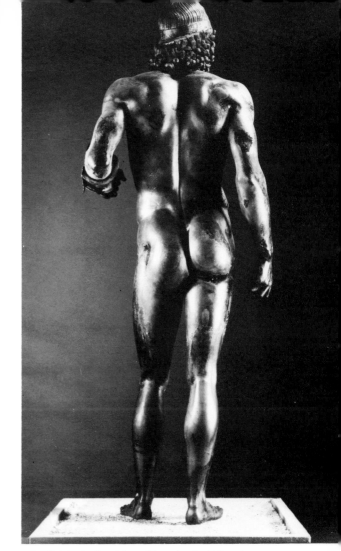

117. Warrior (or hero) from Riace, left side of Fig 115

118. Warrior (or hero) from Riace, back of Fig 115

weight onto one leg – his right hip being markedly higher than his left – his upper body is largely unresponsive to the different degrees of tension in the two arms. The alert turn of the head, however, counteracts any impression of static immobility. The figure may be still, but it is alive with potential energy.

The rejection of the symmetry of the kouros is no longer haphazard but calculated. Bent leg and flexed arm on one side contrast with the straight limbs on the other. Each of the side views (Figs 116 and 117) has acquired a character of its own. The right side (Fig 116) is animated by the

turn of the head and the tense vitality suggested by the arched back and muscular arm that curve in opposite directions above the straight vertical of the supporting leg. The angled limbs lend interest to the left side (Fig 117); originally it must have been further enlivened by the bold and decorative blazon picked out in contrasting colours that would have adorned the shield carried on the left arm. The back (Fig 118) shows how much grace and liveliness small changes in the pose can impart to the figure (contrast Figs 51 and 57), for despite the virtual horizontality of the shoulders, something like an

85

'S' curve runs through the body. The tilt of the buttocks and the turn of the head are powerful devices to give the figure a sense of autonomous life and to create a design with a different kind of beauty from that employed for the kouroi.

The bronze is dramatic and striking. From drab Roman copies it would have been hard to imagine the impact of the intense face, inlaid eyes still partly shaded by bronze eyelashes, red lips of copper slightly parted to show silver teeth. The hair on top of the head is incised with sharp strokes of the chisel, but the full ringlets that escape beneath the head-band and the curls of the beard were actually cast separately and then attached to the head.

Quite another impression is conveyed by the restrained image of a charioteer (Figs 119 and 120), also a bronze original from this period. The Charioteer is the chief surviving portion of a group of which the most important part was probably the horses. We know from an inscription that it was dedicated to Apollo at Delphi by a Sicilian tyrant probably in 474 BC. The Charioteer's introvert, reflective expression is very different from the thoughtless exuberance of the kouroi barely a generation before. His pose, like those of the Kritios Boy (Fig 103) and the Riace bronze (Fig 115), is full of easy asymmetries. The feet, placed at an angle to each other, point to the front, the upper body turns slightly to our left and the head turns even more markedly, so that the whole figure forms a gentle spiral. The long, unbroken fall of the folds is perhaps somewhat exaggerated, as the Charioteer was not intended to be seen in isolation but as part of the group, and his skirt would have been visually cut across by the rails of the chariot.

Draped figures

The Charioteer is an example of a draped male figure; the draped figures we have looked at before were all female (Figs 65-69, 72). During the archaic period, drapery was much prized for the decorative

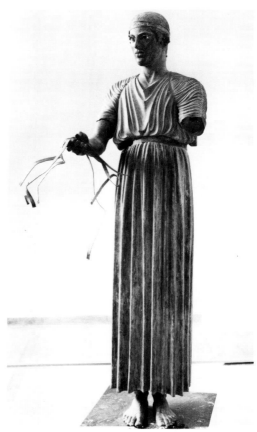

119. Charioteer, bronze statue, part of a chariot group, 480-70 BC, Delphi Museum, Delphi

120. Charioteer, head, detail of Fig 119

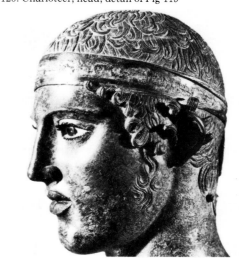

effects it could produce. In the early classical period there was a reaction away from this, and drapery became simpler and more natural. Repetitive patterns were avoided and care was taken to vary adjacent folds in their width, depth and, if possible, direction (Figs 119 and 121).

Around the time of the Persian wars, the peplos (Figs 72 and 73) came back into fashion for female figures. A small bronze statuette of a woman wearing a peplos (Fig 121) which was made in the second quarter of the 5th century BC and used as a support for an incense burner illustrates the qualities that were now gaining value. The pose is suited to the function of the figure but nevertheless looks easy and free. Although the arms are raised symmetrically, the head is turned and gently inclined. The peplos falls in sparse, deep folds, so massive and simple that even the drapery of the Charioteer (Fig 119) looks fussy by comparison.

The body is almost entirely concealed within the heavy clothing, but its position is made perfectly clear. The woman stands with her weight on her back leg, and the drapery on that side falls in straight, unbroken folds. On the other side, the knee of her relaxed left leg protrudes to make the cloth smooth and foldless. The discovery that even so slight a displacement of drapery is enough to indicate the underlying presence of a living body standing quietly at ease must have pleased artists, and for centuries to come they continued to make use of the formula that was invented at this time.

The advances in naturalism are quickly apparent when this austerely graceful figure is compared with the Peplos kore (Fig 72) or the Berlin goddess (Fig 66). The relaxed stance and the plausible fall of the woollen cloth in Fig 121 make the earlier figures seem rigid in pose, with drapery manipulated into a contrived pattern. Even more remarkable is the way that the statuette, despite its severe design, is infused with a sense of spiritual life.

Sculptors of the early classical period

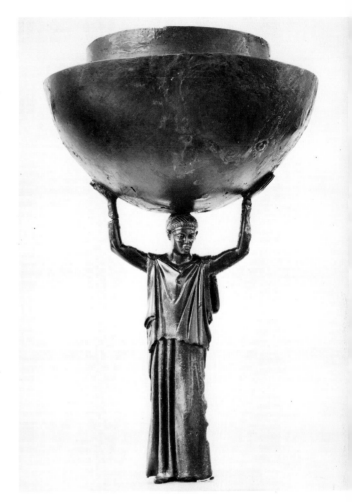

121. Female figure supporting an incense burner, bronze statuette, second quarter of the 5th century BC, Delphi Museum, Delphi

were particularly concerned to demonstrate that external appearances are the result of internal motivations, that the fall of drapery is determined by the position of the body and the position of the body is controlled by an intelligent mind.

Such simple devices as turning the head to one side or displacing the weight onto one leg were often enough to transform mechanical-looking archaic statues into the seemingly self-determined figures of the early classical period. Once they had been mastered, free-standing statues at

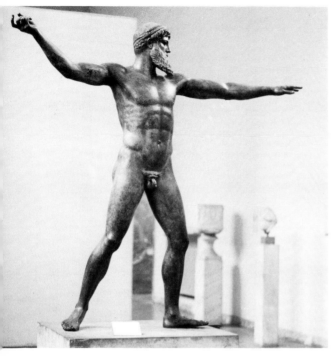

122. Zeus (or Poseidon) found in the sea off Cape Artemisium, bronze statue, second quarter of the 5th century BC, National Archaeological Museum, Athens

123. Zeus (or Poseidon), side view of Fig 122

rest – whether draped or nude – presented artists with few problems. Figures in action were rather different.

Figures in action

The bronze-casters Kritios and Nesiotes broke new ground in their creation of a pair of free-standing statues represented as if actually advancing to attack (Figs 110 and 111). The idea of depicting a large-scale figure visible from all sides in the midst of vigorous action was developed further in the second quarter of the 5th century BC in the magnificent bronze statue of Zeus (or Poseidon) which was found in the sea off Cape Artemisium (Fig 122). The god is shown in the very act of hurling a thunderbolt (if he is Zeus) or a trident (if he is Poseidon) at an unseen enemy.

The artist has succeeded in producing a vivid and convincing figure through cleverly varying the position of the limbs – contrasting straight arm with bent, weight-bearing leg with free – and astutely exploiting the suggestive power of an eloquent contour. But his success was not total.

We have already seen how difficult it is to reconcile innovations with established conventions and noticed that unexpected problems sometimes arise as by-products of new and positive achievements. This has happened with the Zeus of Artemisium. A novel sense of movement has been brilliantly captured in a single free-standing statue, but at the same time two new problems have emerged, neither of which is solved.

First, though the torso should be dramatically affected by the activity of the limbs, it is as still as it would have been in a quietly standing figure like the Kritios Boy (Fig 103) or the warrior from Riace (Fig 115).

Second, though the Zeus of Artemisium

is splendid from the front and back, it is difficult to understand from the sides (Fig 123), which was not the case with the Kritios Boy (Figs 104 and 105) or the Riace warrior (Figs 116 and 117) or even the kouroi (Figs 47, 49 and 64).

These defects probably took the artist by surprise. He may well have felt confident about his mastery of the rendering of anatomy since the work of generations of sculptors had practically perfected the representation of the male nude, and he would not have doubted his ability to depict a figure in action, for this had become a commonplace by now in the decoration of pediments. It may have been a shock to discover that *active figures* required new anatomical explorations and *figures in the round* could not simply rely on an expressive contour as could pedimental figures that are seen from one side only.

Recognising such problems was one thing; solving them another.

One statue made at about the same time was immensely celebrated. This was the Discus-thrower by Myron. It was highly praised by ancient writers (see p. 169) and frequently copied for Roman admirers. Though the original bronze is lost, and with it the immediacy of the master's finish, from the Roman copies we can at least gain some impression of what it looked like (Fig 124).

Myron's choice of the moment to be represented was a stroke of genius: an instant of stillness in the midst of action, the split-second pause between back swing and forward thrust. The suggestion of potential movement is so strong that the figure seems permeated with energy.

But while the illusion of reality was one of Myron's aims, it was not the only one. Like all Greek artists, he was also concerned to produce a work of beauty. During the archaic period beauty was thought to reside in symmetrical organisation and the repetition of forms. These principles were now out of fashion; in fact, they were systematically negated in the design of the Discus-thrower. Notice how consistently both symmetry and repetition are avoided. The right side of the statue is

124. Discus-thrower (Diskobolos) by Myron, Roman copy in marble of a bronze original of the second quarter of the 5th century BC, Museo Nazionale delle Terme, Rome

125. Analysis of the composition of the Discus-thrower (Fig 124)

dominated by the sweep of a continuous, almost unbroken curve, the left by a jagged zig-zag composed of straight lines (Fig 125). Myron has brought to his new aesthetic ideal the refinement of a mathematical proposition: curved versus straight, smooth versus angular, closed versus open.

The simplicity of the basic design, the great arc on one side and the four lines meeting almost at right angles on the other, imposes harmony on the agitated figure. At the same time formal abstraction is combined with maximum representational clarity: the chest is seen from the front and the legs from the side, so that the most characteristic features of each are presented simultaneously. The elegance and lucidity of the front view, even as it is reflected in a Roman copy (Fig 124), remain impressive.

But the problems we saw in the Zeus of Artemisium, which arose from the effort to show a free-standing statue in action, have not been solved. The torso itself is realistic in detail as a study of static anatomy, but shows virtually no response to the violent action of the limbs. The side view (Fig 126), lacking any intelligible contour and presenting both chest and legs from their least characteristic angles, is a muddle of confused shapes.

Sculptors who had begun to explore difficult new poses discovered that their experiments were not always successful.

126. Discus-thrower, side view of Fig 124

Nevertheless the new problems that emerged from their innovations stimulated artists in the succeeding period to formulate what came to be regarded as classic solutions.

7

Early Classical Architectural Sculpture: The Temple of Zeus at Olympia

The flowering of the early classical revolution

The extraordinary achievements of the sculptors of the early classical period, their ability to reveal different kinds of characters and personalities, their skill in depicting figures standing quietly at ease or portraying them vigorously in action, their mastery of drapery that both conceals the body and reveals its pose – all these achievements were powerfully exploited by the designers of the architectural sculpture that decorated the temple of Zeus at Olympia between 465 and 457 BC.

The east pediment

The portrayal of violent conflict had provided a highly satisfactory solution to the problem of filling a sloping pediment with a story enacted by figures conceived of on a single scale (see Figs 36 and 37). Daringly, the designer of the east pediment at Olympia rejected this solution; instead he created an intense scene, but one wholly without action (Fig 127). The success of his design is due to his remarkably original and imaginative evocation of the myth selected.

Oinomaos, legendary king of Pisa near Olympia, was reluctant to let his daughter wed, but nevertheless allowed suitors to compete for her hand. He challenged each aspiring bridegroom to carry the girl off in his chariot and race for the isthmus of Corinth. Oinomaos himself proposed first to sacrifice to Zeus and then set out in pursuit of the couple. If he overtook them before they reached their destination, he would kill the suitor. Since Oinomaos' horses were as swift as the wind, the suitors had little hope, and as one after another failed, Oinomaos decorated the entrance to his palace with their severed heads. Twelve or thirteen had perished thus when Pelops arrived to try his luck.

There are at least two versions of what happened next. According to the poet Pindar, Pelops asked the god Poseidon to provide him with horses faster than those of Oinomaos, and with this divine assistance was able to win the race, the girl and the kingdom. A more popular version of the story is less edifying. This suggested that Pelops bribed Oinomaos' charioteer, Myrtilos, to tamper with the king's chariot so that as the vehicle speeded up, the wheels would fall off. For this act of treachery Myrtilos was to be rewarded with part of the kingdom or a night with the princess, whom he loved. As Oinomaos crashed from the careening chariot to his death, he cursed the perfidious charioteer and prophesied that he would meet his end at the hands of Pelops.

Pelops, once victorious, began to regret his arrangement with the charioteer and became reluctant to share either his bride or his kingdom. Another murder seemed preferable. But before he died, Myrtilos had just time enough to hurl a curse at Pelops and his descendants. This dreadful curse worked itself out over the generations in a bloody feud that turned Pelops' two sons Atreus and Thyestes against one

91

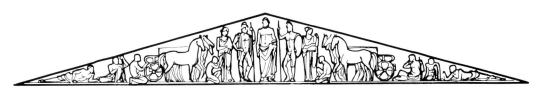

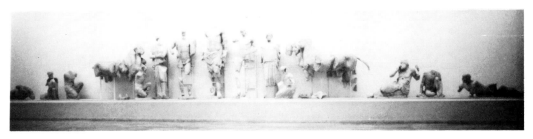

127. Preparations for the race between Pelops and
Oinomaos, east pediment of the temple of Zeus at
Olympia, second quarter of the 5th century BC,
Olympia Museum, Olympia

another, and their respective sons
Agamemnon and Aegisthus into bitter
enemies.

The sculptor of the east pediment has
chosen not to show the climactic race itself,
but the tense moment before it has begun
(Fig 127). Oinomaos stands slightly to the
left of the centre of the pediment (Fig 128),
hand confidently placed on his hip (Fig
129). He is speaking, explaining the
conditions of the race. Pelops, slightly to
the right, head modestly bowed, listens
(Fig 130). Between the two, unseen by the
contestants, stands Zeus (Figs 127 and
128), his commanding presence towering
over the mortals, his authority determining

their fate. The prospective bride stands to
the right of Pelops, adjusting her veil;
Oinomaos' wife, her arms anxiously folded
before her, stands to the left of her husband
(Fig 128). Both women wear simple peploi
with few folds which, nevertheless, clearly
reveal their stance. The principal figures
are flanked by the two chariots, horses'
heads turned toward the centre; servants in
attendance sit or kneel in front of or behind
the horses. Gods representing the two
rivers that flowed past Olympia recline in
the corners, locating the event in space,
raising their heads to observe what will
take place between them.

The design of the whole (Fig 127) has
been beautifully calculated. Five figures
occupy the centre (Fig 128). A god,
superhuman and therefore taller than mere
mortals, is in the middle; he is flanked by
heroes, who are in turn flanked by women.
The arrangement devised by the sculptor

128. Central section of Fig 127

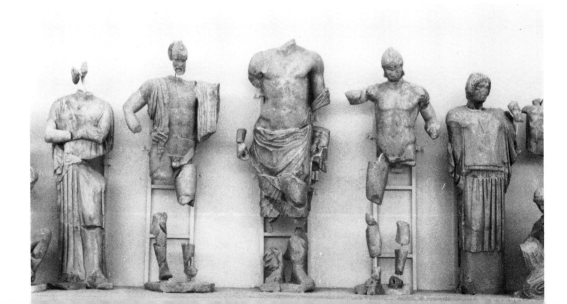

of the pediment of the Siphnian Treasury (Fig 35) has been adopted and improved. The conceptual organisation of the centre of the Siphnian pediment had begun to break down with the woman to the right of Herakles; here it is thoroughly unified by the story that binds *all* the figures together. The horses on the pediment of the Siphnian Treasury were unrelated to the myth illustrated in the centre; here, the chariots are essential to the story. The horses are arranged so as to conform to the slope of the pediment in a seemingly natural way; the area behind the chariots is easily filled by household retainers seated

or kneeling on the ground, while the river gods in the corners lend geographical precision to the scene. The arrangement of the figures appears to be dictated as much by the needs of the story as by the physical confines of the frame, and the narrative is unimpaired by the restrictions of the setting.

Although physically isolated, the figures in the pediment are psychologically closely bound together: the impending contest unites them. Oinomaos is speaking; he alone is active (Fig 129). The others respond, each according to temperament and degree of emotional involvement.

129. Oinomaos, detail of Fig 127

130. Pelops, detail of Fig 127

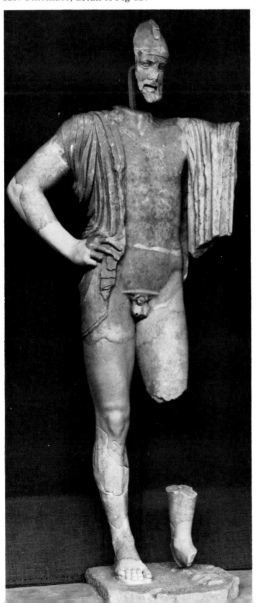

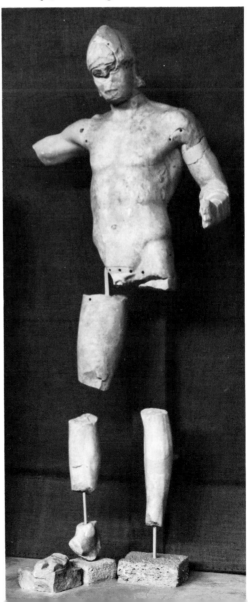

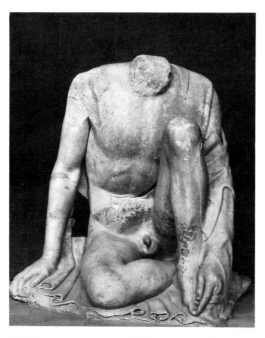

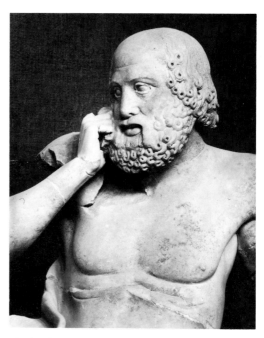

131. Servant boy playing with his toes, detail of Fig 127

132. Anxious seer, detail of Fig 127

Pelops (Fig 130) is withdrawn, listening attentively. The bride beside him looks up and out, her openness opposed to his inwardness. On the other side, Oinomaos' wife, closed in on herself – her chin would have rested on her hand – serves as a foil to her aggressive, assured husband. Contrasts of openness and withdrawal are played off between the two men and between the two women and even within each couple – but all four are intent on what is to come (Fig 128). The intensity of their involvement is accentuated by the indifference of their servants, the girl crouching at her mistress' feet (Fig 127), or the boy seated on the ground furthest from the centre, bored, idly playing with his toes to pass the time (Fig 131).

Very different in mood is the seer beside him (Fig 132). This attendant on the king seems to look past the principal figures' immediate concerns into the bleak future filled with disasters for both victor and vanquished. He raises his fist to his cheek in an instinctive gesture of alarm as he

draws back from his vision. His balding head, wrinkled brow and the sagging flesh on his chest all contribute to the telling characterisation of age, in marked contrast to the proud maturity of Oinomaos and Pelops (Figs 129 and 130) and the tender youth of the boy beside him (Fig 131).

The river gods in the corners (Figs 127 and 133) are intended to personify natural phenomena. The human body is made to emerge from the drapery with the rippling movement of water flowing between its banks. They rouse themselves to watch the central action and yet remain emotionally detached.

The figures are carved with bold simplicity. There is no prettiness about them; yet there is delicacy in the rendering of the folds on the boy's stomach (Fig 131) and sensitivity in the differentiation of the various personalities. Large areas of the figures are devoid of decoration; curves are ample and unbroken, modulations restrained. Eyes, with their heavy lids, full lips, wrinkles on faces and bodies, and

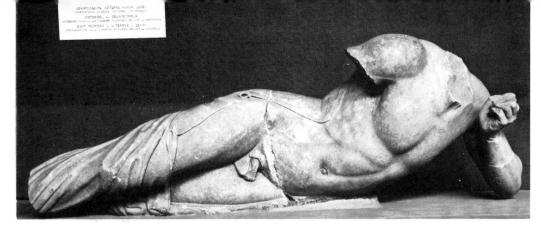

133. River god, detail of Fig 127

folds in drapery are carved crisply. Sharp edges contrast with smooth surfaces. The severe rejection of any superficial ornamentation, triviality or irrelevance gives these sculptures an austere gravity of style and powerful impact that transcends even their fragmentary condition. The seriousness and grandeur of the vision presented here finds its literary counterpart in the tragedies of Aeschylus that were being produced in Athens around the same time and perhaps in much the same spirit.

The west pediment

The play of opposites which is so important in the organisation and psychology of the east pediment extends to a contrast between the two pediments. The east pediment is tense, yet pervaded by an eerie calm, and the figures, for all their complex involvement with one another, never touch (Fig 127). The west pediment is full of action, and virtually all the figures are interlocked in violent combat (Fig 134).

The story illustrated is of the battle of the Lapiths and centaurs. Perithoos, king of the Lapiths, politely invited his neighbours, the centaurs, to attend his wedding. Centaurs, we know, were susceptible to the charms of women (p. 4) and also unfortunately to the power of wine. The heady combination at the wedding feast soon overwhelmed them, and they began to make uncouth advances to the bride, the other women and even some of the boys. Hence a fight broke out. The Lapiths had of course come unarmed, so only Perithoos, being at home, could find a sword with which to defend his bride. Everyone else had to make do with whatever implements were available – spits, wine jars, bare hands or even teeth.

134. Battle of the Lapiths and the centaurs, west pediment of the temple of Zeus at Olympia, second quarter of the 5th century BC, Olympia Museum, Olympia

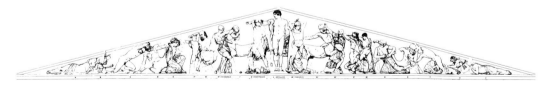

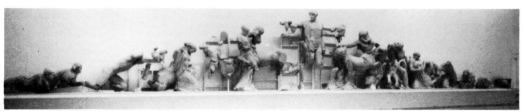

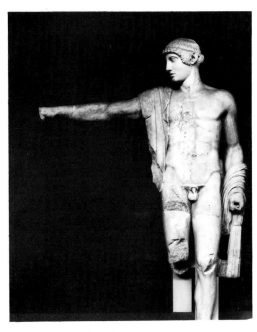

135. Apollo, detail of Fig 134

136. Centaur carrying off Lapith woman (the bride), detail of Fig 134

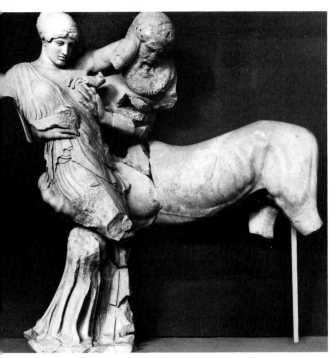

The composition follows the type that was so successful at Aegina (Figs 36 and 37): a god, here Apollo, occupying the centre, groups of combatants on both sides.

Amid the turmoil, Apollo alone is still (Fig 135). His extended arm meets his upright body at right angles, giving an effect of great stability to his commanding presence. Struggling figures surge around him (Fig 134). On each side a hero fights to defend a woman from a centaur. One of these must be Perithoos, the other his friend Theseus. Only fragments are now preserved. The bride, on Apollo's right, grapples fiercely with her assailant (Fig 136). She thrusts an elbow into his face while she tries to pry his hand from her breast. At the same time she endeavours to detach his other hand from around her waist, but the centaur, though he winces, holds her firm and secures his grip further by winding one hoof around her thigh. Though the woman's body clearly expresses her desperation and struggle, her face is unmoved. This is not because the artist was unable to show emotion on it, but more probably because he thought a grimace would not accord with the dignity of this queenly figure. Others' faces show their feelings more freely. Thus a Lapith youth (Fig 137) wrinkles his brow as his lips part to emit a cry of pain, while a centaur sinks his teeth into his arm.

The intricate tangle of men, women and monsters is emotionally richer than the simple battle of well-matched heroes that was illustrated at Aegina. The idea of men defending their women against such a savage onslaught seems to have had a special significance for the Greeks just after the Persian wars, and the theme was used again on the Parthenon (Figs 158-162).

The metopes

In both form and subject a strong contrast was made between the east and the west sides of the temple. The metopes immediately beneath the two pediments were left

blank; nothing distracted from the powerful scenes above.

Within the encircling colonnade of the temple, there were two porches. The twelve metopes here – six over each porch – were carved with sculptured reliefs.

Only the mighty platform of the temple of Zeus at Olympia now stands above its foundations, but from a similar Greek temple built at about the same time, one can see where the carved metopes (luckily preserved) would have been located (their position is marked with an 'x' in Fig 138) and how they related to the rest of the temple.

The theme of the metopes at Olympia, the labours of Herakles, was well chosen,

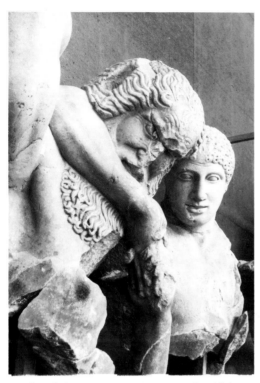

137. Bearded centaur biting the arm of a Lapith boy, detail of Fig 134

138. View of the temple of Hera II at Agrigento, built at around the same time as the temple of Zeus at Olympia. The metopes over the the porches (but not the external metopes) on the temple of Zeus at Olympia were carved in high relief with scenes illustrating the labours of Herakles. These carved metopes have been preserved even though the building itself has collapsed. The positions corresponding to those which they would have occupied over porches on the temple of Zeus at Olympia are marked on this photograph of the temple at Agrigento by 'x's.

1. Lion 2. Hydra 3. Birds

4. Bull 5. Hind 6. Amazon

7. Boar 8. Horses 9. Geryon

10. Apples 11. Kerberos 12. Stables

1-6 west porch; 7-12 east porch

for it provided both a coherent story for the whole series and also a self-contained episode for each metope.

Although very many stories clustered round the illustrious figure of the hero, the architecture of the temple restricted the number that could be illustrated in the metopes over the porches to twelve. Careful thought went into deciding which ones should be selected (Fig 139). The first six (in terms of traditional chronology) took place in the vicinity of Olympia, in the northern Peloponnese:

1. Slaying the Nemean lion (which, having hide that was impenetrable, had to be strangled)
2. Killing the many-headed lethal hydra of Lerna (whenever one of its heads was severed, two new ones grew)
3. Capturing the Erymanthian boar alive (it was huge and destructive)
4. Capturing (or killing – accounts vary) the Kerynitan hind with golden horns
5. Chasing away (or killing) the Stymphalian birds (they shot their feathers out like arrows, or were man-eating)
6. Cleansing the filthy Augean stables in a single day.

The next four sent Herakles to the four points of the compass:

7. Fetching the Cretan bull (South)
8. Fetching the man-eating horses of Diomedes from Thrace (North)
9. Fetching the girdle of the queen of the war-like Amazons (East)
10. Fetching the cattle of triple-bodied Geryon (West).

The last two sent Herakles beyond the confines of mortality:

11. Bringing Kerberos, the triple-headed watch-dog of Hades, up from the Underworld
12. Bringing the golden apples, fruit of immortality, from the Hesperides.

The twelve labours were united by the idea that they were all tasks imposed on Herakles by Eurystheus, king of Mycenae. Later they became accepted as a canonic cycle. It is probable, however, that they were first assembled as a group for the metopes at Olympia, for in their earlier history they varied greatly. For instance, the fight with the Nemean lion had long been immensely popular, while the cleansing of the Augean stables had never been represented before.

Some of the metopes are rather conventional in conception and design; others are revolutionary. The depiction of Herakles and the Nemean lion is one of the latter. Innumerable vase paintings portrayed the fight between the hero and the monster (Fig 140). The combatants could be arranged in various ways, but the moment illustrated was always at the height of the conflict. The Olympia sculptor did something entirely different (Fig 141).

The struggle is over. The lion lies dead at the bottom of the metope. Herakles has placed one foot on top of it, but far from assuming the triumphant pose of the traditional big-game hunter, he rests his elbow on his knee and his weary head upon his hand (cf. Figs 139, 141, and 145). Clearly he is exhausted – and this is only the *first* of his labours! Athena stands by, looking on sympathetically. The fragment of a foot suggests that Hermes was present too.

Previously Herakles had normally been characterised (perhaps a little mechanically) as an invincible hero striding imperturbably from victory to victory. Here the sculptor has begun to think about the price that had to be paid for those

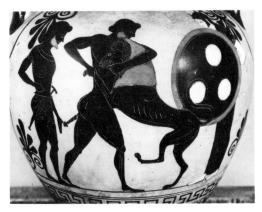

140. Herakles and the Nemean Lion, Attic black-figure neck amphora, painted by Psiax, about 530-510 BC, British Museum, London

victories, the fear and fatigue that could reveal the humanity of the hero and lend a moral dimension to his labours.

By the time he came to cleanse the Augean stables, Herakles was thought to have matured. He is shown as bearded and

141. Herakles and the Nemean Lion, metope from the temple of Zeus at Olympia, Olympia Museum, Olympia (lion, except for the hind quarters, in the Louvre, Paris), see Fig 139

confident, in the midst of action (Fig 142). This metope occupied a special place on the temple, out of chronological order, for it represented a local event and so had more than ordinary importance at Olympia. It was placed climactically at the far right, at the very end of the series. Athena's calm vertical figure closes off the composition, while Herakles' activity is vividly conveyed by the strong opposing diagonals formed by his arms and legs. Athena holds her arm roughly parallel to Herakles' – a subtle gesture of support. The austerity of Athena's dress, a peplos that falls in broad simple folds and yet reveals the distribution of her weight, is characteristic of the time (cf. Fig 121).

In his struggle with the Cretan bull, Herakles is shown alone (Fig 143). The simple but powerful composition is based on two crossing diagonals. It is all action. The two contestants strain away from each other – this dynamic design was to serve as the basis of many later compositions – yet Herakles has pulled the bull's head round so that man and beast confront each other and interest is brought in toward the centre as well as flung out to the corners of the metope.

Herakles' reward at the end of his labours was immortality. This was symbolically indicated by his acquisition of the golden apples of the Hesperides. According to some versions of the legend, he journeyed to the garden of the Hesperides himself (cf. Fig 214, bottom), but according to the version followed at Olympia, he supported the heavens on his shoulders while Atlas, who usually had this job, fetched the apples for him. On the metope (Fig 144), Atlas is shown at the far right, striding toward Herakles and holding the marvellous fruits in his outstretched hands. Herakles' enforced stillness contrasts with Atlas' freedom of movement. Athena, who stands quietly by choice, turns toward Herakles and raises one hand, effortlessly, to ease his burden. She is again wearing a heavy peplos which falls in deep sparse folds. The formula for indicating the

142. Herakles cleaning the Augean Stables, metope from the temple of Zeus at Olympia, Olympia Museum, Olympia, see Fig 139

143. Herakles and the Cretan Bull, metope from the temple of Zeus at Olympia, Louvre, Paris, see Fig 139

144. Athena, Herakles and Atlas (the Apples of the Hesperides), metope from the temple of Zeus at Olympia, Olympia Museum, Olympia, see Fig 139

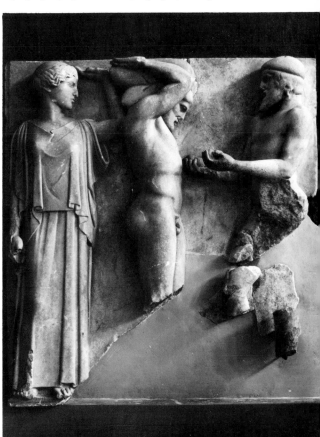

stance of the figure beneath the drapery is becoming conventional: straight folds, uninterrupted, fall over the supporting leg; over the projecting knee of the weightless leg, they are smoothed out. The simplicity of the plain, undecorated areas is contrasted with the sharply cut details, and the severity is enlivened by the calligraphic elegance of the line at the bottom of the overfold, which falls to just below Athena's waist.

Three simple verticals dominate the design, relieved by the strong horizontal accents of Atlas' extended arms. Yet within this austere composition there is systematic variation, for Atlas' body is shown in three-quarter view, while Herakles' is in profile and Athena's fully frontal.

A brilliant range of compositions is used for the metopes – some are based on stable verticals and horizontals (Fig 144), some on dynamic diagonals (Fig 143) and some on combinations of the two (Fig 142). They all achieve harmony while consistently

145. Head of Herakles from the Lion metope, detail of Fig 141

146. Head of Herakles from the Atlas metope, detail of Fig 144

147. Head of Athena from the Lion metope, detail of Fig 141

148. Head of Athena from the Atlas metope, detail of Fig 144

avoiding just those devices which produced the finest archaic metopes (Figs 28 and 29), namely, calculated symmetry and decorative repetition of forms.

The conception of Herakles as human, suffering, exhausted, humiliated and yet bravely enduring was an extraordinary innovation. Previously the hero had been regarded as a sort of superhuman strongman almost automatically overcoming all hardships. Here the artist shows how Herakles grows from being a mere boy when he encounters the lion (Fig 145), his smooth young brow poignantly creased by a single, weary, anxious furrow, into a mature man supporting the heavens for Atlas (Fig 146), his resigned face revealing the experiences of a lifetime of toil.

Touchingly, Athena – who as a goddess has no need to develop and change – is shown so fully in sympathy with the hero that she appears girlish when she stands beside him at the beginning of his labours (Fig 147) and matronly at the end (Fig 148). It is characteristic of the profound humanity of this art that even the gods are susceptible to it.

8

Early Classical Painting and Vase Painting

Developments in wall painting: Polygnotos

The most original features in the architectural sculpture at Olympia – the subtlety of the characterisations, the new humanity imparted to conventional figures, the intensity of feeling conveyed through moments of stillness, the profound reinterpretation of traditional stories – seem not to have been the sculptor's invention at all, but rather his adaptation of ideas first put forth by the greatest painter of the day: Polygnotos.

Polygnotos of Thasos was a wall painter. Not a fragment of his work survives, and yet his influence appears to have been profound. In his famous murals, so writers who saw them say (see p. 169), he excelled in the portrayal of character, temperament and mood. Internal motivation rather than external activity intrigued him, and he often avoided painting the obvious moment of climax. Thus, for instance, instead of depicting the raging night of the sack of Troy, as had been usual, he painted the scene the day after, so that he could explore the movement of the mind when that of the body had been stilled.

In his two great paintings at Delphi, of which we have extensive descriptions, Polygnotos appears to have been less interested in telling the story (one dealt with the sack of Troy, the other showed Odysseus in the Underworld) than in revealing the characters of the participants. His genius allowed him to give hitherto unknown intensity to his quiet figures – his achievement is probably best reflected by the sculptures in the east pediment at Olympia.

Single figures or even small groups could easily be worked into pleasing compositions, but to make large assemblages look interesting without the use of dramatic action was a considerable problem. In order to solve it, Polygnotos made another extraordinary break with tradition. Instead of setting all his figures along the same ground line in the usual way, he placed some of them higher up and some lower down, as if they were standing about on a steeply sloping hillside. Although the figures themselves were relatively static and seldom interacted, the wall had successfully been covered with decoration that filled it from top to bottom (cf. Fig 149).

A result – perhaps unexpected – of this innovation was that some of the figures appeared to be *further back*, as well as higher up, than others. It must have seemed as if a hole had been cut in the solid wall, suddenly giving a view into the mountainous distance beyond.

It is impossible to know whether Polygnotos was pleased to see the illusion of depth that his novel distribution of the figures had created, or disappointed to observe that the pattern he had carefully composed on the surface of his painting had been disrupted by the suggestion of space. We know that he inscribed their names beside his figures – a device that not only helped to identify them, but also served to reinforce awareness of the surface on which they were painted.

The new suggestion of space that

emerged may have been an unintentional consequence of Polygnotos' efforts to create an interesting design made up of actionless figures arranged on a flat surface, but once it was produced, painters could not resist exploiting the effect. From then on, they became ever more concerned to render the illusion of depth increasingly convincingly and were rarely satisfied with producing merely decorative works.

The depiction of space

The first step towards the suggestion of space on a flat surface had been taken long before, when one figure was shown overlapping another, since the figure that was partially obscured appeared to be *behind* the other (Figs 10, 14, 15, 18, 19, 22, 79, 89, 94, 95). Outline drawing, which was occasionally used on vases (cf. Fig 22) and was probably normal in panel and wall painting, made the depiction of overlapping figures easy. The introduction of incision with the black-figure technique made it possible for silhouette figures also to overlap without loss of clarity (cf. Figs 10, 14, 15, 18 and 19).

The next step was taken when artists began to explore the representation of foreshortened figures (cf. Figs 87-89). Bodies which seem to turn freely in space instead of being flattened against the surface on which they are represented and limbs which appear to recede backwards from the plane on which they are drawn conjure up a certain illusion of depth. Contemporary vase painters (Figs 87 and 89), relief sculptors (Fig 88) and painters on walls and panels (p. 67) all worked together in the late 6th century BC to exploit these effects by creating apparently three-dimensional figures which by their very massiveness and the freedom of their movements produce a sense of space around themselves sufficient at least to accommodate their own corporeality and their activities.

A new step was taken by Polygnotos, for the arrangement of his paintings produced the illusion of a spatial setting that existed in its own right quite apart from the figures that were freely disposed within it. This was a step that vase painters could follow only with difficulty. Now, for the first time in Greek art, painters of vases and painters of walls and panels began to go their separate ways.

Vase painting in the early classical period

From the second quarter of the 5th century BC onwards, the greatest painters appear to have been attracted to the art of wall or panel painting and only those with lesser talents chose to decorate vases.

Some of these painters were overwhelmed by their fascination with the novelties being developed in wall painting and tried, however inappropriately, to copy them. The so-called Niobid Painter (Fig 149), for instance, has distributed a number of quiet figures up and down the surface of his krater, so that it is filled with visual interest from top to bottom. He

149. Subject uncertain, Attic red-figure calyx krater, painted by the Niobid Painter showing the influence of Polygnotos, second quarter of the 5th century BC, Louvre, Paris

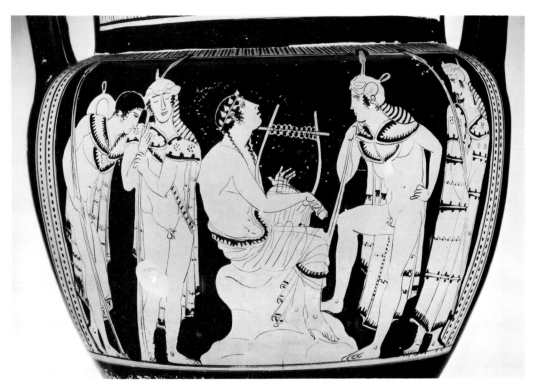

150. Orpheus playing for the Thracians, Attic red-figure column krater, painted by the Orpheus Painter, about the middle of the 5th century BC, Antikensammlung, Staatliche Museen zu Berlin, East Berlin

painted undulating white ground lines to suggest the hilly terrain on which the figures are disposed, but any feeling of space that was present in the wall painting is negated by the shiny black paint that isolates the individual figures. This painter has copied one of the most striking, but also one of the most superficial, qualities of Polygnotan painting.

Other vase painters were inspired by profounder aspects of the great wall painter's innovations. Like him, they sought to reveal character through expressively drawn, inactive figures. One painter has shown Orpheus, the legendary musician, playing among the Thracians (Fig 150). Orpheus, in the centre, is totally absorbed in his song, while his audience of four is carefully differentiated, with each

person responding in his own way. The Thracian just to the left of Orpheus closes his eyes, utterly enraptured by the sound. His friend, at the far left, leans upon his shoulder, gazing unseeingly before him, enthralled. The pair to the right react quite differently. They do not like the idea of music and resent the power it has over them. The one closest to Orpheus stares hard and penetratingly at the musician as if trying to fathom the secret of the spell he has cast. The other, on the far right, has actually turned to go – notice his feet – but he cannot tear himself away.

Simple means, effectively used, have given this image its impact. The poses of the figures and their eyes reveal their feelings. Painters had now learned how to draw eyes in profile and this greatly enlarged the range of subtle emotions they could convey. Slight variations in the length of the lower lid, the placement of the pupil and the angle of the eyebrow could be used to portray different characters and

106

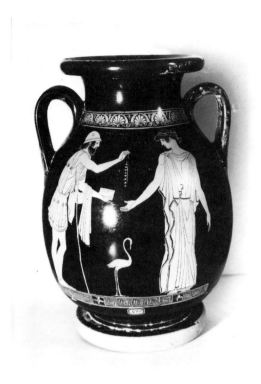

151. Polyneikes and Eriphyle, Attic red-figure pelike, painted by the Chicago Painter, 460-50 BC, Lecce Museum, Lecce

moods in a surprisingly convincing way.

Figures could now look into each others' eyes, thus deepening the emotional content of the scenes in which they were involved, as can be seen in the depiction of Polyneikes and Eriphyle on a pelike (Fig 151). Eriphyle was given the power to adjudicate between her husband Amphiaraos and her brother Adrastos. Adrastos wanted to help establish his son-in-law Polyneikes on the throne of Thebes, but Amphiaraos knew that if he joined the expedition against Thebes, he would never return from it. Polyneikes offered Eriphyle a wonderful necklace, a family heirloom that had been a gift from the gods. Eriphyle could not resist the bribe and agreed to send Amphiaraos to the Theban war. The vase painter has shown Polyneikes, standing at the left, dangling the bauble temptingly before Eriphyle. Eriphyle reaches out her hand to receive it. Their eyes meet, and her husband's fate is sealed. A long-legged bird, a household pet, stands between the two quiet figures; little happens, but the air is charged with ominous forebodings.

It must have been in a similar way, though with far greater mastery, that Polygnotos told his stories. The means at his disposal were hardly more. He would have worked with figures drawn simply but eloquently in outline, enhanced by flat washes of colour against a pale background. The effect was probably similar to that of contemporary vase paintings in which the figures are drawn in outline over a white slip (Figs 152 and 153).

Towards the end of the archaic period, this sort of white ground had occasionally been used as a background for black-figure work, but painters soon came to prefer to draw on it in outline. At first the outlines were drawn with the same crisp black lines that were used in red-figure, but it was not long before artists began to favour dilute paint that fired to a soft golden brown. This is what is used in the sensitive painting by the so-called Sotades painter of

152. Girl picking apples, Attic white-ground cup interior, painted by the Sotades Painter, second quarter of the 5th century BC, British Museum, London

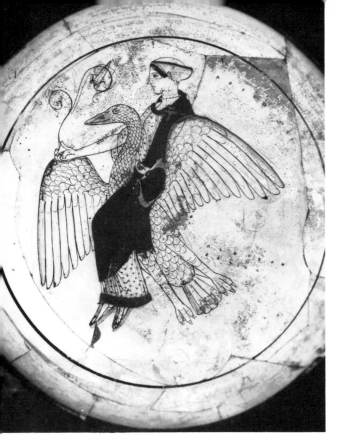

153. Aphrodite riding on a goose, Attic white-ground cup interior, painted by the Pistoxenos Painter, about 460 BC, British Museum, London

154. Perseus, Medusa and Athena, Attic red-figure hydria, painted by the Pan Painter, second quarter of the 5th century BC, British Museum, London

a girl picking apples (Fig 152). The surrounding space is ample, and the figure is drawn with great delicacy. Perhaps it recalls something of Polygnotos' celebrated renderings of women and of their transparent drapery.

Another white-ground cup interior, this by the so-called Pistoxenos Painter (Fig 153 and Plate 2, opposite p. 1), shows a fine balance between the design of the figure – Aphrodite riding through the air on a goose – and the circular space available. The serenity here looks forward to the high classical period.

But some artists preferred to look backwards rather than forwards. The best of these was the so-called Pan Painter (Figs 154 and 155). He carried the slightly artificial charm and elegance of the archaic style on into the early classical period. He decorated the shoulder of a hydria with a ballet-like illustration of Perseus and Medusa (Fig 154). Perseus skips off to the left, looking back. The Gorgon's not-too-terrible head peeps out of the bag he is carrying over his shoulder. Medusa herself, though beheaded, falls with a dancer's grace, and Athena, her spear over her shoulder, brings up the rear holding up the hem of her skirt with comic daintiness. The

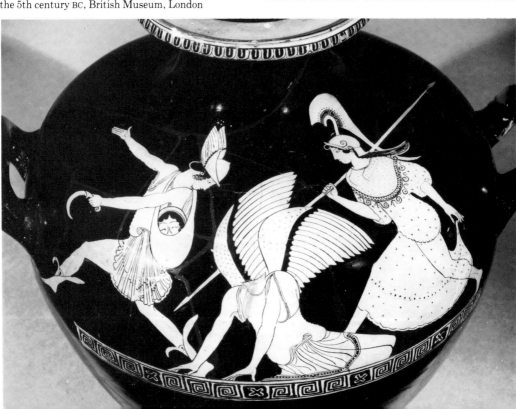

scene is one of amusing pantomime. The Gorgon no longer has the power to terrify that she possessed when artists first struggled to convey her image (Figs 6, 9, 13 and 33). Monsters were now beginning to become something of a joke.

However playful and sophisticated the Pan Painter might be in some of his work, he too was touched by the new emotional depths that artists had begun to explore. On an oinochoe (Fig 155), he painted Boreas, the god of the north wind, pursuing a girl with merry zest, but in the figure of the girl's father, grieving, huddled disconsolately at the right of the picture, he has produced one of those powerful, sad, muffled figures with which Greek art opened up a whole new, hitherto unimaginable world of feeling.

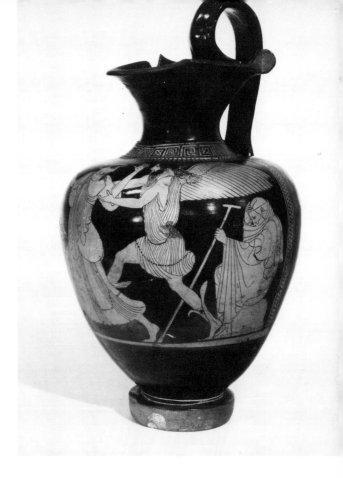

155. Boreas pursuing Oreithyia while her father grieves, Attic red-figure oinochoe, painted by the Pan Painter, second quarter of the 5th century BC, British Museum, London

109

9

High Classical Architectural Sculpture:
the Parthenon

The historical setting

When the Athenians returned to their devastated city after the Persian sacks of 480 and 479 BC (see p. 80), they did not set about rebuilding their temples immediately. Before joining battle at Plataea, where the Persians were decisively defeated in 479 BC, the Athenians had sworn an oath that they would leave the temples destroyed by the Persians in ruins, perpetual testimony to the impiety of the invaders. At first, therefore, they did little more than construct makeshift shelters for the images of their gods.

However, by the middle of the century things had radically changed. Peace had been made with Persia, and Athens, the leader of a confederacy that was rapidly becoming an empire, was flourishing as never before. The shabby ruins on the Acropolis no longer seemed tolerable for so rich and powerful a state, and the oath of Plataea no longer seemed binding. It was not difficult for Perikles (Fig 220), the eloquent leader of the democracy, to persuade the people that the time had come for the temples to be rebuilt. In fact, he encouraged a building programme on a considerable scale which was cleverly devised to provide both employment for the multitude and glory for the city. The first major project to be undertaken was the Parthenon. Work began in 447 BC.

The themes selected and their location

The sculptural decoration of the Parthenon was exceptionally lavish (Fig 156). The pediments of temples were often filled with large statues carved in the round, but because the Parthenon was abnormally broad, both the number and the size of these statues was greater than usual. Thus while just over a dozen figures were enough to fill each pediment at Olympia (Figs 127 and 134), nearly twice as many were required for the Parthenon (cf. Fig 181).

Many Doric buildings were adorned with carved metopes, but only rarely were the metopes on all four sides carved. Most larger buildings had just a few metopes sculpted; at Olympia, for instance, only the twelve metopes over the porches were decorated, while those on the outside of the temple were left blank. On the Parthenon, by contrast, all 92 metopes on the exterior of the building were decorated with sculptures carved in high relief.

Normally, a Doric temple would not have a continuous frieze in the Ionic manner. On the Parthenon, however, a continuous frieze carved in low relief not only decorated the area over the porches (cf. Fig 164) but also ran along the top of the walls enclosing the interior of the building.

Size, importance and position were all considered when the themes for the

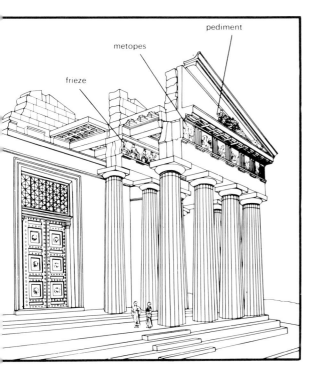

156. Diagram showing the placement of the architectural sculptures decorating the Parthenon

sculptures were selected. Thus the huge pediments were filled with stories concerning the gods; the high reliefs of the metopes displayed heroic combats, while on the low relief frieze the Athenians themselves were represented, apparently celebrating the Great Panathenaia, the quadrennial festival in honour of Athena, the goddess to whom the temple was dedicated (Fig 157).

The decoration of the east end (the front of the temple) was entirely devoted to the gods, with each level of sculpture allotted its appropriate subject (Fig 157). The pediment showed the birth of Athena; the metopes depicted the gods fighting against the giants; and the frieze portrayed the assembled gods receiving homage at the Panathenaic festival.

The west side of the temple – the back, but the part of the Parthenon that one saw first on ascending the Acropolis (Fig 163) – was devoted on all levels to the Athenians,

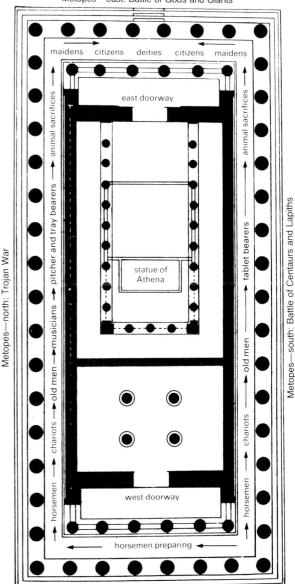

Pediment: east (front)
Birth of Athena

Metopes—east: Battle of Gods and Giants

Metopes—north: Trojan War

Metopes—south: Battle of Centaurs and Lapiths

Metopes—west: Battle of Athenians and Amazons

Pediment: west (back)
Contest of Athena and Poseidon

157. The themes of the architectural sculpture decorating the Parthenon, indicated on a plan of the Parthenon

111

their history and their city. The pediment showed Athena and Poseidon disputing which of them should be the divine patron of the city; the metopes almost certainly showed the Athenians beating back the attack of the legendary eastern warrior women, the Amazons; and the frieze showed Athenians preparing for the Panathenaic procession.

The heroic conflicts depicted on the metopes had themes which could all be interpreted as allusions to the Persian wars, each illuminating a different aspect (Fig 157). The long north side showed episodes from the Fall of Troy, the mighty city in Asia Minor which served as a mythical prototype for Persian power and which had been defeated by the combined Greek armies. The south, at the ends, showed the battle of the Lapiths and the centaurs, as on the west pediment at Olympia (Fig 134). This was probably intended to suggest the struggle of civilisation against barbarism, in which the Greeks could be seen as heirs of the civilised forces of the Lapiths and the Persians as inheritors of the barbarism of the centaurs. The Amazonomachy of the west showed the legendary Athenians repulsing an Asiatic invader, very much as the historical Athenians had done at Marathon (see p. 74), and finally, the Gigantomachy on the east demonstrated how the Greek gods themselves put down barbaric insolence.

All four sides of the frieze showed the progress of a procession, starting out on the west, proceeding along the north and south sides and concluding at the east. Many elements in the frieze recall the Great Panathenaic festival, which was celebrated every four years in honour of Athena and culminated in a procession up to the Acropolis. However, the correspondence is far from exact. The precise meaning of the frieze is much disputed and some think that the participants are more than just ordinary citizens. Interpretations are many, but none has been accepted as conclusive.

The metopes, 447-442 BC

The metopes had to be ready before the roof could be put in place, and work therefore began with them. At Olympia artists had to think up compositions for only twelve metopes; devising them for 92 was a task of far greater magnitude. For so large a project many sculptors had to be collected quickly, and there was not time enough to train them all up to the same standard. Some were much better than others, and the metopes consequently vary considerably in the quality of their design and execution.

The best preserved metopes come from the ends of the south side of the temple and depict the battle of the Lapiths and the centaurs. One of the finest, still in place on the building (Fig 158), shows how brilli-

158. Centaur and Lapith, metope at the south-west corner of the Parthenon, 447-442 BC, in situ on the Parthenon

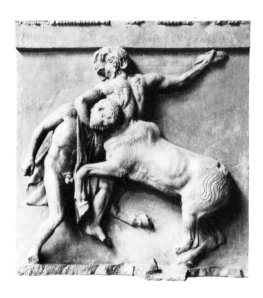

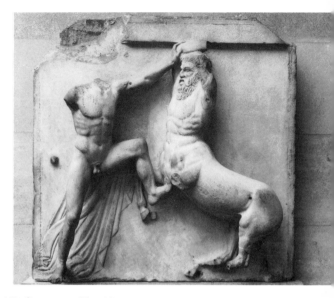

159. Centaur and Lapith, plaster cast made in the 19th century of the metope at the south-west corner of the Parthenon (see Fig 158), British Museum, London

160. Centaur and Lapith, metope from the south side of the Parthenon, 447-442 BC, British Museum, London

antly the sunlight of Athens animates the figures and how they, in turn, lend a touch of humanity to the otherwise austere geometry of the architecture.

A cast made in the 19th century, when the metope was in better condition, gives a clearer idea of the original composition (Fig 159). The centaur rears up. In one hand he holds a rock, the arm flung back ready for attack; with the other arm he has secured the Lapith's head in a wrestler's grip. At the same time the Lapith thrusts a spit (or some such implement) into the centaur's flank. (Weapons were often added in metal, as here, and have been lost in the course of time.) The figures appear to move freely, engrossed in their combat, but their poses have been carefully arranged to fill the entire space. The anatomy of both contestants is rendered with vigour and ease and the head of the centaur is particularly distinguished by the rugged nobility of its features.

Another metope (Fig 160), though similar in composition, illustrates the work of a less accomplished sculptor. Interest is bunched up in the centre – notice the blank expanse to the right. The figures are awkward; harsh lines indicate their muscles; the centaur appears to have no neck and his flattened face is crude and ill-executed. The design was poorly planned to begin with, and then things seem to have gone wrong as work progressed. The Lapith's drapery is meant to be slipping from his arm as he engages in the fight. Some of it can be seen carved rather shallowly against the background, but the part which should be visible between his upraised left arm and his left leg is missing. It seems to have been patched up either with paint or perhaps by means of some sort of attachment.

From such an incompetently carved metope, one could hardly guess how superbly effective sculpted drapery could be. Its potential is, however, realised in another man's work (Fig 161). In this metope Lapith and centaur are shown pulling away from each other in a composition reminiscent of the bull metope at Olympia (Fig 143). The Lapith's cloak falls behind him in deep U-shaped folds called 'catenaries'. The play of light

113

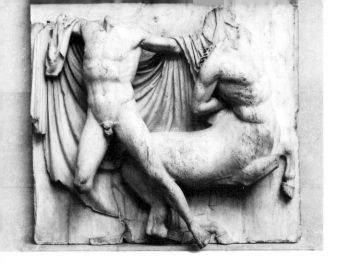

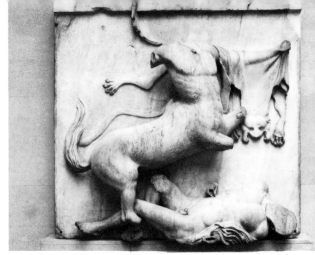

161. Centaur and Lapith, metope from the south side of the Parthenon, 447-442 BC, British Museum, London

162. Centaur and Lapith, metope from the south side of the Parthenon, 447-442 BC, British Museum, London

and shadow provides a splendid foil to the beautiful nude body of the man and the powerful forms of the monster, and suggests how the colours with which the sculptures were originally painted may have contributed to their appearance. The dynamic opposition of the two figures cleverly carries the design out to the sides of the metope, while the strong pattern created by the folds of the cloak serves to stabilise the otherwise centrifugal composition.

In Fig 161 the boldness of the design is matched by the quality of the execution: the telling depiction of rippling muscles and tensed bodies contrasts with the geometric purity of the folds behind. Similarly effective contrasts can be found in another outstanding metope (Fig 162). Here a Lapith lies along the bottom of the metope, his sensitively rendered body crumpled pathetically in death. The triumphant centaur rears above his victim; traces of the wine jar he was using as a weapon can be seen to his right, his left arm is extended parallel to the horizontal body of the Lapith. The animal skin that hangs from the centaur's arm – a hint, perhaps, of his own bestiality – falls vertically, echoing the human part of his body. The slanting horse-body and legs of the centaur provide two diagonals to link the upper and lower parts of the metope. A brilliantly simple composition – one in which stable verticals and horizontals predominate – has been used to embody a poignant and moving image.

The frieze, 442-438 BC

The next part of the architectural sculpture to be undertaken was the frieze. Some 160 metres in length and only one metre high, it was an immensely long ribbon which needed to be filled with decoration that was unified but not monotonous. The designer ingeniously met the challenge by adapting his representation of a procession to the space available. He included a large number of horses, some shown in swift movement, others progressing more sedately, and numerous human figures either walking, standing or sitting down in order to provide variety of pace and accent. The heads of all the figures, whether mounted or on foot, seated or standing, reach to the top of the frieze so that the total impression is one of an even pattern with no undue gaps at any point (cf. Figs 164, 166 and 170).

The procession was shown forming up in the west porch and proceeding along both the north and south sides of the temple towards the east, where its two branches converged (Fig 157). The division into two streams comes at the south-west corner. On paper this arrangement looks arbitrary, but in fact it was carefully calculated in

114

163. The Parthenon from the north-west corner, 447-432 BC, Athens

terms of how a visitor would actually approach the Parthenon. The Acropolis is accessible only from the west, and so it is from that side that a visitor would first see the Parthenon. He would take in the short west side and the long north side together (Fig 163). Approaching from the west, he would normally walk along the north side until he reached the front of the temple, keeping pace, thereby, with the sculpted figures, for the frieze is so ordered that the procession begins at the south-west corner (Fig 163, SW), moves along to the north-west corner (Fig 163, NW) and then turns and continues up the north side to the north-east corner (Fig 163, NE).

Since the frieze was placed high over the porches and the walls of the inner part of

164. West frieze of the Parthenon seen through the outer colonnade, 442-438 BC, in situ on the Parthenon

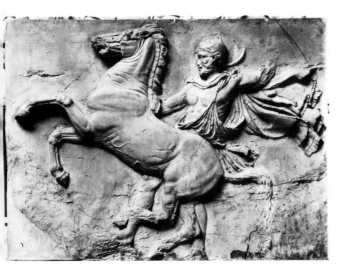

165. Horse, from the centre of the west frieze of the Parthenon, plaster cast made in the 19th century (see Fig 164), British Museum, London

the temple (Fig 156), it could only be glimpsed through the intervals in the outer colonnade. The screen of columns served as a foil to the movement of the procession: the steady, even march of the columns contrasting with the spurts of activity and solemn slowing down of horses, chariots and men on foot (Fig 164).

The west frieze, which remained on the building when the rest of the undamaged

166. Cavalcade, part of the north frieze of the Parthenon, 442-438 BC, British Museum, London

portions were removed, has suffered much decay from air pollution in recent times and the quality of its design and carving can now be better appreciated in 19th-century casts (Fig 165) than in what remains of the original work itself (as can be seen in Fig 164). The spirited animal that forms a central feature on this part of the frieze (Fig 165) seems very natural, an impression enhanced by the meticulous carving of the veins on its belly; yet the amount of detail introduced into the representation is limited and broad areas are only slightly modulated. The effort of the man controlling the horse (the reins would have been added in metal or painted on the surface of the relief) is revealed not only through his pose and his straining muscles, but also by means of the drapery that blows out behind him. The contrast of inanimate but responsive drapery with the carefully modelled body of a man and the more simply defined form of a horse is explored here as it was in the metopes (cf. Fig 161).

On the west, the procession is just starting up. Once it begins moving on the long sides, the pace quickens. Massed cavalcades thunder along (Fig 166), hooves pounding, horses in serried ranks overlapping to produce the illusion of depth, though the shallow carving is only a few centimetres deep. Ahead of them, chariots are shown, some at a walk, others dashing

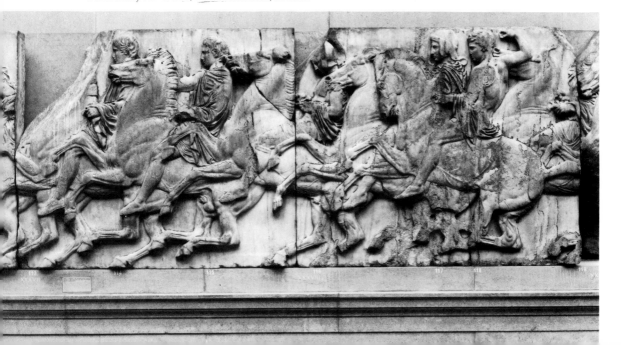

167. Galloping chariot, part of the south frieze of the Parthenon, 442-438 BC, British Museum, London

168. Heifer led to sacrifice, part of the south frieze of the Parthenon, 442-438 BC, British Museum, London

forward (Fig 167). A man wearing a helmet and carrying a shield leaps on and off one chariot as it races along. Speed is convincingly conveyed by his billowing cloak and the wind-blown manes of the four galloping horses.

As the procession nears the east end of the temple, it slows down to a dignified walk. The sacrificial victims are led at a stately pace (Fig 168). One heifer raises her head in mild protest, inspiring Keats' line 'that heifer lowing at the skies ... '. The simple expanse of her body is articulated by a few, carefully chosen details – the wrinkles on the neck and between the legs, the gentle swelling of the muscles at the shoulder – yet they are enough to produce an impression very different from the bold severity that characterises the bull in the metope at Olympia (Fig 143).

Women are represented only on the east side of the frieze. Singly or in pairs, their measured advance controlled by marshals (Fig 169), they approach the climactic centre of the frieze where the gods themselves are assembled (Figs 170-172). The girls' drapery (Fig 169), though still simple, is no longer as austere as it was in the early classical period (cf. Figs 121, 128, 142 and 144) but falls in numerous, narrow, subtly varied, vertical folds, which catch

169. Maidens and marshals, part of the east frieze of the Parthenon, 442-438 BC, Louvre, Paris

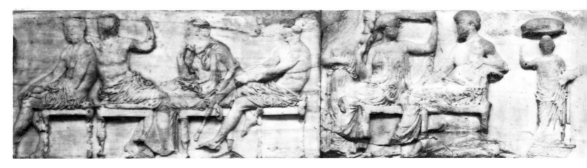

170. Gods and human votaries, from the east frieze of the Parthenon, 442-438 BC, British Museum, London (from left to right: Hermes, Dionysus, Demeter, Ares, Iris, Hera, Zeus, two girls, priestess, magistrate (?) and assistant, Athena, Hephaistos)

the light and produce a dense but regular pattern to contrast with the smooth, ungeometrical forms of their arms.

The twelve gods (Figs 170 and 171), seated at the centre of the east frieze, are divided into two groups of six. Between the two groups a man and a woman assisted by three younger people are busy with a peplos (Fig 172). The climax of the Great Panathenaic festival came when a specially woven peplos was presented to an ancient, sacred olive-wood statue of Athena. This statue, which was reputed to have fallen from heaven, was saved from the Persian sack by the pious Athenians, and was traditionally kept somewhere on the north side of the Acropolis, not on the south side, where the Parthenon was built.

Though the gods are seated, their heads reach to the top of the frieze. This was a subtle way of indicating their superior stature and at the same time maintaining the even pattern made by the figures with no awkward gaps at the top; architectural sculpture was intended to be effective as decoration.

Eight of the gods, now in the British Museum, are shown in Fig 170; three more to the right are in the Acropolis Museum (Fig 171), while Aphrodite and her son Eros (furthest right) are preserved only in fragments. From left to right the gods are: Hermes, the messenger god with his traveller's hat on his knees; Dionysus, god of wine, lolling comfortably on Hermes'

shoulder; Demeter, goddess of grain, sorrowing for her lost daughter; Ares, god of war, restlessly rocking back and forth on his seat; Hera, wife of Zeus, unveiling herself with a bridal gesture (the messenger Iris stands in attendance to our left); and finally Zeus. Then there is the interval with the mortals and on the other side Athena, unarmed, seated at ease, conversing with the lame smith-god Hephaistos, who, like her, was a promoter of the arts. Further to the right (Fig 171) are the mature sea-god Poseidon, chatting with the youthful Apollo, beside whom is seated his sister Artemis.

Notice how freely the gods are disposed in relationship to each other and how varied their poses are, in contrast to the arrangement of the gods on the Siphnian Treasury (Fig 31). Yet within this freedom there is discipline. For instance, look at the unusually long slab from Hera to Hephaistos (Fig 172), which was framed between the central pair of columns on the east side of the temple. The mortal figures in the middle are enclosed on each side by a pair of deities, one male and one female. The inner divinities face outward towards the approaching halves of the procession, while the outer divinities twist round towards the centre. The balance of the composition is thus assured, but rigid symmetry is avoided by alternating the sexes of the gods. On the left, Zeus sits closest to the centre and his female companion (Hera) turns towards him, while on the right the sexes are reversed, with the result that Zeus and Athena, the two most important deities, occupy the most striking positions. Form and meaning are harmoniously

118

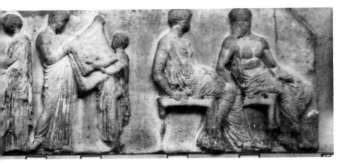

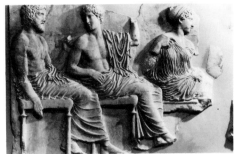

171. Gods from the east frieze of the Parthenon, 442-438 BC, Acropolis Museum, Athens (from left to right: Poseidon, Apollo, Artemis)

resolved, and a variety of requirements are met with the appearance of effortless ease.

Orderly variation can also be seen in the different poses and positions of Poseidon, Apollo and Artemis (Fig 171). As one looks from left to right, each deity overlaps the next, each one is more fully clothed than his neighbour. Notice the placement of the lower arms of the three figures: that of Poseidon hangs down, that of Apollo is raised up to his waist, that of Artemis is lifted to her shoulder – the three positions suggest one continuous movement analysed step by step. The sense of continuity is similar to that produced by the arrangement of the arms of the fallen warrior in the east pediment at Aegina (Fig 39). There is no exact repetition, but a logical sequence of forms – movement rationalised in time and space.

The frieze shows a remarkable range of rhythms and subjects subordinated to a controlled plan. The design maintains the same high quality virtually from one end to the other. The standard of carving is also for the most part very fine. Apparently the disparate group of sculptors who had been hastily assembled to carve the metopes were now being welded into an increasingly homogeneous team. Nevertheless, the men who participated in this great project

172. Central section of the east frieze of the Parthenon, detail of Fig 170. The representation from Hera on the left to Hephaistos on the right was originally carved on a single long slab of marble. It was broken near the middle only when it was being removed from the Acropolis for transport to London in the early 19th century.

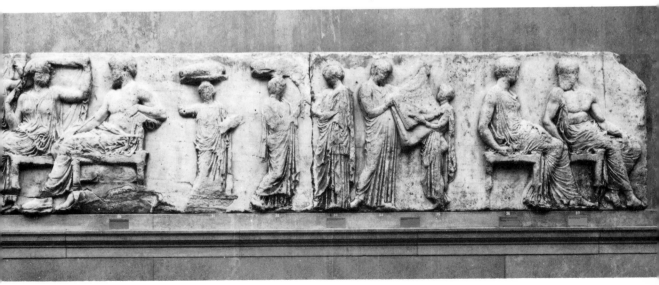

173. Hand of Apollo, detail of Fig 171

remained individuals and the differences between them can still be perceived. One of the most accomplished masters carved the exquisitely finished hand of Apollo (Fig 173) while a less able colleague sketched the one in Fig 174.

174. Hand of a maiden, from the east frieze of the Parthenon, 442-438 BC, Acropolis Museum, Athens

175. Sculptures from the corners of the east pediment of the Parthenon, 438-432 BC, British Museum, London

The pediments, 438-432 BC

The pediments were the last part of the sculptural ensemble to be completed. Some fifty colossal figures originally filled the two pediments; pitifully few have survived.

Pausanias, who travelled through Greece in the 2nd century AD and described what he saw, records that the east pediment illustrated the birth of Athena. According to the myth, this was a most unusual event, for Athena was born – fully grown and fully armed – from the head of her father Zeus. Zeus must have been in the middle of the pediment; Athena, in her full glory, probably stood beside him. The astonishing news of her birth was carried in waves of excitement out from the centre to the sides, decreasing in intensity as it approached the corners (Fig 175). The central figures were destroyed early, for a drawing made in 1674 (Fig 176) shows that they had been lost even before the great explosion of 1687 which damaged the building severely.

The degrees of awareness are carefully graded. The figures reclining at the extreme ends have their backs to the centre and seem wholly oblivious to what is taking place (Fig 175, D and M). Notice that the one on the left is a nude male, while the one on the right is a clothed female – balance is achieved through opposites here, as it was on the frieze (Fig 172). Next to the reclining figures are seated goddesses (Fig 175, E and L). These begin to turn to the front; the taller seated figures beside them turn further still (Fig 175, F and K).

A closer look at the three goddesses to the right (Fig 175 K, L and M and Fig 178) reveals how systematically the axes of the figures are rotated in space, from the fully profile legs of the reclining figure (M), whose upper body turns gently toward the front, through the three-quarter view of the goddess beside her (L), to the fully frontal figure seated closest to the centre (K). A similar orderly progression can be seen in the group of deities to the left (Fig 175, D, E and F).

The deeply carved drapery produces a

K L M

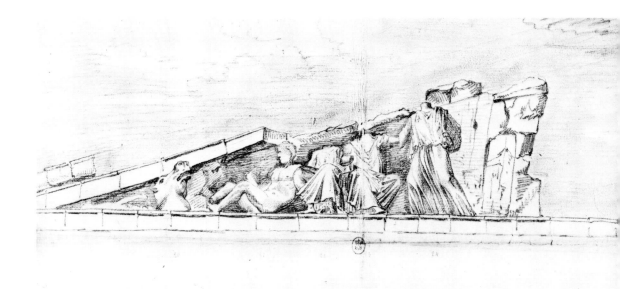

176. Drawing of the east pediment of the Parthenon made around 1674, probably by Jacques Carrey, Bibliothèque Nationale, Paris

lively play of light and shadow and helps to link figures to one another by means of a unifying rhythmic pattern. Sometimes it is also used to model forms almost as an artist drawing with a pencil might model them. Thus the roundness of the legs of the reclining goddess (Fig 178) is conveyed by the sharp ridges of stone which are left protruding at right angles to the curvature of the legs. These ridges do not follow the shape of the legs exactly but describe broad curves, catching the bright sunlight to throw shadows that help to suggest the three-dimensionality of the underlying forms. Such 'modelling lines' are an

177. Three goddesses from the east pediment of the Parthenon (E, F and G), detail of Fig 175

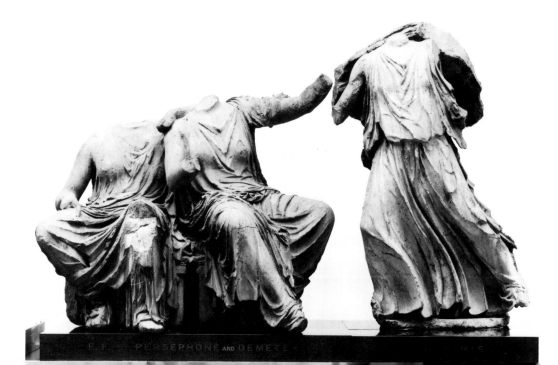

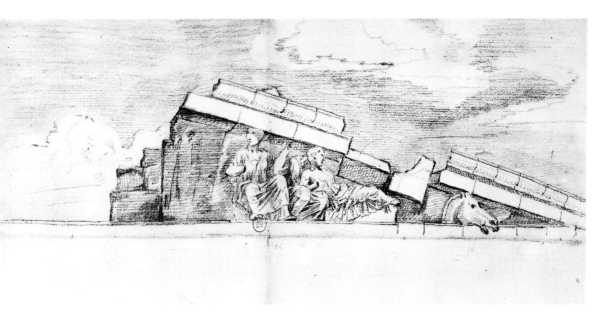

ingenious device created by sculptors to accentuate the roundness of forms apparently covered by thin drapery. They were already used in a modest way on the frieze, for instance in the drapery on Apollo's legs (Fig 171), but were developed more fully in the pediments.

Drapery could also be used to enhance

178. Three goddesses from the east pediment of the Parthenon (K, L and M), detail of Fig 175

the impression of movement. A messenger rushes up to the two seated goddesses at the left on the pediment (Fig 177), the nearer of whom turns towards her with eager interest. The folds in the messenger's peplos swirl back from her advancing leg in a double curve that conveys her haste. Such 'motion lines', double curves used to indicate the effect of movement on pliant cloth, were found to be more expressive

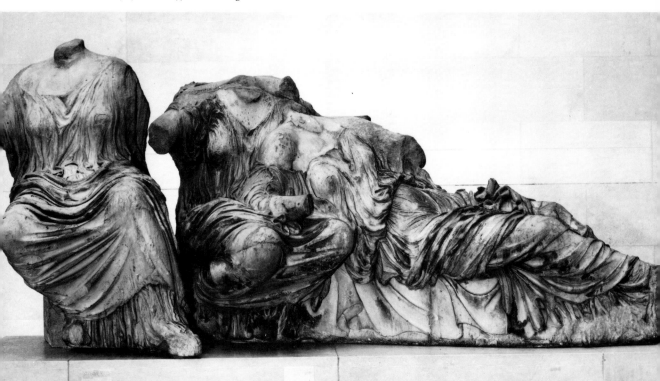

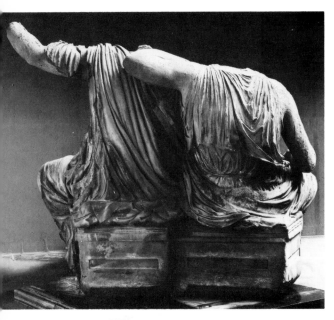

179. Two seated goddesses (E and F) from the east pediment of the Parthenon, back of Fig 177

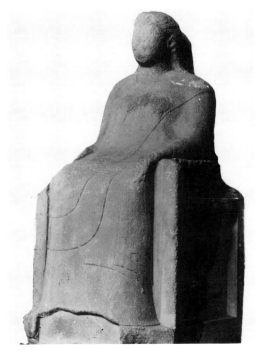

180. Seated figure from near Didyma, second quarter of the 6th century BC, British Museum, London

than nude figures in violently active poses, for while nude figures may seem frozen, agitated drapery records the effects of an action and visually suggests continuity.

Even though the backs of pedimental figures could not be seen once the statues were in position, those on the Parthenon were carefully finished (Fig 179). The parallels created by the upraised arms of the two goddesses produce an elegant composition, the very existence of which could hardly be guessed from the front view of the figures (Fig 177). Details, too, are

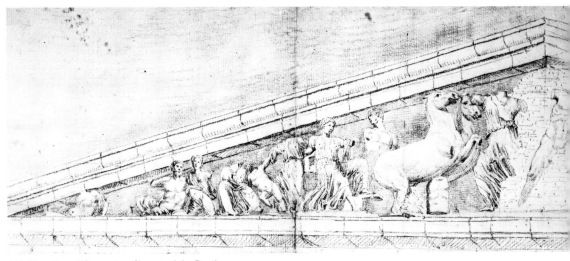

181. Drawing of the west pediment of the Parthenon made around 1674, probably by Jacques Carrey, Bibliothèque Nationale, Paris

carved with minute attention. The sculptor has taken great pains to differentiate the quality of living, draped bodies from soft but inanimate cushions and to distinguish these from the hard and unyielding chests on which they rest (Fig 179). The representation is so successful that it is difficult to remember that these are not the different substances they seem to be but are all part of the same piece of shaped marble. The progress that has been made by Greek sculptors can be gauged if one compares these accomplished seated figures with a seated figure from the first half of the 6th century BC, 150 years before (Fig 180). In that work, seat, drapery and living figure intersect at abrupt angles, and all partake of the same hard, stony quality.

A drawing made in 1674 of the west pediment (Fig 181) gives a good impression of what the original composition must have looked like. Athena and Poseidon have arrived simultaneously on the Acropolis ready to claim patronage of the city. In the centre of the pediment they are shown striding away from each other, but turning to look back (as in the bull metope at Olympia, Fig 143). Excitement ripples outward through the assembled audience of gods and heroes. The conception is magnificent, the entire pediment being filled with lively figures and rich in

decorative complexity. At the time the drawing was made, little more was missing than the horses of Poseidon. Now the pediment is bare but for replicas of three figures. Only fragments are preserved in Athens and London.

The most complete surviving figure from the west pediment of the Parthenon is a river god from the left-hand corner (Fig 182). Distinctions between hard bone, elastic muscle and soft layers of fat are brilliantly indicated in the flowing forms of this mobile figure. In position and function, he is similar to the river god in the east pediment at Olympia (Fig 133), but in style he is different. The river god at Olympia is rendered in terms of grand simplifications, while the one on the Parthenon is characterised by a wealth of subtle anatomical detail and transitions of great delicacy. The back view of the Parthenon river god (Fig 183) reveals the drapery seeming almost to lap at the body, as if the current were sweeping by.

During the fifteen years in which the sculptors were busy carving the architectural sculptures for the Parthenon, they were also contributing to the development of the high classical style. Little by little they began to relax the severity of the early classical period and to temper dignity with

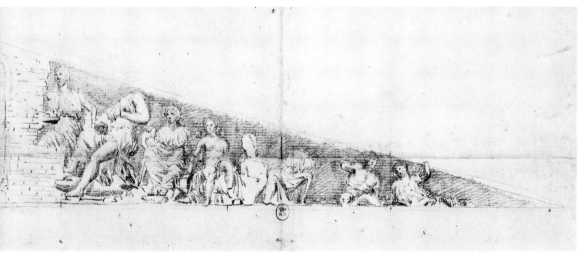

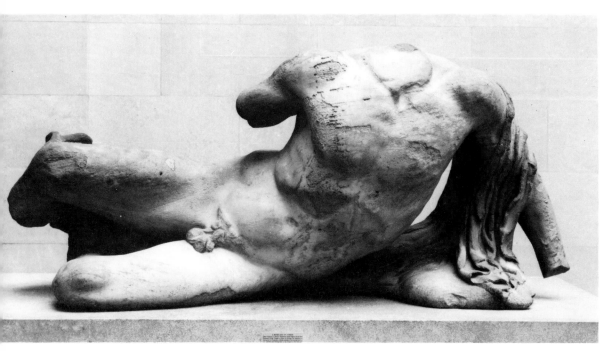

182. River god (Ilissos?) from the west pediment of the
Parthenon, 438-432 BC, British Museum, London

183. River god, back of Fig 182

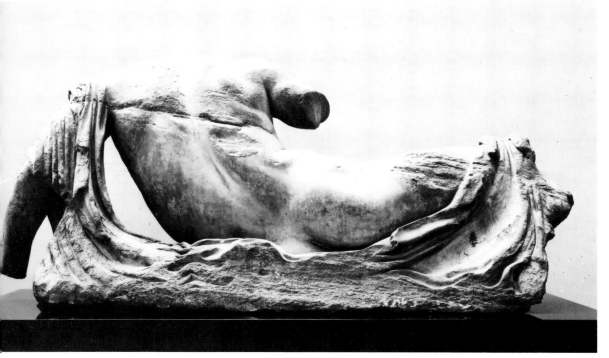

grace. They created broad, swinging rhythms to make unified groups out of isolated figures (Figs 175-79) and used opposing but comparable figures to produce a balance that was dynamic rather than static (Figs 172 and 175). They avoided repetition and cultivated variety, but disciplined it by means of arrangements that developed logical sequences (cf. Figs 171 and 178). They portrayed drapery falling in deep channels of different widths or crumpled into many small, carefully varied folds that made complex patterns of light and shade to contrast with the gently undulating surfaces of nude bodies. The austere simplicity of the early classical style, despite its formal strength and emotional depth, seems harsh beside the richly expressive carving used in the architectural sculptures of the Parthenon.

Yet none of these achievements can completely disguise the logical flaw underlying the design of the pediments: the fact that there is no consistency of scale. The gods in the centre are gigantic, those in the corners dwarfed (Fig 181). The pediments of the Parthenon were considerably wider than those at Aegina (Figs 36 and 37) and Olympia (Figs 127 and 134), so that it was proportionately more difficult to represent figures on a consistent scale, but it is still surprising that after the great strides that had been made in the design of pedimental compositions from the end of the 6th century BC, the figures further from the centre in the Parthenon pediments are simply represented as smaller than those that are more central, just as they had been on the pediment of the Siphnian Treasury (Fig 34, p. 33).

10

High Classical Sculpture and Vase Painting

Pheidias

Though many sculptors helped to decorate the Parthenon, we know very little about any of them beyond the surviving fruits of their labours. With Pheidias the situation is different; his personality stands out from the crowd of anonymous craftsmen. He was a versatile artist who worked both in marble and in bronze (some scholars think that the warrior from Riace (Figs 115-118) was actually one of his early works), but was most renowned for his colossal *chryselephantine* (gold and ivory) images of gods.

Pheidias had friends in high places, but his association with Perikles proved to be a mixed blessing, for though it enabled him to exert his influence on the magnificent sculptures for the Parthenon, it also exposed him to attacks by Perikles' political enemies, who hit at the statesman through the artist he favoured.

Pheidias was appointed general overseer of the buildings erected by the Athenians under the leadership of Perikles. This meant that, among other things, he was responsible for assembling and directing the large team of sculptors who executed the architectural sculpture of the Parthenon.

When work began on the metopes, little central authority was exercised. The fact that the finest carving appears on those metopes with the finest compositions suggests that, within very general guidelines, each sculptor was permitted to make his own designs. The physical independence of the metopes allowed for a good deal of artistic independence.

The frieze and the pediments required more co-ordinated planning. Behind the unified design that integrates the many varied elements within the frieze, and behind the complexity of the compositions developed for the pediments, we may sense the guiding hand of Pheidias. It is not likely, however, that he did any of the actual carving, for he was obliged to devote a large part of his time and creative energy to producing the great chryselephantine statue of Athena that was to be the crowning glory of the temple.

This huge and costly image was some ten metres high and covered from head to toe in rich materials. The face, arms and feet of the goddess were veneered in ivory and the drapery was covered with thin plates of gold. Within the dark interior of the temple the ivory would have glowed and the gold glimmered: the appearance of this towering goddess must have been awe-inspiring.

Although gigantic statues had been created in earlier times (fragments of enormous marble kouroi have survived) and life-size statues had been covered with gold and ivory during the archaic period, the idea of combining colossal scale with rich veneering appears to have originated in the classical period. The execution of such magnificent works seems to have been a speciality of Pheidias'. He made not only the chryselephantine statue of Athena for the Parthenon, but also one of Zeus for the temple of that god at Olympia. The Zeus was immensely admired, not only for its

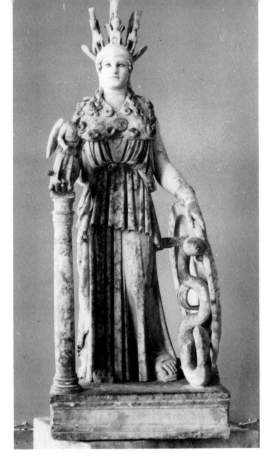

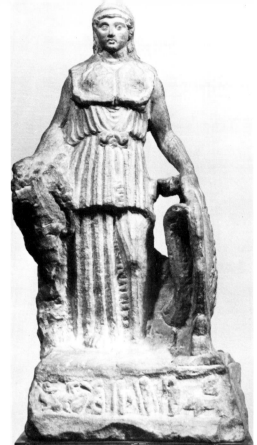

184. Athena Parthenos by Pheidias, Roman copy in marble, on a reduced scale, of the colossal chryselephantine original created between 447 and 438 BC (Varvakeion Athena), National Archaeological Museum, Athens (1.05 metres high)

185. Athena Parthenos by Pheidias, Roman copy in marble, on a reduced scale, of the colossal chryselephantine original created between 447 and 438 BC (Lenormant Athena), National Archaeological Museum, Athens (0.42 metres high)

size and the splendour of the materials used, but also for the grandeur of the conception it embodied which was, according to the Roman writer Quintilian, supposed to have added a new spiritual dimension to the traditional religion. Though many later images of Zeus were obviously inspired by Pheidias' creation and both poetic and circumstantial descriptions of it exist, it is difficult to form any clear idea of what the lost original looked like.

The Athena, too, remains elusive. The statue itself disappeared some time during the Middle Ages, and all we have left are some rather long descriptions (concerned mostly with details of the decoration), a few large-scale copies of small parts of the statue (for instance, the shield or the sandals) and some small copies of the whole – souvenirs that were probably made for the Romans, the tourists of antiquity (Figs 184 and 185). These unattractive statuettes show a grim goddess confronting the observer with uncompromising frontality. Her weight rests on her right leg; she holds her elaborately decorated shield with her left hand, while she extends her right to receive a small figure of Victory which alights upon her palm. Though probably accurate enough in giving an idea of the pose and attributes, these drastically reduced copies (no more than one-tenth the scale of the original), executed by mediocre workmen in inferior materials, miserably fail to convey any sense of the quality of the work, which must have been remarkable.

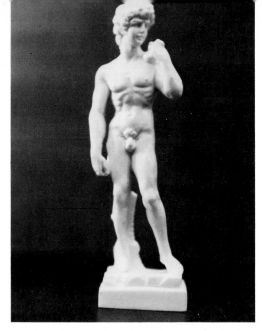

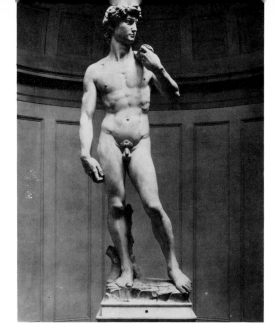

186. David by Michelangelo, modern copy in plastic, on a reduced scale, of Fig 187 (0.14 metres high)

187. David by Michelangelo, 1502-4, colossal marble statue, Accademia, Florence (5.41 metres high)

Souvenir copies of famous works of art usually present a travesty of the creations they are meant to recall. A modern analogy is offered by a 14-centimetre copy in plastic (Fig 186) of Michelangelo's five-metre marble statue of David (Fig 187). If the original were lost and we had only the copy, we could learn from it something of the pose and proportions of Michelangelo's masterpiece, but we would find it difficult to imagine the magnificence of the conception and the subtle treatment of the marble. The copies of the Athena in the Parthenon (Figs 184 and 185) are similarly limited in the kind of information that they give us.

A rather larger copy by a more gifted artist made in the 2nd century BC (Fig 188), though less literally exact, may actually reflect the spirit of the original rather better. The liveliness of the features and the sense of energy compressed within the quiet pose suggest that Pheidias' image combined grace with power.

In antiquity, scant attention was paid to the lavish sculptural decorations on the exterior of the temple and all praise was reserved for the wondrous image within. Its design and execution must, therefore, have been even finer than the most beautiful of the surviving architectural sculptures, difficult as this is to believe.

Polykleitos

While Pheidias was acclaimed the supreme creator of images of gods during the high classical period, his slightly younger contemporary Polykleitos obtained similar renown for his statues of men. Unlike the Athenian Pheidias, whose influence was widespread, Polykleitos' work was mostly confined to the neighbourhood of his native Argos in the Peloponnese. Since he was primarily a bronze-caster, he was more interested in analysing the anatomy and arranging the nude forms of figures than in exploring the expressive potential of drapery – something that was better done in marble anyway, as can be seen in the pediments of the Parthenon.

Polykleitos developed a theory of proportions which he expounded in a treatise called the *Canon* (the 'measure' or 'rule') and illustrated by a statue he made of a youth carrying a spear, thereby becoming, as one ancient critic observed, the only sculptor to have 'embodied the rules of art within a work of art'.

Neither the treatise nor the statue have

The Spear-bearer is shown pausing for an instant as he steps forward (Fig 189) – a stable image which retains the suggestion of movement. His activity is slight compared with the dramatic vigour of Myron's Discus-thrower (Fig 124), yet his torso is fully responsive to it. The Spear-bearer (Fig 189) held the spear in his left hand (to our right); his left shoulder is therefore tensed and slightly raised. His left leg bears no weight and the hip drops; thus, the torso on this side is extended. The Spear-bearer's right arm hangs relaxed by his side and the shoulder is lowered. His right leg supports his weight so that the hip is raised. The torso between hip and armpit is contracted.

The contrast of contracted torso on one

189. Spear-bearer (Doryphoros) by Polykleitos, Roman copy in marble of a bronze original made around 440 BC, Museo Nazionale, Naples

188. Athena Parthenos by Pheidias, free Hellenistic copy in marble, on a reduced scale, of the colossal chryselephantine original created between 447 and 438 BC, Antikensammlung, Staatliche Museen zu Berlin (3.51 metres high)

survived. Roman copies of the Spear-bearer (Fig 189) coarsen the delicate surface of the bronze original and conceal the subtle mathematical scheme on which it was constructed; nevertheless they do help us to appreciate something of Polykleitos' achievements.

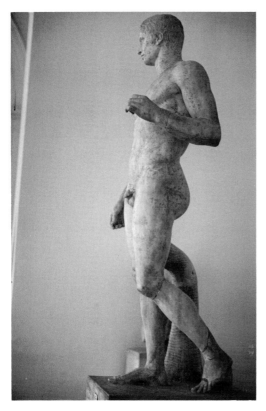

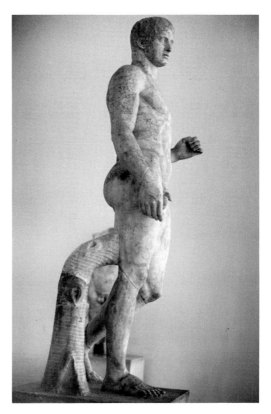

190. Spear-bearer, left side of Fig 189

191. Spear-bearer, right side of Fig 189

side and extended torso on the other holds the body in dynamic equilibrium; this is the classical balance of opposites that we have seen in the design of the architectural sculptures of the Parthenon (Figs 172 and 176), applied here to a single figure.

The side views, unlike those of earlier figures represented in action (Figs 123 and 126), are both intelligible and harmonious. Each has its own character. The left side (Fig 190) is enlivened by the angular elbow and the bent knee, while the right side, with pendant relaxed arm and vertical supporting leg, is animated by the turn of the head (Fig 191). This view was so much appreciated in antiquity that an Argive relief sculptor of the late 5th or early 4th century BC adopted it for his representation of a spear-bearer leading a horse (Fig 192).

To some extent this design was already prefigured in early classical statues of figures in repose (cf. Figs 115-118), but Polykleitos has made two important changes in the earlier formulation: first, he has shown the relaxed leg drawn back so that the Spear-bearer seems to be in motion, caught in the midst of a step, and second, he has modified the severity of the upper part of the body so that the shoulders incline, in response to the movement of the arms, in the opposite direction to the incline of the hips. This can be perceived better from the back of the statue (Fig 193) and was developed more fully by Polykleitos in his later works (cf. Fig 194).

Polykleitos has produced a figure that seems to be in action, but in which the shortcomings of earlier representations of

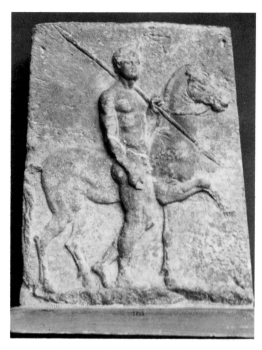

192. Spear-bearer with a horse, relief from Argos, late 5th or early 4th century BC, National Archaeological Museum, Athens

figures in action have been overcome: the torso responds to the movement of the limbs, and the sides are as lucid as the front and back. It is as if he had rediscovered the virtues of the ambiguity of the standing-walking pose of the kouros with its four fine views, but replaced the rigid bilateral symmetry of the kouros with the calculated contrast of one side of the body with the other to give a more natural appearance.

The Spear-bearer was probably created around 440 BC. About a decade later, Polykleitos made a bronze figure of a youth tying a fillet or ribbon around his head, the *Diadoumenos*, which is preserved only in Roman copies (Fig 194). The careful opposition of relaxed and tensed limbs has here been sacrificed for the sake of a more graceful rhythm. Both arms are raised this time, the left higher than the right. A gentle double curve runs through the torso. The different parts of the body are

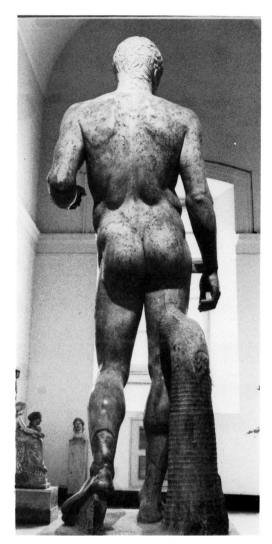

193. Spear-bearer, back of Fig 189

markedly tilted in different directions (Fig 195). Internal self-containment is thus suggested through the living balance of the body rather than by means of static organisation in terms of clear verticals and horizontals such as was imposed on the kouroi (Fig 196).

The Polykleitan invention in which hips and shoulders slant in opposite directions so that the two sides of the body are contrasted and yet, taken together, com-

133

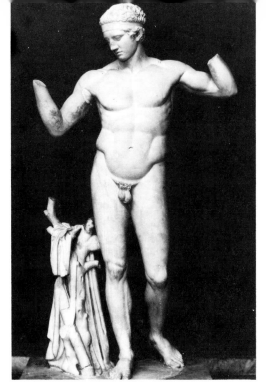

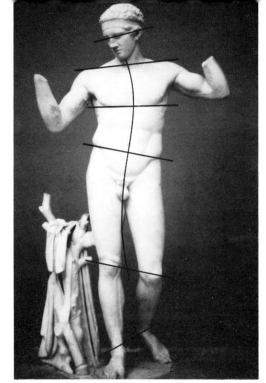

194. Youth winding a fillet or ribbon around his head (Diadoumenos) by Polykleitos, Roman copy in marble of a bronze original from around 430 BC, National Archaeological Museum, Athens

195. Diadoumenos (Fig 194), with lines showing the compositional effects of using contrapposto

196. Kouros (Fig 44), with lines showing the compositional effect of archaic organisation in terms of bilateral symmetry

pensate for one another to produce a dynamic equilibrium is called *contrapposto* (Figs 189 and 194).

Vase painting

Some red-figure vase painters seem to have fallen under the spell of the Parthenon, and they tried to produce images of comparable serenity and grandeur. Thus one painter made his scene of cattle led to sacrifice (Fig 197) imitate in mood and form the analogous procession on the Parthenon frieze (Fig 168); and another made the fleeing woman in his mythological illustration (Fig 198) resemble the running messenger in the east pediment of the Parthenon (Fig 177). Despite their good intentions, the efforts at dignity and solemnity made by these humble craftsmen appear rather pompous and vapid, and their use of a profile eye with a very short lower lid makes their figures seem sentimental.

Occasionally one finds something better. A serious note, both grave and moving, has

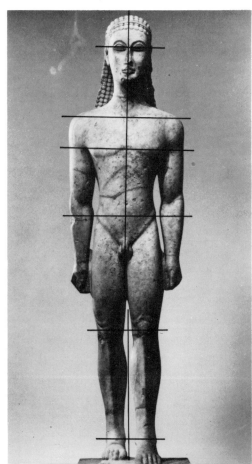

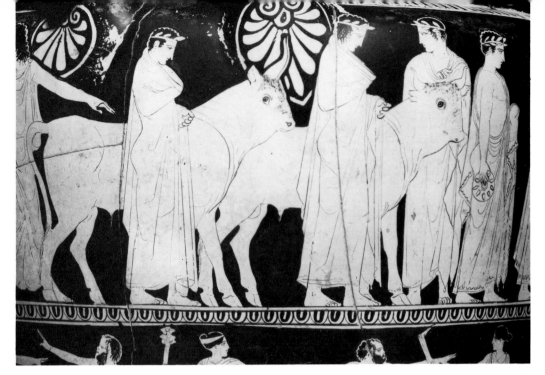

197. Cattle led to sacrifice, Attic red-figure krater, painted by the Kleophon Painter, third quarter of the 5th century BC, Museo Archeologico Nazionale, Ferrara

198. Amymone fleeing from Poseidon, Attic red-figure lekythos, painted by the Phiale Painter, third quarter of the 5th century BC, Metropolitan Museum of Art, New York

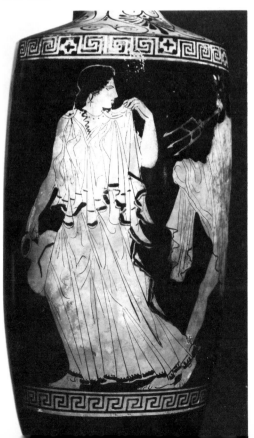

been struck by the so-called Lykaon Painter in his representation of Odysseus. The hero is shown seated at the edge of the Underworld beside the sheep he has sacrificed, watching his erstwhile companion Elpenor emerging from the reeds at the left to ask for decent burial (Figs 199 and 200). Elpenor had unwisely gone to sleep on a roof when he was drunk, and having forgotten where he was upon wakening and making haste to join Odysseus, had plummeted to his death. Odysseus, though still living, had come to seek information from the land of the dead, where he found that Elpenor had preceded him. Odysseus sits listening attentively, while Elpenor, visible from the knees up, explains his plight. The rocky landscape is indicated by thin lines, behind which or upon which the figures are placed (Fig 200). Hermes is shown at the far right. He does not appear in Homer's account of this scene, but because he was the conductor of souls to the Underworld, the painter decided that he had a place here. The three-quarter view of Elpenor's face and body is rendered with great skill; Euthymides would have been filled with admiration (pp. 64-6). But though the

drawing is effective and convincing, it lacks the clarity and decorative beauty so characteristic of earlier vase painting. Here we see the dilemma that was overtaking red-figure vase painting in the third quarter of the 5th century BC. As representational skill and sophistication in the arrangement of figures in space grew, the emphatic linearity and sharp contrasts of colour most appropriate to the red-figure technique became increasingly unfashionable.

By now few outstanding artists were painting vases. Among those who were, most found the white-ground technique more amenable to their artistic aims than red-figure. The finished surface of white-ground vases was, however, too delicate for them to be suitable for everyday use. Thus although a number of cup interiors had been painted in the white-ground technique during the first half of the 5th century BC (Figs 152 and 153), from the third quarter onwards the technique came to be reserved for the lekythoi that were presented as offerings to the dead.

The so-called Achilles Painter was a great master of white-ground lekythoi. He painted quiet scenes – a woman offering a man his helmet (Fig 201), a mistress receiving her jewel box from her maid

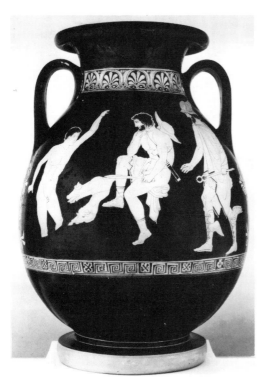

199. Odysseus meets Elpenor in the Underworld, Attic red-figure pelike, painted by the Lykaon Painter, third quarter of the 5th century BC, Museum of Fine Arts, Boston

200. Odysseus meets Elpenor in the Underworld, drawing of Fig 199

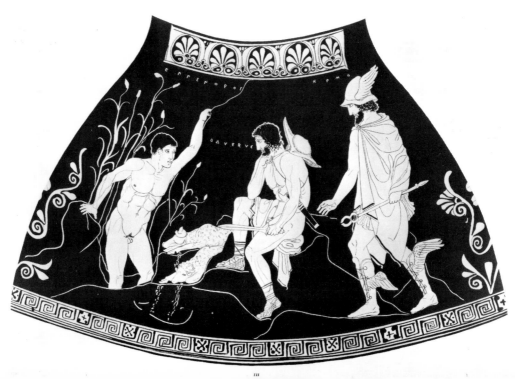

201. Woman and man, Attic white-ground lekythos, painted by the Achilles Painter, third quarter of the 5th century BC, British Museum, London

202. Seated woman and maid, Attic white-ground lekythos, painted by the Achilles Painter, third quarter of the 5th century BC, Staatliche Antikensammlungen und Glyptothek, Munich

(Fig 202), young men standing beside their tombs, women bringing offerings – with eloquent simplicity. Long, sure, unbroken lines were used to outline the calm figures and a wider than usual range of colours was applied to enliven them. Since these vessels were intended for the grave rather than daily use, painters felt free to employ flat washes of colour which were not as durable as those used on more utilitarian pottery. Thus the colour which once covered the dresses of the women has often disappeared, revealing the nude figure that the artist had sketched in order to be quite sure about the way the body was placed under the drapery (Fig 201).

These fine vases are the painted counterparts of the architectural sculpture of the Parthenon, dignified without being pretentious, graceful without becoming trivial. To us they are breathtakingly beautiful, but in antiquity they were considered minor works executed by humble craftsmen, hardly worthy of notice. The ancient writers pass over them virtually in silence, reserving their attention for those more celebrated works by great masters which are probably lost to us forever.

137

11

Art in the Last Quarter
of the 5th Century BC

Draped female figures

During the early classical period an austere
and serious style was formulated; in the
high classical period strength and grandeur
were tempered by ampler rhythms and
softer forms; by the end of the 5th century
BC a rich style was developed in which
elegance, decorativeness and linear grace
superseded all other values.

These three stages can be illustrated by
three draped female figures, all wearing
woollen peploi (Figs 203-205).

The early classical statue, preserved in a
Roman copy (Fig 203), is rendered with
great simplicity. The line of the overfold
cuts a severe horizontal across the figure;
the pouch that is visible just below the
overfold lacks elaboration. The figure looks
restrained when compared with the quiet
dignity and unaffected majesty of a high
classical goddess (also known only through
a Roman copy, Fig 204). The high classical
drapery appears softer, the full pouch dips
more toward the sides; and the pose seems
relaxed and easy. But even so gracious a
figure as this looks reserved beside the
almost finicky refinement that became
fashionable in the later 5th century BC and
can be seen in one of the maidens from the
Erechtheum (Fig 205). The drapery
gathered to form the pouch here describes a
sweeping curve over belly and hips, and
falls, like that over the weight-bearing
right leg, in minute folds. Illogically, the
drapery over the bosom and the left leg
looks so thin as to appear transparent. This
effect was achieved by carving parts of the
figure as if they were nude (the breasts and

203. Goddess, Roman copy in marble of a Greek
original made in the second quarter of the 5th century
BC, Museo Communale, Rome

the left leg), but leaving narrow ridges of stone protruding from the surface at wide, irregular intervals to suggest that a thin veil of cloth is covering the body. The impression would have been strengthened by the addition of paint which would have clearly indicated which parts of the body were supposed to be draped.

Such effects were already being developed when the Parthenon pediments were carved, and they were sometimes combined with 'modelling lines' (Fig 178) or with 'motion lines' (Fig 177). By the last quarter of the 5th century BC, they had become so popular that they began to be used even in defiance of reality. A real peplos was worn in such a way that two layers of woollen cloth actually covered the bosom (Fig 73); this fact is blithely ignored by the sculptor of the Erechtheum maiden (Fig 205). New values were now emerging;

204. Goddess, Roman copy in marble of a Greek original made in the third quarter of the 5th century BC, Cherchel, Algeria

205. Maiden, from the Erechtheum, last quarter of the 5th century BC, British Museum, London

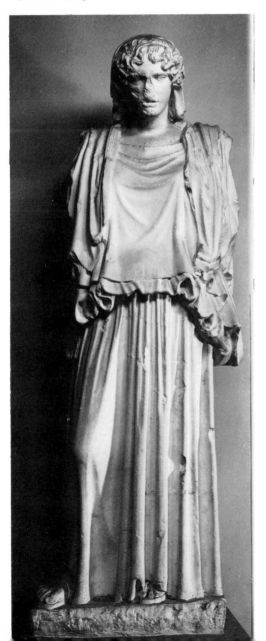

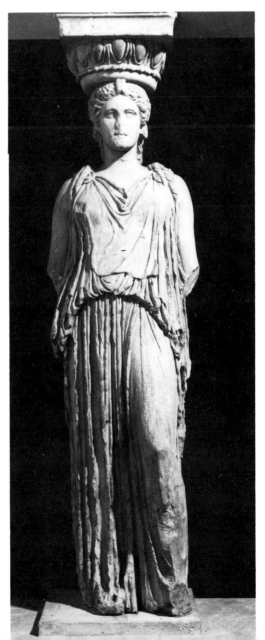

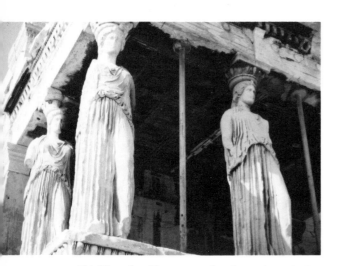

206. View of maidens supporting the south porch of the Erechtheum, Acropolis, Athens. The Erechtheum was a temple built by the Athenians in the last quarter of the 5th century BC on the north side of the Acropolis, across from the Parthenon. Its design was unusual and included porches on its north and south sides which were not a normal part of Greek temples. The roof of the south porch was not supported by columns, but rather by the maidens shown here.

charm has begun to displace nobility, delicacy to supplant dignity and decorative detail to replace naturalism.

The Erechtheum maiden, carved probably in the teens of the 5th century BC, was one of six such maidens who were used instead of columns to support the south porch of the Erechtheum (Fig 206). A particularly sensitive appreciation of the beauty of pure pattern can be seen in the back view of another of the Erechtheum maidens (Fig 207), each of which was slightly different from the others. Here the elaborately stylised hair, symmetrically arranged, surmounts the cascade of U-shaped catenary folds described by the cloak. These contrast with the simple vertical pleats of the skirt to produce a design more complex but no less powerful than that of the Berlin goddess a century and a half before (Fig 67).

The style favoured in the last quarter of the 5th century BC for draped female

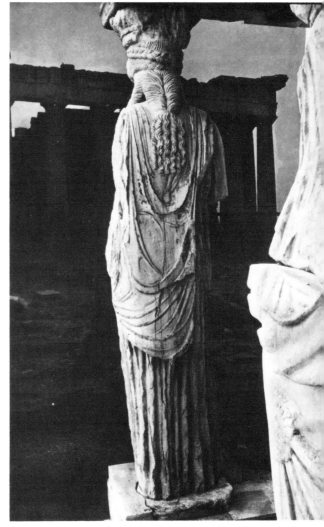

207. Maiden from the Erechtheum, back, last quarter of the 5th century BC, Acropolis Museum, Athens

figures delighted in decorative linear effects applied to the surface of a statue. There was little interest in manipulating the underlying three-dimensional forms. Line was everything; mass counted for little. The play of lines could be used to animate otherwise tranquil figures. Thus a motionless standing figure of Aphrodite is engulfed in a swirl of vigorous curvilinear drapery (Fig 208). Unconstrained by the architectural function that the Erechth-

140

208. Aphrodite, last quarter of the 5th century BC, Agora Museum, Athens

209. Nike untying her sandal, from the balustrade of the temple of Athena Nike, last quarter of the 5th century BC, Acropolis Museum, Athens

eum maidens had to serve, an artist could use a figure like this almost as an excuse for his virtuoso rendering of exuberant drapery.

Figures carved in relief provided an even better field for linear enrichment. Some of the most beautiful come from the balustrade that was erected around the temple of Athena Nike on the Athenian Acropolis in the last quarter of the 5th century BC (Figs 209 and 210). On this balustrade, images of victories (*Nikai*: singular, *Nike*) were shown bringing cattle for sacrifice or decking trophies in honour of Athena, who was herself represented seated on each of the three sides of the balustrade.

Fig 209 shows one of the Nikai stooping to adjust her sandal. Transparent drapery thinly veils her body. Her cloak, draped over her raised right thigh and suspended from her left arm, falls in a bold pattern of catenary folds, varied, yet harmonious, to give grace and stability to what otherwise might seem to be an ungainly figure.

Other linear devices are applied to another Nike (Fig 210, right), who halts momentarily in her forward stride as her

companion restrains a restive animal. Her body is posed in a static lunge, but the swirling drapery makes it look lively and full of action. Double curves in rich variety enliven the image; they move horizontally above the waist, undulate vertically to the right of the figure and swing back diagonally between the legs. The suggestive power of such 'motion lines' was already appreciated by the sculptors of the Parthenon pediments (Fig 177), and the

210. Two Nikai bringing cattle to sacrifice, from the balustrade of the temple of Athena Nike, last quarter of the 5th century BC, Acropolis Museum, Athens

formula was quickly adopted by vase painters as well (Fig 198). During the last quarter of the 5th century BC such formulae came to be valued for their decorative potential as much as for their descriptive effectiveness, as can be seen in this wonderfully calligraphic relief.

Attic grave stelai

Figures gorgeously attired in complicated curvilinear drapery show one aspect of late-5th-century BC style. There was also another, more sober side to art at this time; it is best seen in the grave stelai which, after a lull in the earlier part of the century, were carved in Athens again from the third quarter of the 5th century BC.

A broader format was now preferred to the one that had normally been used in the archaic period (cf. Figs 59-63). Figures were often shown seated, alone or with others (Figs 211 and 212). On a stele carved towards the end of the 5th century BC, the

211. Grave stele of Hegeso, end of the 5th century BC, National Archaeological Museum, Athens

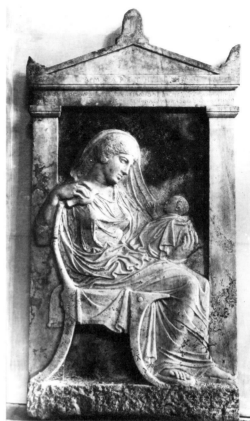

212. Grave stele of Ampharete, end of the 5th century BC, Kerameikos Museum, Athens

dead woman Hegeso sits at the right selecting an ornament (originally indicated in paint) from the jewel-box held for her by a patient slave girl (Fig 211). The scene is not very different from one on a white-ground lekythos (Fig 202), but the composition on the grave stele has been monumentalised. The dead woman is made proportionally larger so that the heads of the two figures are almost level. The image no longer simply reflects an everyday event, as the vase does, but by imposing upon it a strong formal structure has imparted to it both solemnity and grandeur. The composition is dominated by repeated verticals and horizontals framing the central action and suggesting a quiet, serious mood. The exuberant curves

of the Nike balustrade (Figs 209 and 210) have no place here; yet the fine, transparent drapery which falls around the necks in catenary folds and subtly models the legs of the figures is in the same style.

The stele of Ampharete (Fig 212) shows the dead woman holding her dead grandchild on her arm. A few flowing curves are used here to enliven the melancholy scene, but the graceful figure remains restrained within the simple composition. The dead woman gently inclines her head towards the gesticulating little bundle she holds so fondly, but her serious, serene expression remains unruffled. As in the archaic grave stele of a mother and child (Fig 62), the understated, almost unemotional, directness and simplicity of the representation succeeds in conveying tender feelings.

Late-5th-century BC grave stelai like these discreetly combine the new fashions in the rendering of transparent drapery with the quiet dignity that distinguishes the figures on the Parthenon frieze (cf. Figs 170 and 171).

Vase painting

The rich style of the late 5th century BC with its graceful figures and delicate, light draperies could inspire some very attractive red-figure vase paintings, especially in scenes with women. The Eretria Painter produced particularly charming works around 420 BC (Fig 213). The poses of his women seem spontaneous and natural, and they are prettily varied. Thin, transparent drapery that falls in numerous fine folds is contrasted with thick cloaks. The dense patterns produced by the drapery and furnishings are balanced against the simplicity of the heads on their long necks and the bare arms and feet. Though the sense for decorative organisation remains strong, figures are now rendered more naturalistically than they had been at the beginning of the century, as can be seen by comparing the woman lifting her cloak and looking

213. Women indoors, Attic red-figure epinetron, painted by the Eretria Painter, about 425 BC, National Archaeological Museum, Athens

143

behind her (second from the left in Fig 213) by the Eretria Painter with a similar figure painted by the Brygos Painter (Fig 94).

A somewhat later hydria by the Meidias Painter is divided into two registers (Fig 214). The lower register shows Herakles in the garden of the Hesperides (Fig 215). A snake curls languidly round the tree with the golden apples, while one of the Hesperides stands, lifting her veil like a bride, before the seated hero. This was how the late 5th century liked to see Herakles: not fighting with monsters or wrestling with his implacable fate, but peacefully at rest, rewarded at last for all his labours. A few deft lines are all the Meidias Painter required to sketch the seated figure of the hero in a convincing three-quarter view. Even fewer lines suffice for the standing figure to his right. There is great skill here and fine control, but the contours are less eloquent than they were

214. Attic red-figure hydria, painted by the Meidias Painter, last quarter of the 5th century BC, British Museum, London (upper section, Girls abducted from a sanctuary of Aphrodite by the Dioskouroi; lower section, Herakles in the garden of the Hesperides)

215. Herakles with Hesperides (and others), detail of Fig 214

144

before, and the characterisations seem less profound. The three-quarter view of the girl's face is rendered with accomplished ease (contrast Fig 149). No doubt advances in wall or panel painting made this possible, but such effects, which must have been very successful in suggesting the three-dimensionality of a figure in other techniques, are not appropriate for red-figure vase painting, where the old-fashioned profile tells better against the black background.

Vase painters had to decide just how far they would follow the painters of walls and panels, who (according to our literary sources) were now exploring the use of shadows and modelling and analysing the representation of space in terms of rational perspective – feats that could ill be applied to red-figure vase paintings. Various uneasy compromises were tried. Some advances were adapted for use on vases with greater or less success.

The upper register of the hydria by the Meidias Painter shows the abduction of two sisters from a sanctuary of Aphrodite (Fig 214 and detail, Fig 216). The stiff cult statue in archaic style (far right upper corner, its head obscured by the lip of the vase in the photograph in Fig 216) contrasts with the soft and seductive forms of the women with their transparent drapery blowing in the breeze and their heads coyly tilted. The figures are scattered up and down the surface of the vase, without any effort at spatial coherence. The arrangement seems, rather, to be dictated by purely decorative considerations (Fig 214).

The delicacy of the figures and their drapery is almost too sweet, but the drawing of the racing horses (Fig 216) has a redeeming strength and elegance.

Painters of white-ground lekythoi which were used as grave offerings tackled different problems. The function of the vases helped painters resist the temptations of prettiness and over-elaboration.

216. One of the Dioskouroi carrying off a girl, detail of Fig 214

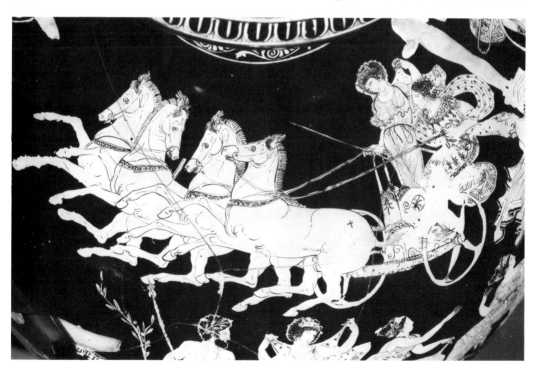

217. Woman seated on a tomb, Attic white-ground lekythos, painted by the Woman Painter, end of the 5th century BC, Staatliche Antikensammlungen und Glyptothek, Munich

Compositions remained uncomplicated and figures few. The comparatively simple style of the lekythoi (Figs 217 and 218) bears much the same relationship to the more ornate contemporary red-figure ware (Figs 213-215) as the reserved grave stelai (Figs 211 and 212) bear to the more decorative reliefs on the Nike balustrade (Figs 209 and 210).

By the last quarter of the 5th century BC painters of white-ground lekythoi had begun to use matt paint instead of dilute glaze, and this encouraged them to develop a new style of drawing (Figs 217 and 218). Outlines were no longer made sharp and clear but became softer and freer – more suggestive and less explicit. Contours were no longer defined by long, unbroken outlines; instead bold, discontinuous curves were used to hint at massive volumes (for instance, the back and legs of the

woman in Fig 217) or to indicate dramatic foreshortenings (as on the seated youth in Fig 218). Greater intensity of feeling was portrayed both in the faces and the poses of the figures. The muffled woman seated by a grave marker (Fig 217) is the late-5th-century BC counterpart of the grieving father painted by the Pan Painter half a century earlier (Fig 155). The drawing is looser, the suggestion of volume more convincing, the brooding expression deeper. The powerfully evocative motif, an early classical invention, has been reworked in terms of the new style.

The intense male figure seated before his own grave stele (Fig 218) probably reflects the innovations in foreshortening and emotional expressiveness that writers say were now being developed by the panel painter Parrhasios. Deft, short lines are used to suggest forms receding or advancing in space – notice how close the feet of the seated figure are to us, how effectively the thighs are foreshortened to show their recession into a further plane, and how cleverly the right forearm is made to seem as if it is advancing forward from the further plane. The figure is drawn so that it seems to have a complex relationship to the space it occupies; this is a figure that penetrates an imagined depth rather than simply decorates the surface. Both in conception and in the way he is drawn, this sad youth is different from anything that had been painted before (contrast Fig 201).

White-ground lekythoi made use of the same pale backgrounds as painted walls and panels, and this fact must have encouraged their painters to incorporate advances made in other fields of painting in their experiments with dramatic three-quarter faces and bold foreshortenings. The strongly contrasting background used in red-figure vase painting required artists to produce eloquent silhouettes if they wished to achieve satisfying effects. Painters of white-ground lekythoi were liberated from such restraints and so could freely pursue innovations in the representation of figures in space.

146

218. Man seated at a tomb between two standing men, Attic white-ground lekythos, end of the 5th century BC, National Archaeological Museum, Athens

Throughout the last third of the 5th century BC, Athens was embroiled in a debilitating war against Sparta and her Peloponnesian allies, which towards the end of the century was drawing to its disastrous conclusion. Although the griefs and anxieties caused by this war seldom seem to obtrude into the art of the period, they can, perhaps, be glimpsed in these darkly troubled images (Figs 217 and 218).

Portraiture

Many of the works of the late 5th century BC are highly ornate and decorative; some have a grave seriousness. Different tendencies began to develop simultaneously at this time, for this was a complex period. Art continued to flourish in Athens, but the long-drawn-out Peloponnesian war which the Athenians fought with more daring than wisdom was beginning to take its toll. By 404 BC when Athens was decisively defeated, the youth and power of the high classical period had been frittered away in wasteful aggressive campaigns. Nevertheless, the creative energy of the city remained astonishing: throughout the war moving tragedies and biting comedies were produced. Only a few of those by Sophokles, Euripides and Aristophanes have survived, but they are remarkable enough. Perhaps the most extraordinary phenomenon to emerge during the war years was Sokrates. A man of humble birth but outstanding intelligence – provocative, inspiring, irritating and edifying, he strolled around the city disturbing or delighting everyone he could find to engage in conversation. He was so notorious that Aristophanes drew laughs by caricaturing him in his comedy *The Clouds*, and so stimulating that Plato drew a lifetime's inspiration from youthful contact with the man and his teachings.

Sokrates was as strikingly ugly in appearance as he was morally exemplary in character. To the Greeks, beauty and goodness traditionally went together; Sokrates, in his person, gave the lie to this

219. Head from a portrait of Themistokles, Roman copy in marble from a full-length original made in the second quarter of the 5th century BC, Museo Ostiense, Ostia

and interest in depicting different kinds of characters had been aroused (p. 72). It is not surprising that efforts should now be made to record the actual features of a famous person. Such is the portrait of Themistokles (Fig 219). The original statue was, like all Greek portraits, full length, for the body was considered as expressive of personality as the face. The Romans, however, thought the head was enough, so that was all they copied. The head of Themistokles, the ingenious man who engineered the Greek victory at Salamis, shows the traits of the early classical style – its severity and bold expressiveness – but it also presents an image of an unusual, powerful and determined man.

The high classical period was less interested in specific characterisations, less willing to sacrifice ideal beauty to expressive realism. Thus the Roman copy of the head of a portrait of Perikles made during this period (Fig 220) reveals much less individual personality than the portrait of Themistokles. The aloof, idealised rendering of the great statesman shown with regular features and a lofty expression was no doubt influenced by the image that Perikles himself wished to project, echoes of which can be found in Plutarch's biography.

A portrait can be designed to reveal a person's character or to record his features. It is not always easy to combine the two. Sokrates with his ugly satyr-like features and his intense moral integrity presented a more difficult subject than the statesman-generals of the earlier 5th century BC. Literary portraits of the late 5th and early 4th centuries BC wrestled with the problem. Xenophon tried to resolve the paradox of Sokrates' external ugliness with his internal beauty by revising the definition of beauty itself. Thus he presents Sokrates as arguing in humorous defence of his appearance that those things are most beautiful which are best suited to their functions, and therefore his bulging eyes which provided him with superior lateral

conventional association. It was, therefore, not only in discussions that Sokrates overturned traditional beliefs and conventional wisdom, but also in his very being. The challenge of trying to create a portrait of the man in which the beautiful character that underlay the unattractive exterior would be revealed now began to appeal to artists.

During the archaic period, little effort had been made at any kind of personal portraiture; the means were not available. It was difficult enough to make a statue look like a man without trying to make it resemble a particular man. Any kouros could serve as a portrait if a specific name were attached to it.

Images of individuals that actually reflected their physical appearance began to be made in the early classical period. The necessary skills had been acquired,

148

a moment whatever Sokrates commanded.'

Could artists capture so elusive an image? We have Roman copies of a head of Sokrates (Fig 221), a man with satyr-like features (cf. Figs 95 and 96), yet with something quizzical, intelligent, spiritually alive infused into them. Whether the original that these reflect was made towards the end of the 5th century BC or near the beginning of the 4th is debated, but they must have been close in time to the man they represented (Sokrates was executed in 399 BC). Efforts to depict Sokrates, to convey his unusual combination of fine character and ugly appearance in one complex vision, helped to stimulate a more profound approach to portraiture, one that blossomed only in later times.

221. Head of Sokrates, Roman copy in marble from a full-length original probably made at the end of the 5th century BC, Museo Nazionale, Naples

220. Head from a portrait of Perikles, Roman copy in marble of a full-length original made by Kresilas in the second or third quarter of the 5th century BC, British Museum, London

vision should be judged more beautiful than those conventionally regarded as handsome, that his wide, flaring nostrils were better for receiving scents, his big mouth better for biting off food, and so on.

Xenophon is amusing in his attempt to make Sokrates' ugliness seem to be beauty, but still we are left with a caricature.

A portrait should go deeper. The way was pointed in Plato's *Symposium*. Plato has Alkibiades describe Sokrates: 'I say he is exactly like the busts of Silenus [an ageing satyr] which are set up in the statuaries' shops ... and ... made to open in the middle and have images of gods inside. ... his outer mask is the carved head of Silenus ... but ... within I saw in him divine and golden images of such fascinating beauty that I was ready to do in

12

Sculpture of the 4th Century BC:
The Opening of New Horizons

The rediscovery of massiveness and simplicity

The development of new techniques in marble carving during the 5th century BC had been impressive. Formulae had been invented to indicate movement, to suggest transparency and to model forms. Creative Greek artists of the 4th century BC appreciated these achievements, but were unwilling simply to apply them to the point where they lost their freshness and became hackneyed studio shorthand devices. (Later sculptors were often less scrupulous.) Since little improvement was possible along the old lines, a change in direction became essential.

The nature of this change becomes apparent when one compares a work from the last quarter of the 5th century BC with one made in the first quarter of the 4th. The Nike carved by Paionios about 420 BC was a masterpiece of late-5th-century BC sculpture (Fig 222). It was originally placed some ten metres above the ground on a triangular pillar so that the impression was created of Victory herself rushing down from the heavens. The speed of her descent is conveyed by the way her drapery billows out behind her – originally it was more abundant and the cloak held in her left hand bellied out like a sail, providing a bright, coloured background to her body. The characteristic linear formal devices of the late 5th century BC – transparency, modelling lines and, most especially, sweeping motion lines – are cleverly deployed to create a vivid illusion. The Nike was shown facing full front, leaning forward a little; the drapery was used to give her flight drama and impact.

The *acroterion* (a figure designed to stand on top of one of the three angles of the gables of Greek buildings) carved for the temple of Asklepios at Epidauros in the first quarter of the 4th century BC (Fig 223) is a similar figure, but the principles on which it was designed are different. Emphasis has shifted away from reliance on the suggestive potential of lines to a bolder depiction of masses. The drapery itself is more substantial but less important in defining the figure and its action; the assertive volumes of bosom and thigh are stressed instead. Furthermore the body does not simply face forward, but is twisted on its axis so that the upper part turns slightly to her left while the lower part is rotated to her right. Thus the figure has been designed to have a complex relationship to the space it occupies and to appear interesting from more than one point of view. Space and mass are now beginning to count for more than plane and line.

Draped female figures created in the late 5th century BC were often elaborate and artificial. In the early 4th century BC such qualities were rejected; simplicity and naturalism once more gained in value. This can be seen in the contrast between the decoratively draped Aphrodite of the late 5th century BC (Fig 208) and the stately figure of Eirene (Peace), a Roman copy of a

222. Nike by Paionios, about 420 BC, Olympia
Museum, Olympia

223. Acroterion from the temple of Asklepios at
Epidauros, beginning of the 4th century BC, National
Archaeological Museum, Athens

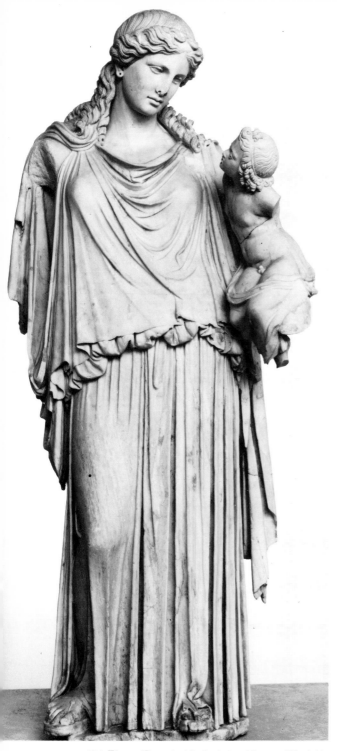

224. Eirene (Peace) with the infant Ploutos (Wealth),
Roman copy in marble of an original by Kephisodotos,
made around 375 BC, Staatliche Antikensammlungen
und Glyptothek, Munich

work created around 375 BC (Fig 224),
when the cult of Peace was established in
Athens. Thin, transparent clothing ani-
mated by means of curvilinear patterns
(Fig 208) has been replaced by simple,
heavy, enveloping drapery that falls in
straight, natural folds (Fig 224).

New formal and intellectual developments: groups and ideas

The Eirene of Kephisodotos (Fig 224) is not
just a single figure, but a concise group;
and it is not simply an image, but also an
idea embodied in sculptural form.

Eirene holds a baby on her arm. The
relationship between the two is suggested
by the way the baby turns towards the
goddess and the way she gently inclines her
head towards him, very much the sort of
thing we have already seen in the grave
stele of Ampharete (Fig 212). On that stele
tenderness was represented as a purely
human quality; here it is attributed to a
goddess. The exploration of the range of
human emotions (now in free-standing
statues as well as reliefs and paintings) on
the one hand and the humanising of the
gods on the other became matters of
increasing interest to artists in the 4th
century BC.

But there was more to the group than
simple naturalism and emotional tender-
ness, for the baby that Eirene holds on her
arm is the infant Ploutos (Wealth), and the
idea behind the image is that Peace is the
nurse of Wealth; that if nurtured by Peace,
Wealth will flourish and grow – a fact of life
much appreciated in basically agricultural
communities. Thus the statuary group
represents an abstract concept. Such an
analytic, intellectual approach to an image
is less surprising than it might be when we
realise that this was a time when philo-
sophy was developing rapidly and philo-
sophers were beginning to analyse concepts
along rather similar lines.

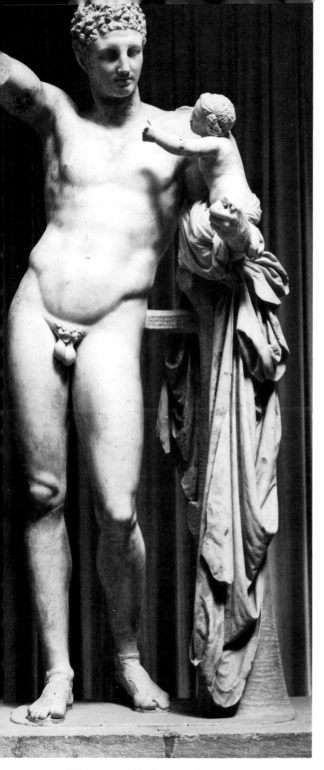

225. Hermes with the infant Dionysus by Praxiteles, third quarter of the 4th century BC, Olympia Museum, Olympia

Humanising images of the gods: Praxiteles

The most famous example we have of a group of an adult with an infant was created by the man who was probably Kephisodotos' son, Praxiteles (Fig 225). It represents the messenger god Hermes carrying the baby god of wine, Dionysus, to the nymphs who will bring him up. The grown god originally dangled a bunch of grapes temptingly before the baby, who, sensing his destiny, reaches greedily for them (see p. 171).

Sculptors working in the 5th century BC had created nude male figures in a variety of new poses and had learned how to make their anatomy responsive to the position of their limbs. The greatest advances were made in bronze, since the tensile strength of the material permitted sculptors to experiment freely without anxiety about how their figures would be supported. In the 4th century BC Praxiteles revealed that marble had qualities which could be used to convey the softness of flesh and the radiance of skin, for while earlier artists had been largely concerned with showing the body as a rational mechanism with bones and muscles held in dynamic equilibrium, Praxiteles was interested in texture and surface as well.

Hermes' body is tall and slender, his head proportionately smaller than was usual in the 5th century BC (cf. Figs 189 and 194). He stands indolently off-balance in a relaxed, languid pose. His weight is on his right leg and his right arm is raised so that the whole figure is dominated by the swinging rhythm of curve and counter-curve. The self-contained balance produced by Polykleitos' contrapposto (pp. 131-4) is abandoned for the design of this statue, and the tree trunk with the drapery to the right is as important as a visual and psychological support for the leaning figure as it is necessary as a physical support for the heavy mass of marble.

Copies of the most famous of all Praxiteles' statues, the marble Aphrodite

153

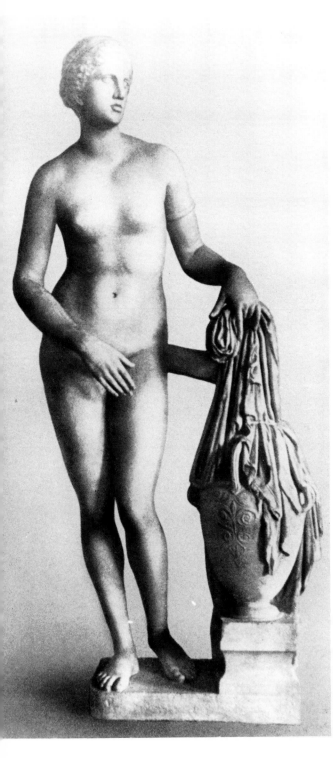

226. Aphrodite of Knidos, Roman copy in marble of a marble statue made by Praxiteles in the third quarter of the 4th century BC (from a composite cast: body in the Vatican, Rome, Kaufmann head in the Louvre, Paris)

of Knidos (Fig 226), showed that Praxiteles could, when he wished, also make use of Polykleitan contrapposto in a creative and original way.

The Knidian Aphrodite is the first large-scale Greek representation of a female nude. Most earlier images of Aphrodite had shown her clothed (cf. Fig 208), and women whose professions (courtesans) or predicaments (e.g. Cassandra in Fig 99) left them naked appeared only in the minor arts (vase paintings, terracottas and small bronzes).

Praxiteles' masterpiece demonstrated that sensuousness as well as equilibrium can be conveyed by applying contrapposto to the female form. Aphrodite (Fig 226) rests her weight on her right leg, raising the hip on that side; her right shoulder is lowered as she holds her hand modestly in front of her genitals. That side of her torso is contracted, while the other side is extended. The incline of her shoulders (downward to our left) contrasts with the incline of her hips (downward to our right) to produce a rhythm that is both organically alive and dynamically balanced. The weight-bearing foot is slightly in advance of the other; the knees are pressed together so that the swelling mass of thighs and hips expands gracefully from the narrow base. The formal arrangement that had originally been devised for an athletic male figure has been brilliantly modified to become a vehicle to reveal the newly discovered charm of the feminine form.

Aphrodite looks sharply to her left, as if suddenly disturbed. Her nudity is explained by the fact that she is preparing to bathe. She holds her clothing to one side; it falls over the hydria containing the water she needs. The limp, inert drapery and the rigid water-jar contrast with the soft, living body of the goddess. The statue has been carefully worked out in terms of contrasts

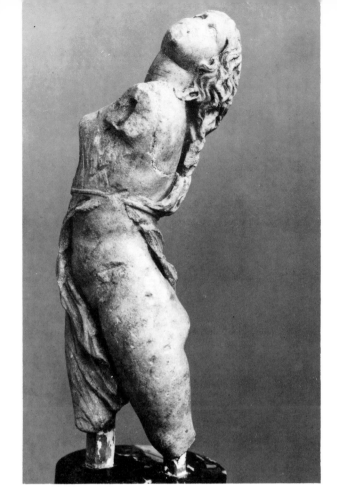

227. Raging maenad, Roman statuette copy in marble of an original by Skopas made in the third quarter of the 4th century BC, Staatliche Kunstsammlungen, Dresden

228. Raging maenad, side view of Fig 227

and composition. The hydria and the drapery provided the supports that were required for sculpture in marble, but an artist as skilful as Praxiteles would probably have found a way of doing without the strut at the hip which the copyist found necessary.

Praxiteles' Aphrodite at Knidos was extravagantly admired in antiquity. Poets vied with one another to sing the statue's praises; one exclaimed: 'Who gave a soul to marble? Who saw Aphrodite on earth? Who wrought such love-longing in a stone? This must be the work of Praxiteles' hands, or else perchance Olympus is bereaved since Aphrodite has descended to Knidos.' Another observed: 'You will say, when you

look on Aphrodite in rocky Knidos, that she, though stone, may set a stone on fire ... ', and others suggested that Praxiteles' image of the goddess was so perfect a likeness that she herself inquired 'Where did Praxiteles see me naked?'

None of the extant copies does justice to this celebrated statue, and even a combination of the best elements of different copies (Fig 226) leaves a great deal to be desired. The delicacy of the surface, the radiance, joyousness and captivating loveliness that were so highly praised by the ancient critics are lost forever with the original, but we can still appreciate something of the idea behind this great work of art.

The motif of taking a bath is an everyday one, and the gracious goddess shown here

155

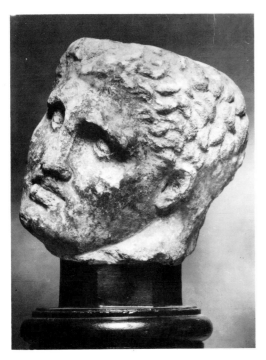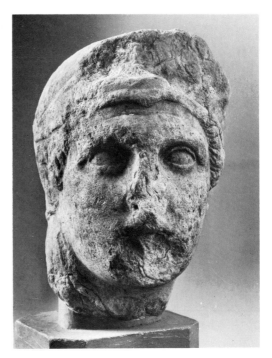

229. Two heads from the pediments of the temple of Athena Alea at Tegea for which Skopas was the architect, third quarter of the 4th century BC, Tegea Museum and National Archaeological Museum, Athens

seems very human, yet the ritual bath of Aphrodite also had special significance in a cult context. This blending of meanings – imparting a new humanity to divinities and at the same time preserving an allusion to their superhuman status – was characteristic of Praxiteles and applies as much to the baby Dionysus reaching for grapes (Fig 225) as to the bathing Aphrodite. The power of the gods is not forgotten, but they no longer are represented as so distant in their grandeur as they were in the 5th century BC (cf. Figs 184, 185 and 188).

The expression of passionate emotion: Skopas

The exploration and depiction of various emotions and of different kinds of characters had begun in the early classical period, but had virtually ceased during the high classical period. Formal problems of another kind had interested Pheidias and Polykleitos, and the enormous influence of these two artists induced other sculptors to follow their lead. Both were dead by the beginning of the 4th century BC and not long afterwards interest in portrayals of emotion and of character revived.

The 4th century BC was a period in which specialisation was gaining ground. Specialised mercenaries started to replace traditional citizen-soldiers, specialised athletes the all-rounders of the 5th century BC, and Plato argued that even statesmen should be specialised. As society became more complex, division of labour became more usual, and this development appears to have affected artists as well as others. Certain sculptors seem to have specialised in certain types of figures. The Athenian Praxiteles, for instance, excelled in the evocation of gentle, lyrical moods (cf. Figs 225 and 226), while his contemporary Skopas, from the marble-rich island of

Paros, was the master of passion. Skopas' renowned Raging Maenad no longer exists, but a Roman copy (Figs 227 and 228), though small and lacking in detail, still conveys the drama which he was able to infuse into his work. The violent turn of the head, the arched back and twisted torso contrast markedly with the serenity and calm of Praxiteles' Knidian Aphrodite (Fig 226).

The poise of the body alone is enough to capture the Maenad's frenzy, but this was not the only device that Skopas used. He also developed the potentialities of facial expression, only traces of which are visible in the copy of the Maenad. The rather square faces, deep-set, yearning eyes and dramatically parted lips that Skopas created to carry his conception of intensity of feeling can be seen in some of the heads, damaged though they are, from the temple of Athena Alea at Tegea (Fig 229) for which he served as architect. They are quite unlike the almond-eyed, tranquil ovals that Praxiteles delighted in.

The very different strengths of Skopas and Praxiteles, who appear to have been among the leading sculptors of the mid-4th century BC, were obviously appreciated by their contemporaries. The Megarians, for instance, employed both sculptors in their effort to modernise their temple of Aphrodite. They already had an ancient ivory image of the goddess, but in the 4th century BC they decided to elucidate and explain her divine powers more fully by means of the intellectual abstractions (like Peace nurturing the infant Wealth, Fig 224) that were now becoming fashionable. They therefore asked Praxiteles to create images of Persuasion and Consolation for them, the gentler sides of the goddess' realm, while Skopas was commissioned to give them Love, Desire and Yearning, the more passionate aspects of her sway – statues now known, alas, only through our literary sources.

230. Woman with her maid, grave stele from the Piraeus, second quarter of the 4th century BC, National Archaeological Museum, Athens

Attic grave stelai

The increased emotional intensity that could be rendered in the 4th century BC quite naturally affected funerary reliefs. Although a relief from the second quarter of the 4th century BC (Fig 230) greatly resembles the late 5th century BC grave stele of Hegeso (Fig 211) in subject and composition, the differences are telling. In both stelai, a maidservant holds a jewel-box before her seated mistress. In the 5th-century stele (Fig 211), Hegeso gravely selects an ornament; in the 4th-century relief (Fig 230), the dead woman has withdrawn into herself, muffled in her grief like the brooding figure on a white-ground lekythos (Fig 217). One foot drawn back restlessly, head bowed in sorrow, the emotion remains restrained and yet is more palpable than in the earlier relief.

The forms are simpler and more massive in the 4th-century stele; there is less linear play in the drapery, which is thicker and more enveloping. The carving of the relief is deeper, everything is squarer and heavier

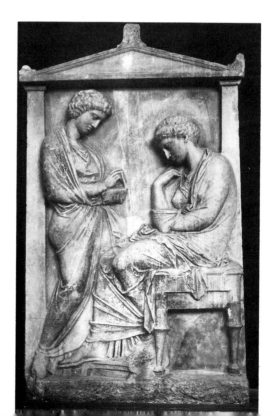

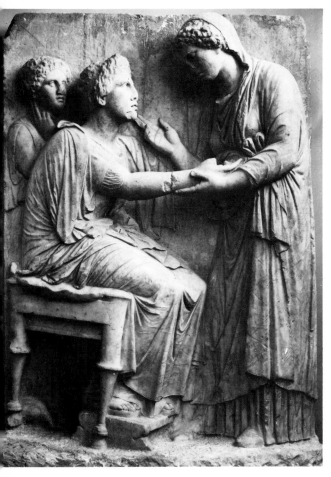

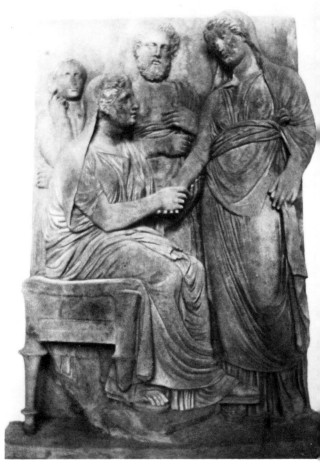

231. Two women and a girl, grave stele, third quarter of the 4th century BC, National Archaeological Museum, Athens

232. Two women with two other figures, grave stele, mid to third quarter of the 4th century BC, National Archaeological Museum, Athens

– the figures, their limbs, even the chair's legs and the jewel-box.

Emotion is more outspoken in a relief from the third quarter of the 4th century BC (Fig 231). The seated woman reaches out to the standing one, hands and wrists meet as the two look deeply, tenderly into each other's eyes. Many stelai at this time showed a seated figure and a standing one clasping hands, often in the presence of others. The craftsmen who carved these reliefs possessed different degrees of talent. Some were merely competent (Fig 232), but a few were able to communicate depth of feeling in an extraordinarily moving way (Fig 231).

While some artists used physical contact between individuals to reveal emotion (Fig 231), others could equally effectively use its absence. On a stele carved in the third quarter of the 4th century BC and found on the bed of the Ilissos river in Athens (Fig 233), a young man gazes dreamily out of the relief, clearly oblivious to the figures surrounding him. An old man, in deep but silent grief, stares intently at the youth; a servant boy crouches weeping at his feet, and his dog,

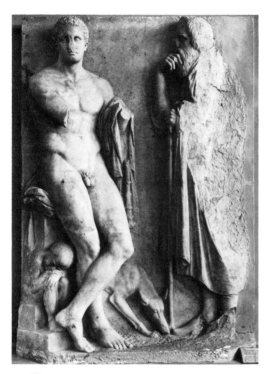

233. Ilissos stele (grave stele with father and son accompanied by servant (?) boy and dog), third quarter of the 4th century BC, National Archaeological Museum, Athens

Originally, an architectural frame enclosed the figures and enhanced the sense of massiveness.

Tradition was always important in Greek art; it provided the fertile ground from which innovations grew. Thus it is worth noting that even such an apparently original work as the Ilissos stele (Fig 233) was not isolated in its time, but must be seen as a distinguished example of a conventional type. Another approximately contemporary relief (Fig 234) again shows an assemblage of representatives of the three ages of man in the withdrawn youth, the weeping boy and the grieving father. Only the dog is missing. Here the young man's head is bowed; he mourns his own untimely death. The carving is cruder than that of the Ilissos stele – compare the renderings of the servant boy – and the impact is lessened by the way the father is overlapped by rather than totally cut off from his son. And yet it is a fine and

234. Father, son and boy, grave stele, third quarter of the 4th century BC, National Archaeological Museum, Athens

sniffing the ground, is baffled and dismayed that he cannot find his master's scent. Old man, young boy and faithful dog share the same sorrow, but each manifests it in a different way. The young man, perfect in his strength and beauty, is wholly detached. He belongs to another world. The tragedy of life cut short in its prime could hardly be conveyed more poignantly.

In these reliefs there is no effort at individualisation or portraiture. The inscription of the names was considered sufficient to identify the figures; the generic mode in which they are represented raised them above the particular concerns of everyday life and brought them closer to the heroic realm reserved for the dead.

As time passed, the carving of the reliefs became ever deeper until, as here (Fig 233), they are cut almost in the round.

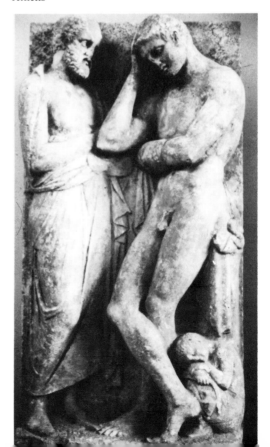

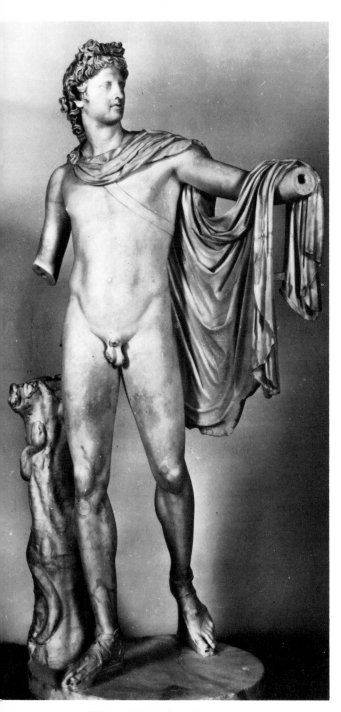

235. Apollo Belvedere, Roman copy in marble of a Greek original in bronze probably made in the third quarter of the 4th century BC, Musei Vaticani, Rome

moving work. Though not of the outstanding quality of the Ilissos stele, it is perhaps more characteristic of the generally high level of craftsmanship available in Athens at the time.

Artistic diversity in the mid-4th century BC

Many sculptors were active during the 4th century BC. Praxiteles and Skopas perhaps stand out unduly in our minds because so many copies of their works have been identified that we are able to form some idea of the distinctive qualities of their style. But though they were both influential, they by no means entirely dominated this rich and creative period. Two outstanding works by other artists can help to illustrate the diversity that was possible at this time.

The Apollo Belvedere (Fig 235) was for centuries one of the most celebrated of all ancient statues. It is a marble copy of a bronze original distinguished for its grace and elegance. The forms are smooth, the figure slim, the god youthful. Caught in the midst of his stride, he turns suddenly to one side, in the direction of his extended hand.

This refined figure much resembles (in mirror image) the magnificent Apollo in the centre of the west pediment at Olympia (Fig 135). The differences are instructive. The Apollo at Olympia is absolutely still, while the Apollo Belvedere is clearly in motion. The limbs of the Apollo at Olympia are arranged in strong verticals and contrasting horizontals whereas the limbs of the Apollo Belvedere, though similarly arranged, avoid geometrical precision. The anatomy of the Apollo at Olympia is hard and majestic and his stance is firm. The anatomy of the Apollo Belvedere is sleek and soft, his step light and graceful. The austere grandeur of the Apollo of Olympia has been superseded in the 4th century BC by suave urbanity.

By contrast, the bronze statue recovered from the sea off Antikythera (Fig 236)

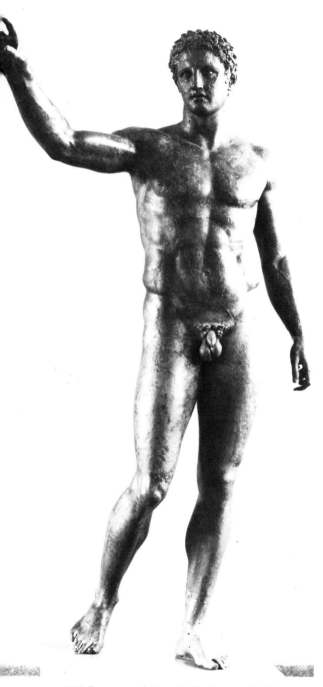

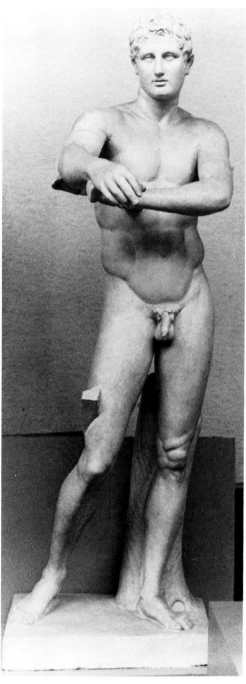

236. Bronze youth from Antikythera, mid-4th century BC, National Archaeological Museum, Athens

237. Man scraping himself (Apoxyomenos), Roman copy in marble of a bronze statue by Lysippos made in the third quarter of the 4th century BC (from a cast in Cambridge, based on a statue in the Vatican, Rome)

161

offers a totally different kind of 4th-century ideal. This youth is athletic and robust. Muscular and sturdy, his figure suggests suppressed vigour rather than attenuated grace. Muscles ripple under the tight skin, while traditional Polykleitan contrapposto is enlivened by the unusual position of the right arm, which reaches forward into space. This emphatic gesture breaks the imaginary front plane behind which the limbs of earlier statues seem to have been restricted (compare Figs 124, 189, 194 and 222) and gives the figure a more intimate relationship with the space surrounding it and a more immediate involvement with the beholder. The realistic rendering of the details of the muscular anatomy has progressed well beyond the attainments of the 5th century BC.

Lysippos

The 4th century BC saw a revival of interest in naturalism, a re-definition of ideal proportions, and an increasing effort to explore the spatial potentialities of sculpture. These efforts culminate in the work of Lysippos of Sikyon, the most celebrated and influential sculptor of the second half of the century.

Lysippos was immensely prolific and worked on both a gigantic and a tiny scale. He was renowned as a portraitist and as a sculptor of gods and heroes, but one of his most famous works was known simply as the *Apoxyomenos*, the man scraping himself (Figs 237-240). Lysippos worked only in bronze, and his daring compositions were not easy to translate into marble, but the fame of the Apoxyomenos was enough to challenge the ingenuity of more than one copyist.

The subject is remarkable for its banality. Athletes in ancient Greece would rub themselves down with oil before exercise and afterwards scrape oil and dirt off together. This is what the Apoxyomenos is in the process of doing. Representation of this humble activity was part of Lysippos' programme of radical naturalism. So too

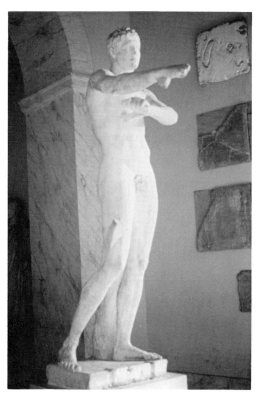

238. Man scraping himself (Apoxyomenos), right side of a Roman copy in marble of a bronze statue by Lysippos made in the third quarter of the 4th century BC, Musei Vaticani, Rome

the particularised features of this tough athlete relate on the one hand to the increased realism that was becoming fashionable and on the other to the new emphasis on the individual, which also found scope in the burgeoning art of portraiture.

The once celebrated delicacy of surface is lost in the insensitive copy, though something of the excellence in the rendering of anatomy can still be perceived. Once again, though, it is little more than the composition and the idea behind the work that can be appreciated through the Roman copy (Figs 237-240).

The stance is extraordinarily mobile, for although the weight is on the figure's left leg, he seems almost in the act of shifting it onto the right. The arms, strikingly

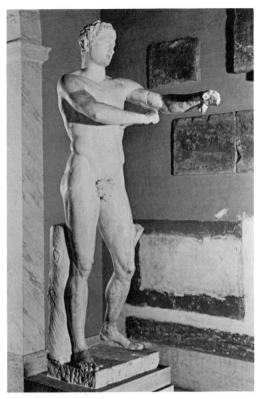

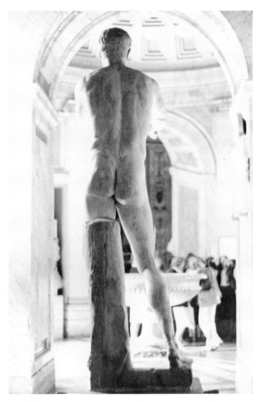

239. Man scraping himself (Apoxyomenos), left side of a Roman copy in marble of a bronze statue by Lysippos made in the third quarter of the 4th century BC, Musei Vaticani, Rome

240. Man scraping himself (Apoxyomenos), back view of a Roman copy in marble of a bronze statue by Lysippos made in the third quarter of the 4th century BC, Musei Vaticani, Rome

extended before the figure and drastically foreshortened from the front, carry the idea of the statue penetrating the surrounding space to its logical conclusion. The first stirrings in this direction could already be seen in the raised arm of the Antikythera youth (Fig 236) which breaks into the space in front of the figure in a way that had never been considered in the 5th century BC.

The figure is tall and slender, with a proportionally small head which adds to the impression of wiry leanness. Lysippos consciously altered the proportions that Polykleitos had found ideal for his Canon (Fig 189). This was not simply a matter of naturalism, but also a point of theory, since for Lysippos the two went hand in hand.

The pose, like the proportions, forms part of Lysippos' systematic refutation of the Polykleitan ideal. The bent left arm of the statue deliberately cuts the front view of the torso so that no appreciation of carefully balanced forms is possible. The bold foreshortening of one or the other arm from the four cardinal points of view compromises the finality of the very views that Polykleitos had made so harmonious. The intermediate angles, somewhere between full front and full profile, which were less successful in Polykleitan works, have, however, been made very much more interesting by Lysippos (Figs 238 and 239). He has created a statue that has no single entirely satisfactory point of view, but which is visually exciting from a multitude of viewpoints and which the observer is

163

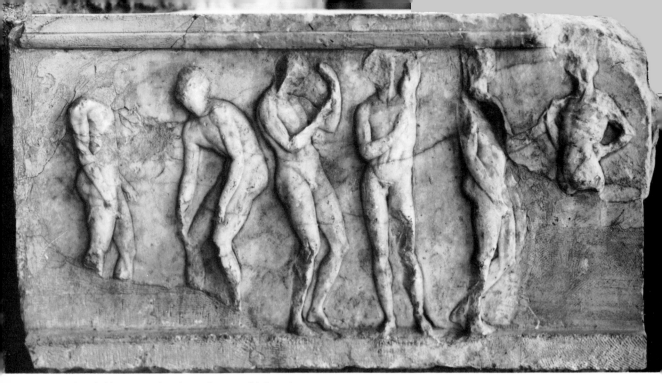

241. Athletes scraping themselves, marble base from the Acropolis, late 4th century BC, Acropolis Museum, Athens

invited to walk all round if he is to appreciate its full spatial complexity.

The new freedom of the figure within space, the easy way the limbs stretch away from the body or cross in front of it and the accomplished realism in the depiction of anatomy were all Lysippean innovations. By the end of the 4th century BC they could already be reflected in the carvings on a marble base in Athens (Fig 241). Six athletes were originally shown, all scraping oil off their bodies after exercise. The central three are well preserved and reveal several stages in the process of which Lysippos' statue could only present a single moment.

The assured rendering of the anatomy of the figures and the confidence with which they are unhesitatingly shown foreshortened at different angles in space contrasts markedly with the portrayal of athletes on the late 6th century BC Attic statue base (Fig 88) and illuminates the preoccupations and technical achievements of the intervening two centuries.

The Apoxyomenos (Fig 237) has nothing of the ideal beauty of the Spear-bearer (Fig 189); on the contrary, it is a very individualised rendering of a rather unglamorous athlete. Lysippos' interest in specific characterisations, as can be seen here, no doubt contributed to his renown as a portraitist. So excellent was he that Alexander the Great considered him the only sculptor able to create an adequate image of him in bronze, for Lysippos alone could capture not only the beauty of Alexander and the melting glance of his eyes, but also his manliness and the lion-like qualities of his character.

Lysippos' most famous portrait of Alexander, the Alexander with the Spear, no longer exists, but from a small bronze statuette that presumably copies it (Fig 242), one can still see something of the vigour of Alexander and the skill of Lysippos. Alexander strides forward; his upper body is rotated slightly to his left, but his attention is caught by something to his right and he turns his head sharply to look at it. The figure is mobile, active and alive. The axis of the body is not confined to a single plane but shifts in direction – the development of an idea already

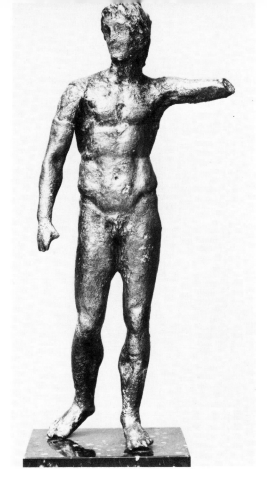

242. Alexander with the spear, Roman statuette copy in bronze after a large bronze original by Lysippos made in the third quarter of the 4th century BC, Louvre, Paris

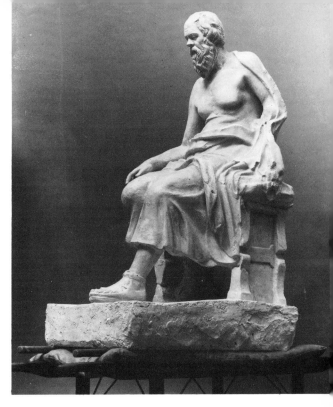

243. Sokrates, Roman copy in marble of an imaginary portrait made by Lysippos in the third quarter of the 4th century BC (reconstructed cast based on a body preserved in Copenhagen and a much-copied type of head as shown in an 18th-century engraving), Ny Carlsberg Glyptothek, Copenhagen

244. Sokrates, Roman copy in marble of the head from a full-length imaginary portrait of Sokrates created by Lysippos in the third quarter of the 4th century BC, Museo Nazionale delle Terme, Rome (see Fig 243)

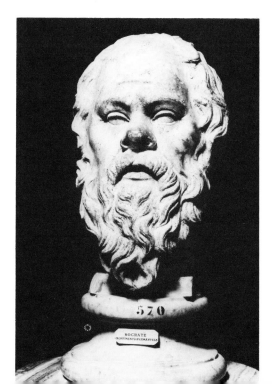

adumbrated in the Epidauros acroterion (Fig 223). Limbs extend freely into space; the figure is open and expansive; the sense of unbounded physical vitality and mental energy are worthy of both Alexander and his great sculptor.

Character counted for more than mere physical resemblance in 4th-century BC portraiture, and this no doubt explains the success of one of Lysippos' most remarkable portraits – a seated image of Sokrates which now exists only in copies (Figs 243, 244). The pose itself is full of restless activity, as was the subject in life. One foot is drawn back, one arm reaches forward. The flesh on the old body sags, but the radiance of the youthful intellect shines through the face (Fig 244). The features are

245. Herakles resting from cleansing the Augean stables, Roman statuette copy in bronze based on a colossal bronze statue made by Lysippos at the end of the 4th century BC or the beginning of the 3rd century BC, Private Collection, Palermo

guises – weary at the end of his labours, rejoicing in the feast or struggling with adversaries – and on various scales ranging from the miniature to the colossal.

One of the most moving must have been the huge bronze he made for the Tarentines. Despite the great size of the statue and the immense strength of the hero, no triumph was shown. A small statuette copy (Fig 245) reveals that the hero sat disconsolately, his weary head resting on his hand, snatching a moment's rest from his labours. Exhaustion and fatigue are conveyed through a richly complicated three-dimensional composition.

The mighty statue is lost, but a reflection of it on a much later Byzantine ivory (Fig 246) may give a clue to the subject. Herakles is seated on a basket over which he has thrown his lion-skin. The basket could only have been used in the

246. Herakles resting from cleansing the Augean stables, Byzantine ivory based on a colossal bronze statue made by Lysippos at the end of the 4th century BC or the beginning of the 3rd century BC, Cathedral, Xanten

the same as those represented in the 5th-century portrait (Fig 221), but now they are more convincingly infused with intelligence, humour, shrewdness and wit. Lysippos never saw Sokrates, but he knew what sort of a person he was and had the ability to convey this in an imaginary portrait that brings us closer to the reality of the man than any simple recording of his features could.

Penetrating characterisation, sculptural inventiveness, aggressive naturalism – all these qualities mark the genius of Lysippos. But like other great Greek artists, his innovations are often remarkable not so much for breaking with tradition as for enlarging it in a new and unexpected way.

He made many images of Herakles, a favourite hero from the archaic period on. Lysippos depicted Herakles in various

166

most degrading and unheroic of his labours, the cleansing of the Augean stables.

This labour was illustrated on a metope at Olympia (Fig 142), where the theme had particular prominence because of local associations. Otherwise the subject was not popular with artists for it did not show Herakles in a heroic light, confronted him with no monsters and exposed him to no danger. It was sheer drudgery, such as common humanity faces every day, but which heroes seldom encounter. Herein lies the significance of Lysippos' original interpretation, for through his statue he was able to impart a new dimension of humanity to the great hero and thus to deepen his artistic message. What the sculptor at Olympia had done in relief to humanise the labour of the lion (Figs 141 and 145), Lysippos has done in three dimensions for the entire image of the hero. Tradition provided the springboard for invention, naturalism the means for its expression and sympathy with mankind the power of its effect. The achievements of Greek sculpture can be summed up in this vision that brings art, without loss of formal excellence, to the heart of the observer.

Conclusion

The development of Greek art during the four centuries that separate the geometric vase (Fig 3) from the works of Lysippos (Figs 237-240 and 242-246) is astonishing. The conquest of natural appearances is perhaps the most immediately striking feature, but two other qualities are equally significant: the increasing ability to convey the subtlety and richness of human feelings and the undiminished sense for harmonious formal arrangements. Without these qualities the depiction of reality would be lacking in emotional power and aesthetic impact.

The earliest Greek portrayals of the human figure appear on geometric vases. These lucidly articulated, flat, neat, stick figures provided the starting point for the systematic, analytic development that culminated in works like Lysippos' spatially uninhibited, anatomically unimpeachable Apoxyomenos (Fig 237-240).

By the beginning of the 5th century BC, artists had progressed so far in their ability to capture natural appearances that they could begin to explore ways to reveal character, feeling and emotion. Soon they were able to create such moving figures as the weary Herakles on the Lion metope at Olympia (Figs 141 and 145) and the grieving father on the Pan Painter's oinochoe (Fig 155), as well as such dramatically intense ones as Skopas' Raging Maenad (Fig 227 and 228).

But even while they were refining their representational techniques and deepening their insight into the human condition, the Greeks never forgot the need to make of their creations objects of beauty which conformed to certain formal principles. These principles changed with time: during the archaic period beauty was produced by means of symmetrical organisation (cf. Figs 28, 45 and 196) and decorative repetition (cf. Figs 22 and 29), while during the classical period it was obtained by means of a subtler balance of opposites (cf. Figs 172 and 175, 189 and 195) and arrangements based on the development of orderly sequences (cf. Figs 39, 171 and 178).

The Greeks were adventurous, and sometimes their ambitious experiments led them into unexpected difficulties (cf. Figs 58, 123 and 126). These proved to be stimulating rather than discouraging, for the Greeks thrived on challenges. Their ability to resolve the search for increasing naturalism and the revelation of emotional truth with the demands of formal discipline enabled them to create the works that are the glory of Greek art.

Notes

Literary sources

It would be possible, though difficult, to write about the history of Greek sculpture and vase painting on the basis of surviving works of art only, but it would be far less interesting and accurate than following the story, as we have, with the help of literary sources as well. These aid us, too, in identifying works that are preserved only in copies made by the Romans or adaptations made by vase painters.

The literary sources that have survived are in many ways as fragmentary and as much victims of chance as the works of art. Some Greek artists wrote treatises, as Polykleitos did in his lost *Canon*, and by the 4th century BC actual histories of art were written by Greeks who recognised that their compatriots had created something new and remarkable. Most of this material has been lost without trace, but some of it was quoted by later authors whose work we still have. The elder Pliny is one such.

Pliny provides a major source of information. He was a Roman polymath living in the 1st century AD who seems to have been interested in everything. He wrote an encyclopaedic book, the *Natural History*, which was divided into sections on animals, vegetables and minerals. In part of the section on minerals he dealt with the stones and metals used by sculptors and the mineral pigments used by painters, and this led him to give a short history of sculpture and painting. He discussed the development of the arts, the contributions of different artists and some individual celebrated works. Pliny drew on many

sources that were still available in his time but are lost to us.

Another very important but rather different source of information is provided by Pausanias. He was a Greek traveller who lived in the 2nd century AD and wrote a guide to Greece addressed to the tourists of his day. He walked through the cities and sanctuaries of mainland Greece, noting things of interest and describing the famous works of art that he saw. As his work progressed he became garrulous and his descriptions grew increasingly detailed. In Athens, where he started, he was brief. He devoted only a few words to the architectural sculpture of the Parthenon (though he said more about the celebrated statue within), but even those few words are invaluable to us, for without them we would not know what the subjects of the two pediments were. By the time he got to Delphi he was describing the paintings of Polygnotos in such detail that he has enabled modern scholars to recognise Polygnotos' influence on vase painting (Fig 149).

Other authors give us more fragmentary bits of information, often no more than an aside, as in Quintilian's very brief history of art, which he introduced to elucidate his history of rhetoric (the *Institutio Oratoria*, 12.10. 3-9, late 1st century AD). The witty writer Lucian (2nd century AD) was very sensitive to art and often gives helpful, detailed descriptions of works, for instance of Myron's Discus-thrower, ' ... who is bent over into the throwing position, is turned toward the hand that holds the discus, and has the opposite knee gently flexed, like one who will straighten up again after the

throw ... ' (*Philopseudes* 18). This word-picture enables us to identify unmistakably extant copies of this work (Fig 124).

Unexpected pieces of information can be found in Aristotle's *Poetics*, some of the dialogues of Plato, the orations of Cicero, the writings of Plutarch and other sources. J.J. Pollitt has conveniently collected a number of such references in *The Art of Greece 1400-31 BC* (Sources and Documents in the History of Art) Prentice-Hall, Englewood Cliffs, New Jersey, 1965.

The names of vase painters

Two kinds of signature appear on vases: 'so-and-so made me (*epoiêsen*)' and 'so-and-so painted me (*egrapsen*)'. Sometimes one person signs as both potter and painter. Signatures with 'made me' outnumber those with 'painted me', but all kinds of signature are extremely rare. Nevertheless the artistic personalities of many vase painters are very well known, even if their names are not. The problem is what they should be called.

When an artist has signed 'painted me', we can feel sure of his name; examples are Sophilos, Kleitias, Exekias, Euphronios and Euthymides. Even when works are unsigned a sensitive observer can note that they were painted by the same hand. Sir John Beazley was such a sensitive observer. A sharp eye, critical mind, phenomenal visual memory and a lifetime of hard work enabled him to identify hundreds of vase painters and to attribute thousands of vases to individual artists (or sometimes to groups who worked closely together and shared much the same style).

Many unsigned works could be attributed to painters whose names were known, but for the great majority of the artists that Beazley identified, names simply had to be invented. Some he derived from the present location of a particularly fine work, e.g. 'The Berlin Painter', 'The Chicago Painter'; some from the place where an important example was found, e.g. 'The Eretria Painter'; some from the subject of a notable piece, e.g. 'The Gorgon Painter', 'The Achilles Painter'; some from the name of a potter (who signed) with whom the painter worked, e.g. 'The Amasis Painter', 'The Andokides Painter', 'The Brygos Painter'; and some from a particular characteristic of style, e.g. 'Elbows Out' or even an abbreviation: 'The C Painter', where 'C' stands for 'Corinthianising'.

Occasionally the beauty of a fair youth (or, less frequently, fair girl) is praised on a vase – 'so-and-so is fair (*kalos*)' – and Beazley sometimes used such 'kalos' names to designate painters, e.g. 'The Antimenes Painter', 'The Leagros Group'. Sometimes a key vase identified by its inventory (or catalogue) number might provide the artificial name that tags the personality: 'The Painter of Tarquinia RC 6847'. The possibilities are endless and scholars following Beazley, who died in 1970 at the end of a long and productive life, have continued to make their own contributions.

The names given to statues

The Greek statues that have come down to us either as originals or in copies seldom have labels of any sort attached to them. Modern scholars, therefore, have had to invent names for them so that they can be referred to conveniently.

Some statues are identified by the place where they were found, for instance 'the Sounion Kouros' (Fig 52). Some are identified by their present location: 'the Apollo Belvedere' in the Belvedere Court of the Vatican Museum (Fig 235) or 'the New York Kouros' (Fig 44) or 'the Berlin Goddess' (Fig 66). When many figures of the same type have been found together and are located in the same place, inventory numbers are sometimes used for identification. 'Kore 675' (Fig 69) is one of a large number of korai found on the Athenian Acropolis and now in the

Acropolis Museum. Others of her sisters have nicknames, for instance 'the Peplos Kore' (Fig 72), a sobriquet based on the unusual attire of this figure. 'The Kritios Boy' is also a nickname. It rests on the observation that this youth (Fig 103) resembles Harmodios, the younger of the two Tyrannicides, as he appears in Roman copies (Figs 111 and 112). Since we know that the Tyrannicides were made by Kritios and Nesiotes, the name of Kritios has been associated (on purely stylistic grounds) with this youth.

The name of the Tyrannicides was acquired in quite another way, for, indirectly, this group does have a label. Scholars ingeniously recognised that the two statues in Fig 111 were Roman copies of works described in our literary sources, i.e. that the anonymous statues in Naples corresponded to the works by Kritios and Nesiotes mentioned by Pausanias and others.

Many statues have been recognised as Roman copies of famous originals described by ancient authors, for instance, the Discus-thrower or Diskobolos by Myron (Fig 124), the Diadoumenos by Polykleitos (Fig 194) and the Apoxyomenos by Lysippos (Figs 237-240).

Sometimes original statues can be recognised from literary sources: such are the Kleobis and Biton (Fig 53) which were mentioned by Herodotus (1.31). The Hermes of Praxiteles (Fig 225) was found in the temple of Hera at Olympia just where Pausanias reports having seen a statue with this subject by Praxiteles. As soon as the work was excavated, scholars realised that this was the very statue that Pausanias had seen (though they disagree as to whether it is an original by the famous Praxiteles or a later copy; see below).

Occasionally statues actually do have labels attached to them when they are found together with their inscribed bases, as was the kouros set up as a grave monument for Aristodikos (Fig 58).

The names by which we call works of art influence our perceptions of them. Often they can do a disservice to the range of feeling in a work. Whistler, in the 19th century, wanted to draw attention to the purely formal qualities of a painting and titled it 'Arrangement in grey and black', but other qualities impressed the public more and it became known and loved as 'Whistler's mother'. Formal art historians in antiquity tried, like Whistler, to find purely objective terms of description. Unfortunately they suceeded. Thus we meet Myron's great invention under the bland name 'the Discus-thrower' and Polykleitos' brilliant canon as 'the Spear-bearer', the ancient names recorded in the literary sources. It is unlikely that Polykleitos intended to portray just any man with a spear. Rather, as has been persuasively argued, the statue probably represents Achilles. This would be appropriate, for the figure of Achilles, as portrayed by Homer, was already in many ways canonic. He excelled as a warrior and athlete and had no peer in beauty. Achilles could serve as an unchanging exemplar of a young man in his prime, for he knew no old age. Achilles had been offered a choice: either a long undistinguished life or glory cut short by an early death. He selected the heroic course. The Spear-bearer would make a fine image of Achilles, proud and beautiful, a manly youth full of grace and nobility and yet aware – the sober inclination of the head indicates this – of the tragic fate that ultimately awaits him. Called by the name of Achilles, the statue gains in meaning and evokes emotions untouched by the more usual descriptive title.

The authenticity of the Hermes of Praxiteles

Pausanias (5.17.7) says that in the temple of Hera at Olympia there was 'a Hermes of stone, who carried the infant Dionysus, the work of Praxiteles'.

In 1877 German archaeologists excavating the temple of Hera uncovered the

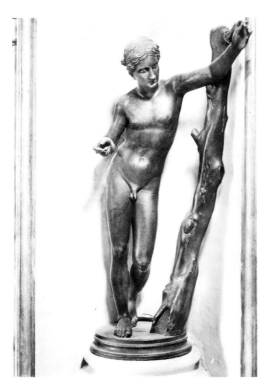

247. Apollo as a boy about to slay a lizard (Apollo Sauroktonos), Roman bronze statuette based on a bronze statue made by Praxiteles in the third quarter of the 4th century BC, Villa Albani, Rome

4th century BC. Instances are known when the Romans, having removed a famous work of art, commissioned a copy to be made to be left in its place. Could this have been the case with the Hermes?

Praxiteles worked both in bronze and in marble; the famous Aphrodite of Knidos was marble (Fig 226), while the Apollo Sauroktonos (Lizard-slayer) was originally cast in bronze. As usual the original itself is lost, but the composition was frequently copied (Fig 247 shows a bronze statuette, Fig 248 a marble copy). Apollo was depicted as a young boy idly toying with an arrow in order to threaten a lizard crawling up a tree. Characteristically Praxiteles has humanised the image of the god, but at the same time has retained cult implications,

248. Apollo as a boy about to slay a lizard (Apollo Sauroktonos), Roman copy in marble of a bronze statue made by Praxiteles in the third quarter of the 4th century BC, Louvre, Paris

very statue that Pausanias had seen over 1700 years before (Fig 225). The extremely beautiful surface of the figure and its splendid execution convinced many that here at last was an original work by one of the most celebrated sculptors of antiquity. Others, however, had doubts.

As time passed several scholars noted technical details that made the statue seem more like a Roman copy than an original work of the 4th century BC: the back is unfinished and has been partially recut; the tree trunk covered with drapery is a device more frequently found in Roman copies of bronze originals than in original compositions, as is the strut at the hip; part of the sandal strap is not shown in relief and would have had to have been completed in paint; the base on which the statue was found dates from later than the

for the lizard alludes to the fierce Python that Apollo slew at Delphi, and the childish scene is really a prefiguration of a later heroic deed. The tree is structurally unnecessary for a bronze statue; it is, however, essential for the lizard, who otherwise would have nowhere to perch, and so it was obviously part of the original design of the statue. From such a design the statue could easily have been executed either in bronze or in marble (we know it was bronze because Pliny says so), and it has been suggested that Praxiteles habitually made designs suitable for execution in either material.

Hence the tree trunk and the drapery in themselves do not automatically prove the Hermes to be a Roman copy. The way they are carved seems to some scholars typical of Roman workmanship, while others find it profoundly different!

Whether the Hermes is an original statue from the hand of Praxiteles has still not been settled. Arguments on both sides of the question have been clearly stated by a number of scholars in the *American Journal of Archaeology* (35) 1931 (three of the best have been reprinted in *The Garland Library of the History of Art*, Volume II: *Ancient Art: Pre-Greek and Greek Art* (ed. H.W. Janson) Garland Press Inc., New York 1976) and new arguments have been brought forth periodically ever since.

The colour used on Greek sculpture

Colour made an important contribution to the original appearance of Greek statues. This fact was appreciated by even so great a sculptor as Praxiteles, for it is reported that once when he was asked which of his statues he thought were the best, he replied: 'Those that Nikias has painted.'

It is easier for us to understand the role colour played in bronze statues, since substantial traces of it have often survived (Figs 115, 120 and 236). Eyes were normally inlaid with paste or coloured stones, lips

and nipples reddened with copper and teeth silvered. We can readily accept this life-giving enhancement of statues and may feel the loss of eyes uncomfortably when we are confronted with empty sockets (e.g. Fig 122).

It is more difficult for us to grasp the important part colour played in the appearance of marble statues, since we are accustomed to seeing Renaissance and later marbles unpainted and the traces of paint on preserved ancient statues are rather meagre (e.g. Figs 55, 69, 108). Hair, eyes, lips, nipples, drapery and the background of reliefs were all originally painted. In many cases the addition of colour helped to clarify the composition (for instance the fact that one leg is clothed and the other nude in Fig 222), define objects (the ornament selected by Hegeso in Fig 211), and make architectural sculptures more intelligible at a distance.

When the original colours are preserved (see Figs 55 and 69), they never seem garish, but when efforts are made to restore colours (usually on plaster casts) the result is generally unpleasant. Nevertheless one should always try – if only in imagination – to think the colours back onto marble statues, especially the eyes and the hair, since the loss of the paint has markedly changed their character and deprived them of much of the life and vitality they had when they were new. Some idea of the

249. Terracotta rhyton (drinking horn) in the shape of a donkey's head, second quarter of the 5th century BC, British Museum, London

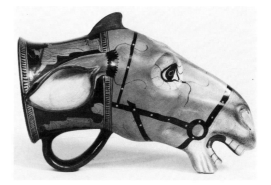

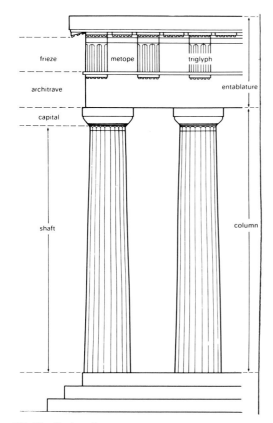

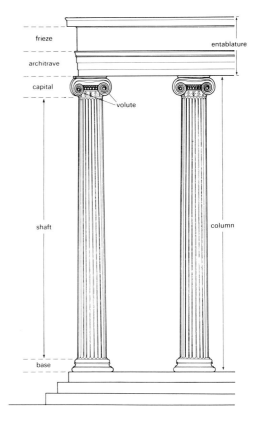

250. The Doric order

251. The Ionic Order

original effect can be gained from terracottas and vases where the colours that have been painted on before firing have not been dimmed or altered by time (Fig 249) although, of course, the actual range of colours applied to fired clay is very much more restricted than would have been the case for statues.

Colour would also have been contributed by metal attachments representing jewellery, weapons and reins (of horses); these too have disappeared with time.

The Doric and Ionic orders

Greek temples were constructed on a simple post-and-lintel principle. Vertical posts (or columns or walls) supported horizontal lintels (or entablatures or ceilings). The earliest temples were built of wood and mud-brick on stone foundations. By the end of the 7th century BC stone, which was both more expensive and more durable, began to be the preferred material for the whole building.

Stone temples were built almost without exception either in the *Doric order* or the *Ionic order*. The *order* determined the proportions and the constituent elements used for the columns and the superstructure they supported (the entablature). It gave the elevation its distinctive appearance.

The Doric order (Fig 250) was strong, simple and massive. The columns were sturdy (their height was four to six times their width) and rested directly on the top

174

step of the temple. They were topped by capitals that looked like simple cushions and supported a plain horizontal band of stones called an *architrave*. This in turn supported another band, called the *frieze*. The Doric frieze was divided into alternating *triglyphs* (vertically grooved rectangles) and *metopes* (rectangles that could be painted, sculpted in relief or simply left blank). There was one triglyph over each column and one between each pair of columns.

The Ionic order was more elegant and ornate. It made use of slimmer columns – their height being eight to ten times their width – which rested on a base and were topped by volute capitals (Fig 251). The architrave was divided into three horizontal steps. The frieze above it was undivided and could be decorated by a continuous band of carving in relief or replaced by a row of tooth-like features called *dentils* (not illustrated).

The order decided the basic form of the columns and the entablature, though details and proportions could be modified within limits. The Ionic order was generally treated more freely than the Doric. Occasionally, elements from one order were introduced into the other, as in the case of the Parthenon frieze, an Ionic feature in an otherwise Doric building (Fig 156).

The identification of mythological figures and scenes

Greek artists often provided clues to the identity of the figures and scenes they represented. Some of these clues are obvious and easy to understand; others are subtler. Occasionally they can prove misleading.

The simplest way to identify a figure is by writing his name beside him. By means of inscriptions artists can show unambiguously that two otherwise anonymous warriors are intended to represent Ajax and Achilles (Figs 18, 19 and 23 – all by different vase painters). Inscriptions are used abundantly by Sophilos (Fig 14) and Kleitias (Figs 15-18) and occasionally by other artists as well (for instance Figs 10, 23, 79, 92 and 151).

Inscriptions can serve not only to identify individuals but also to distinguish between scenes which might be confused without them. For instance, there are several myths which tell of a centaur carrying off a woman. The inscriptions show that Figure 79 is a representation of Nessos and Deianeira, not an excerpt from the battle of the Lapiths and the centaurs (cf. Figs 134 and 136).

Attributes are used more frequently than inscriptions and can often identify figures just as precisely. Athena is unmistakably portrayed when a female figure is shown fully armed with helmet, spear and shield and wearing the characteristic snake-fringed aegis (Figs 84 and 85; the statue of Athena in the Parthenon (cf. Figs 184, 185 and 188) was originally represented with all these attributes). Often one or another element is omitted (cf. Figs 76-78, 80, 92, 149 and 154) but the aegis alone is sufficient to identify the goddess (seated just to the right of the break in Fig 31 or leading her protégé Herakles in Fig 20; the aegis was shown in her lap in Fig 172). The god Hermes can often be recognised by his travelling hat (petasos), herald's staff (kerykeion) and boots (sometimes winged) in combination or individually (cf. Figs 15, 16, 76, 170, and notice the travelling hat on his lap in Fig 170, far left). Dionysus, the god of wine, often carries a drinking vessel (cf. Figs 21, 22 and 24). The god Apollo is youthful and usually characterised as an archer; he originally carried a bow (now lost) in Figs 102, 135 and 235, but sometimes he can be recognised more from the context in which he appears than by his attribute, for instance in Fig 35, where he must be the figure left of centre trying to prevent Herakles from carrying off the tripod. He is close to his twin sister Artemis, who is also an archer, and the pairing of the two frequently helps to identify them both (for instance in Fig 30,

where they fight side by side, or in Fig 171, where they sit side by side – last two figures on the right). It is this association, too, that suggests that the female figure to the right of Apollo in Fig 80 is Artemis, a matter of proximity rather than attribute. The hero Herakles is usually identified by his lion-skin and/or his club (for instance in Figs 20, 74, 75, 80, 89 and 215; club only in Fig 78); he is also an archer and often carries bow and arrow (Figs 20 and 149); in Fig 76 he has hung up his quiver while he feasts. Occasionally he is identified by his opponent or opponents (cf. Figs 4-5, 10 and 28) rather than by any attribute of his own.

Certain creatures are characterised in a special way: Dionysus' votaries, the satyrs, have horses' tails and ears and snub-nosed faces (Figs 21, 95 and 96); Gorgons are characterised by their front-facing, frightful visages; centaurs are identified by their combination of horse and human bodies, but individual centaurs have to be distinguished by inscriptions (Figs 10, 14 and 79) or context (Figs 4-5).

Sometimes it is not the individual participants but the scene itself that identifies a story. Thus, the slaying of an old man upon an altar – a shocking event – can at once be identified as an illustration of the death of Priam (Fig 100 and probably also the left corner of Fig 32), or a number of men poking a stake into the eye of a seated giant can be recognised as Odysseus and his companions blinding the cyclops (Fig 6).

Identification must, however, always be made with caution. Letters written beside figures can prove not to be intelligible names at all, but nonsense inscriptions, and attributes taken out of context can be misleading (for instance, the female figures wearing helmets in Fig 89 are Amazons, not representations of Athena).

The identification of certain scenes or parts of scenes remain disputed among scholars. The pediment of the Siphnian Treasury (Fig 34) provides one example. The subject at the centre is clearly the theft of the tripod; Herakles (at the right) is unambiguously identified by his lion-skin and his action, Apollo, at the left, by the context (his role in the story) and his sister, Artemis, to his left, by her association with him. The central, very large figure, intervening between the contestants is now agreed to be Zeus (but for many years was thought to be Athena). Scholars still disagree about the identity of the flanking figures, on whether the chariots are or are not related to the central scene and on whether only one or more than one story is represented. Perhaps even more baffling is the subject of the vase illustrated in Fig 149. Herakles, more or less in the centre, can be recognised by his lion-skin, club and bow and Athena, at the left, by her aegis, helmet and spear, but the identity of the other figures and the story in which they are involved remains uncertain. Many ingenious suggestions have been made by different scholars, but none seems entirely convincing.

Glossary

Acropolis (at Athens) a large, flat-topped rock accessible only from the west. It was originally a citadel, but from the 6th century BC it was increasingly given over to sanctuaries of the gods.

acroterion (pl. **acroteria**) decorative ornament placed over each of the three angles of the pediment on the front and back of a gabled building.

aegis a sort of goat-skin breast-plate fringed with snakes, worn by Athena.

alabastron (pl. **alabastra**) (pottery) ovoid, narrow-necked perfume holder; see Fig 11.

Amazons mythical female warriors thought to live in Asia Minor and therefore often used as mythological prototypes for the Persians. Herakles and Theseus fought them in their own land and Theseus carried one off to Athens. In anger the Amazons invaded Athens, but were beaten back.

Amazonomachy battle of Greeks and Amazons.

amphora (pl. **amphorae**) (pottery) capacious storage jar with two handles; see Fig 11.

Aphrodite goddess of love and beauty.

Apollo god of music, archery and prophecy; brother of Artemis.

Apoxyomenos man scraping off the oil he used to rub himself down with before exercise; the name of a celebrated bronze statue by Lysippos; see Figs 237-240 for a Roman copy.

archaic term referring to the early period of Greek art and history, about 650-490 BC.

Ares god of war.

Artemis goddess of the hunt, sister of Apollo.

articulate (verb) make clear, distinct and precise in relation to other parts; bring various parts of a work of art into coherent relation to each other.

aryballos (pl. **aryballoi**) (pottery) small spherical container used by athletes to carry the oil they rubbed down with before exercise. It could be suspended by a thong through the handle; see Figs 11 and 61.

Athena patron goddess of Athens, usually shown wearing an aegis and a helmet and often carrying a spear and shield.

Attic the adjective pertaining to Athens, its people, territory and products.

Attica the territory belonging to the Athenians.

attribute object associated with a particular character, for instance, the lion-skin of Herakles or aegis of Athena.

black-figure a technique of vase painting in which the figures are drawn in black silhouette, details and internal markings are incised in the black paint and touches of white and purplish-red are added. The technique was invented by the Corinthians in the 7th century BC. It continued to be used for Panathenaic amphorae as late as the 2nd century BC, but otherwise lost popularity after the mid-5th century BC.

calligraphic making elegant linear patterns.

Canon the title used by Polykleitos for his treatise on proportions and also applied to the statue (the Spear-bearer or Doryphoros) he made to illustrate it. From the Greek word meaning 'a rule' or 'ruler'.

catenary the curve formed by a chain of uniform density hanging freely from two fixed points not above each other, used by Rhys Carpenter in *Greek Sculpture*

177

(Chicago 1960) to describe 'U'-shaped folds in drapery. He also discusses and defines *modelling lines*, *motion lines* and *transparency* in his chapter 5.

centaurs mythical creatures, the lower part of which is horse and the upper part of which is man. They had a weakness for women and wine; see Figs 4, 10, 14, 134, 136, 158-162.

chiton a woman's dress made out of linen. It is made from a rectangular piece of cloth buttoned along the arms to make sleeves; see Fig 70.

chryselephantine a technique for veneering statues in gold (for drapery) and ivory (for the flesh parts). The core was usually made of wood. Pheidias made several such statues on a colossal scale; Polykleitos, though primarily a bronze-caster, made a chryselephantine Hera for Argos.

classical the term referring to Greek art and history from the end of the Persian Wars (490-479 BC) to the death of Alexander the Great (323 BC).

composition arrangement of forms within a work of art.

contrapposto balanced pose of a human figure in which the weight is unevenly distributed and the axis of the shoulders slopes in the opposite direction to the axis of the hips; see Figs 189, 194, 195 and 226 among others.

cyclops monstrous, one-eyed man-eating giant. One was blinded by Odysseus, see Fig 6.

Demeter goddess of grain. Her daughter was abducted by the god of the Underworld and she is often shown mourning her loss.

Diadoumenos youth winding a fillet (or ribbon) around his head; the name of a bronze statue by Polykleitos; see Fig 194 for a Roman copy.

dinos (pl. **dinoi**) (pottery) a bowl in which wine and water are mixed; see Figs 11-14.

Dionysus god of wine.

Diskobolos athlete hurling a discus, name of a bronze statue by Myron; see Figs 124 and 126 for a Roman copy.

Doric order an architectural system controlling the design and proportions of columns and their superstructure; see pp. 174-5 and Fig 250.

Doryphoros Spear-bearer; the name of a bronze statue by Polykleitos which illustrated his theory of proportions; see Figs 189-191 and 193 for a Roman copy.

Eirene Peace, the name of a statue made by Kephisodotos for the altar of Peace set up by the Athenians in 375 BC. She is shown holding the infant Ploutos (Wealth); see Fig 224 for a Roman copy.

early classical period from the time of the Persian Wars (490-479 BC) to about the middle of the 5th century BC, during which the bronze-casters Kritios and Nesiotes were active and the architectural sculptures for the temple of Zeus at Olympia were carved.

filling ornament small bits of pattern – geometric (e.g. zig-zags) or floral (e.g. outline or dot rosettes) – used in the background of figure-scenes of 8th- and 7th-century BC vases in order to tone down the contrast between figures and background.

foreshortening the apparent shortening of the form of an object in relation to the angle from which it is seen; a device for suggesting the recession of forms in depth.

free standing statues carved fully in the round, detached from any background.

frieze a long, continuous strip. In architecture: in the Doric order, the frieze is divided into triglyphs and metopes (Figs 138 and 250); in the Ionic order the frieze is unbroken (Figs 26 and 251). The Parthenon frieze is a continuous Ionic frieze used, exceptionally, on a Doric building (Fig 156).

generic general, as opposed to particular; the representation of a funeral, for instance, is generic if no specific funeral is intended. Generic scenes (of battle, revelry, love-making, etc.) can be made specific by the addition of names.

geometric style the prevailing style during the 8th century BC; see Fig 3.

Gigantomachy battle of gods and giants.

Gorgon a monster with so terrible a face that just to look at her was enough to turn a man to stone. There were three Gorgon sisters; the mortal one, Medusa, was beheaded by Perseus; see Figs 6, 9, 13, 33 and 154.

Hera goddess of marriage, wife of Zeus.

Herakles Greek hero who fought monsters and performed twelve labours; see Fig 139.

high classical the period from about the middle of the 5th century BC to about 420 BC, during which Pheidias and Polykleitos were active and the Parthenon was built.

hydria (pl. **hydriai**) (pottery) a jar for carrying water, equipped with two horizontal handles at the sides and a vertical one at the back; see Fig 11.

Ionic order an architectural system for controlling the design and proportions of columns and their superstructure; see pp. 174-5 and Fig 251.

incision a scratched line (in black-figure pottery: a line scratched in the black paint before the vase was fired); (in sculpture: a shallow line scratched on the surface).

kantharos (pl. **kantharoi**) (pottery) an elegant, high-handled cup; Dionysus is often shown holding one; see Figs 11, 22.

kore (pl. **korai**) technical term used to refer to archaic draped female standing figures (literally: maiden).

kouros (pl. **kouroi**) technical term used to refer to archaic nude male figures standing with their weight evenly distributed on both legs, with one leg advanced (literally: youth).

krater (pottery) a wide-mouthed bowl used for mixing wine and water; see Fig 11.

kylix (pl. **kylikes**) (pottery) two-handled, stemmed cup; see Fig 11.

late classical the period from the last quarter of the 5th century BC to the death of Alexander the Great (323 BC).

lekythos (pl. **lekythoi**) (pottery) narrow-necked container for oil; see Fig 11.

loutrophoros (pl. **loutrophoroi**) (pottery) ritual vessel used to carry the water for a bride's bath; see Fig 11.

maenad ecstatic female votary of the wine-god Dionysus.

meander right-angled running pattern or elaborate fret, the 'Greek key' pattern, especially popular during the geometric period; see Fig 3.

Medusa the only one of the three Gorgons who was mortal; killed by Perseus; mother of Pegasus and Chrysaor.

metope stone panel inserted between pairs of triglyphs in the Doric order, sometimes decorated with sculpture in high relief; see Figs 25 and 250.

modelling in painting: the technique of rendering the illusion of a volume on a two-dimensional surface by means of shading; in sculpture: suggesting the roundness of a form visually (by means of modelling lines) or describing the undulations produced by the musculature of a torso, the curve of a cheek, etc; the representation of solid form in sculpture.

modelling lines sculptural technique in which ridges of stone in sweeping curves at right angles to a rounded surface model the forms (see also **catenary**).

motif a particular type of subject or a distinctive feature or element of a design or composition.

motion lines long, double-curving lines in drapery suggestive of movement (see also **catenary**).

Mycenaean the modern name given to the civilisation which flourished in Greece from the 16th to the 12th centuries BC.

Nike (pl. **Nikai**) personification of victory.

Nessos centaur who attacked Herakles' wife, Deianeira; see Figs 4, 10 and 79.

Odysseus hero who fought in the Trojan war, blinded the cyclops (Fig 6) and met Elpenor in the Underworld (Fig 199).

oinochoe (pl. **oinochoai**) (pottery) jug; see Fig 11.

orientalising period the 7th century BC, during which the Greeks were deeply influenced by certain aspects of Near Eastern art.

palmette stylised floral decoration consisting of an odd number of petal-shaped forms of which the central one is the tallest; often used in the borders on painted pottery; see, for instance, Fig 81.

Panathenaia annual Athenian festival in honour of the goddess Athena, celebrated with special pomp and athletic competitions every four years, the **Great Panathenaia,** when a new peplos was presented to the venerable wooden statue of the goddess.

Panathenaic amphorae (pottery) specially made amphorae used to hold the olive oil awarded to victors in the Panathenaic games; see Figs 84-86.

pediment triangular end of a gabled roof which could be filled with sculpture either carved in relief or free-standing; see Fig 27.

pelike (pl. **pelikai**) (pottery) a two-handled, pot-bellied jar; see Fig 11.

peplos woollen woman's dress made from a rectangular piece of cloth pinned at the shoulders; see Fig 73. The cloth was folded over at the top (instead of shortened by a hem at the bottom). The overfold could reach as far down as the waist or even further and could come over or under a belt (Fig 121 shows the overfold coming over the belt; Figs 184, 185, and 188 show the belt over the overfold). Sometimes some of the material was pulled up over the belt so that it formed a pouch, as in Figs 203-205.

Perseus Greek hero who slew the Gorgon Medusa.

peristyle colonnade surrounding a temple.

perspective a technique for painting three-dimensional scenes on a two-dimensional surface to give the illusion of objects existing in space.

phiale (pl. **phialai**) (pottery) a saucer-like bowl used for pouring libations to the gods; see Fig 11.

plinth the bottom part of a marble statue (and sometimes also of a small bronze); the part beneath the feet which is set into the cavity made in the base to receive it; see Fig 53 for statues complete with plinths that are not set within a base.

pyxis (pl. **pyxides**) (pottery) cylindrical box for trinkets or cosmetics; see Fig 11.

red-figure technique of vase painting in which the figures are left in the natural colour of the clay and the background and details are painted black.

relief sculpture which remains attached to the background, either very deeply carved (high relief) or shallowly carved (low relief).

satyr horse-eared, horse-tailed, snub-nosed male creatures devoted to Dionysus; see Figs 21, 95 and 96.

skyphos (pl. **skyphoi**) (pottery) a deep, two-handled, mug-like, stemless cup; see Fig 11.

stele (pl. **stelai**) an upright stone slab often bearing carved or painted decoration (frequently an image representing the deceased) serving as a tomb monument or marker.

tensile strength the resistance of a material to longitudinal stress.

Theseus Athenian mythological hero who fought Amazons and centaurs.

tondo circular centre on the interior of a cup.

torso the trunk or portion of the human body which remains when the head and limbs are removed.

transparency technique of carving which leaves occasional ridges standing up on otherwise nude forms to suggest they are covered by a thin veil of drapery (see also **catenary**).

white-ground technique of covering the surface of a vase with a white slip (primary clay with little or no iron content) and using this as the background to paint on.

white-ground lekythos a narrow-necked oil container painted in the white-ground technique and used as a grave offering. After the middle of the 5th century BC fugitive colours (mauves, blues and greens) were applied after the vessel had been fired; they were not so durable as the more usual, rather restricted range of ceramic colours.

Further Reading

General

Beazley, J.D. and Ashmole, B., *Greek Sculpture and Painting*, Cambridge University Press 1932

Boardman, J., *Greek Art*, Thames and Hudson 1985

Pollitt, J.J., *Art and Experience in Classical Greece*, Cambridge University Press 1972

Pollitt, J.J., *The Art of Greece 1400-31 BC* (Prentice-Hall Sources and Documents), Englewood Cliffs, New Jersey 1965

Richter, G.M.A., *Handbook of Greek Art*, Phaidon 1974

Robertson, M., *A Shorter History of Greek Art*, Cambridge University Press 1981

Woodford, S., *The Art of Greece and Rome*, Cambridge University Press 1982

Sculpture

General

Barron, J., *An Introduction to Greek Sculpture*, Athlone 1981

Boardman, J., *Greek Sculpture: The Archaic Period,* Thames and Hudson 1978

Boardman, J., *Greek Sculpture: The Classical Period*, Thames and Hudson 1985

Carpenter, R., *Greek Sculpture*, University of Chicago 1960

Hanfmann, G.M.A., *Classical Sculpture*, George Rainbird Ltd (London) 1967

Richter, G.M.A., *Sculpture and Sculptors of the Greeks*, Yale University Press 1970

Temple of Zeus at Olympia and the Parthenon

Ashmole, B., *Architect and Sculptor in Classical Greece*, Phaidon 1972

Ashmole, B. and Yalouris, N., *Olympia: The Sculptures of the Temple of Zeus*, Phaidon 1967

Cook, B.F., *The Elgin Marbles*, British Museum Publications 1984

Woodford, S., *The Parthenon*, Cambridge University Press 1981

Vase painting

Arias, P.E., Hirmer, M. and Shefton, B.B., *A History of Greek Vase Painting,* Thames and Hudson 1962

Beazley, J.D., *The Development of Attic Black-Figure*, Cambridge University Press 1951

Boardman, J., *Athenian Black-Figure Vases*, Thames and Hudson 1974

Boardman, J., *Athenian Red-Figure Vases: The Archaic Period*, Thames and Hudson 1975

Cook, R.M., *Greek Painted Pottery*, Methuen 1972

Henle, J., *Greek Myths: A Vase Painter's Notebook*, Indiana University Press (Bloomington and London) 1973

Robertson, M., *Greek Painting*, Skira 1959

Williams, D., *Greek Vases*, British Museum Publications 1985

Index